for hon, who I hope to welcome at

THE HOME OF
THE SURREALISTS

Best wishes
Antony Penrose
30-7-18

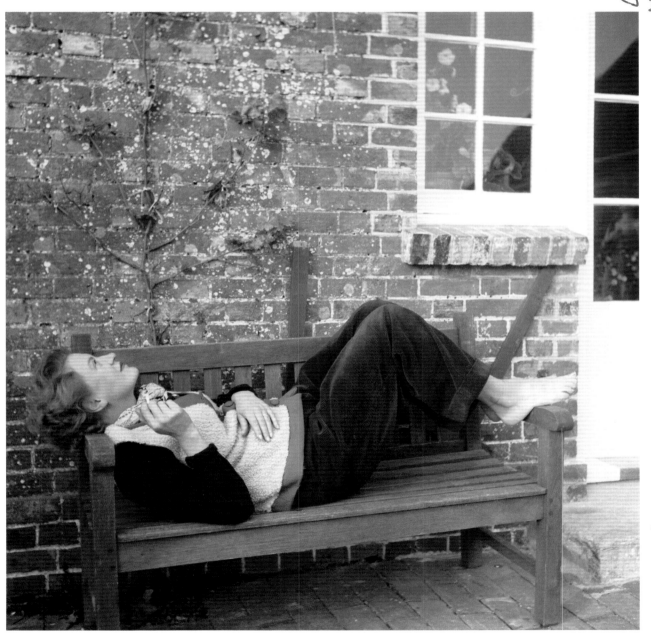

THE HOME OF THE SURREALISTS

Lee Miller, Roland Penrose and their circle at Farley Farm

ANTONY PENROSE

SPECIAL PHOTOGRAPHY

TONY TREE

PENROSE FILM PRODUCTIONS LTD
WWW.LEEMILLER.CO.UK
ARTWORK & PRINT BY WWW.FLOPRINT.CO.UK

For Patsy with love and thanks.
Without you Farleys would not have existed
and my life would have been unbearably bleak.

First Edition: Frances Lincoln 2001

British Library Cataloguing in Publication Data.
A catalogue record of this book is available from
the British Library

ISBN 978-0-9532389-1-0

COVER IMAGE: Dining Room Fireplace, Farleys House, East Sussex, England.
PAGE ONE: Lee Miller seated outside the sitting room, Farleys House,
East Sussex, England c1953' photographed by Roland Penrose.
PAGE TWO: Kitchen passage at Farleys House.
PAGE THREE: Sitting Room Fireplace, Farleys House, East Sussex, England' by Tony Tree.
ABOVE: Patsy Murray, Farleys, East Sussex, England 1951 by Lee Miller.
OPPOSITE: Farleys House from the South, Chiddingly, East Sussex, England c1952' by Lee Miller.
BACK COVER IMAGE: Lee Miller and Antony Penrose, Farleys House 1953.

CONTENTS

INTRODUCTION

The Surrealists were dedicated to the exploration and expression of the sub-conscious, and although it is unlikely that Roland Penrose and Lee Miller regarded Farleys House as a deliberately conceived art form that is indeed what it became. The places we live in and the way we decorate them become revealing statements about us as individuals. Our choice of possessions, colours and furnishings that surround us is a creative statement as unique as a signature, which interpreted by a graphologist can reveal the secrets of our innermost character.

The eighteenth century façade of the house visible from the road is almost severely formal, and as deceptive as Roland's own conformist appearance – well-presented, impeccably mannered, modest and reserved. Like Roland, Farley's exterior gives no hint of the visual excitements and the lack of formality to be discovered within - it's brightly coloured walls of blue, yellow and brick red, its rambling corridors and generously proportioned oddly asymmetric collection of rooms. In the heart of the house Lee's kitchen was the focal point of all activity, presided over by our house-keeper Patsy when Lee was absent. Like Lee, the brightly lit room, crammed with saucepans and gadgets was warm, chaotic and fragrant, and exuded an open friendliness that readily embraced all comers.

In the years that Roland and Lee occupied Farleys, the place continued to develop, as it had probably done since Neolithic people left their flint tools on the farm. Each successive metamorphosis had obliterated the traces of the previous dwelling until, in the early eighteenth century, timber, thatch, wattle and daub were replaced by more permanent brick. Over the next quarter of a millennium, time and weather toned the walls, the passage of hobnail boots wore the brick floors to smooth undulations and the house gained an air of rustic mellowness. Roland continued with care the tradition of adding extensions to the house, using old handmade bricks salvaged from a derelict barn on the farm.

Our British friends found Farleys exotic, but amusingly many of our overseas visitors thought it was typically English, unaware that not every English farmhouse had sabots by the back door, and an outstanding collection of modern art on the walls. Pablo Picasso, Joán Miró, Max Ernst, Dorothea Tanning, Paul Éluard, Man Ray, Leonora Carrington, André Masson, and Echaurren Matta were among those who came, stayed and clearly enjoyed the ambience and the art. You will gain your own impression of Farleys from these pages, and I hope enough of the spirit of Roland and Lee's hospitality remains to make it a rewarding and perhaps inspiring experience.

OPPOSITE: *Boat Bath*, c1927, oil on canvas, hangs above *Queens College Cambridge*, c1920, pencil on paper, with *Flight of Time*, 1949, oil on canvas, in the Hall all by Roland Penrose.
BELOW: Farleys visitors' book open at the page signed by Picasso on his first visit, 11th November 1950.

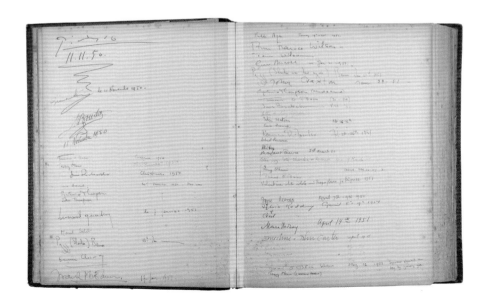

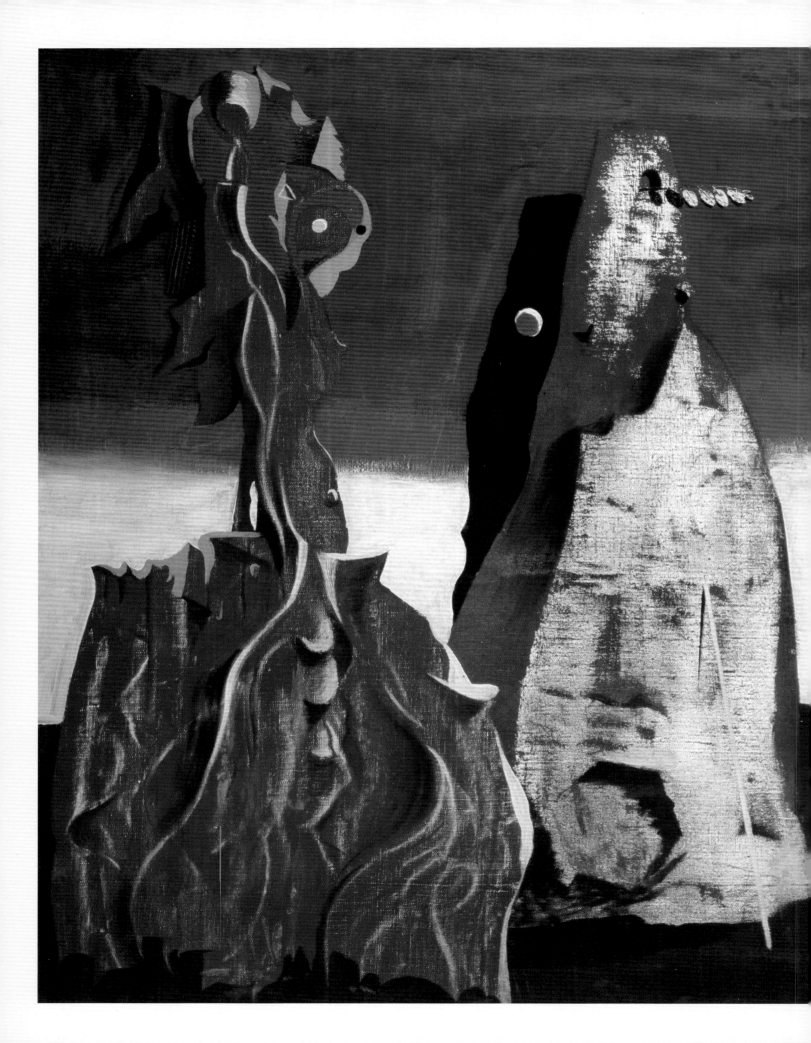

A SURREALIST IN FRIENDSHIP

*If we are to move towards a wider consciousness we need
constantly to experiment and to understand the experiments of others.
That is why I am a Surrealist. To experiment with reality.*

ROLAND PENROSE, NOTES TO HIS SPEECH, 'WHY I AM A PAINTER' 1937

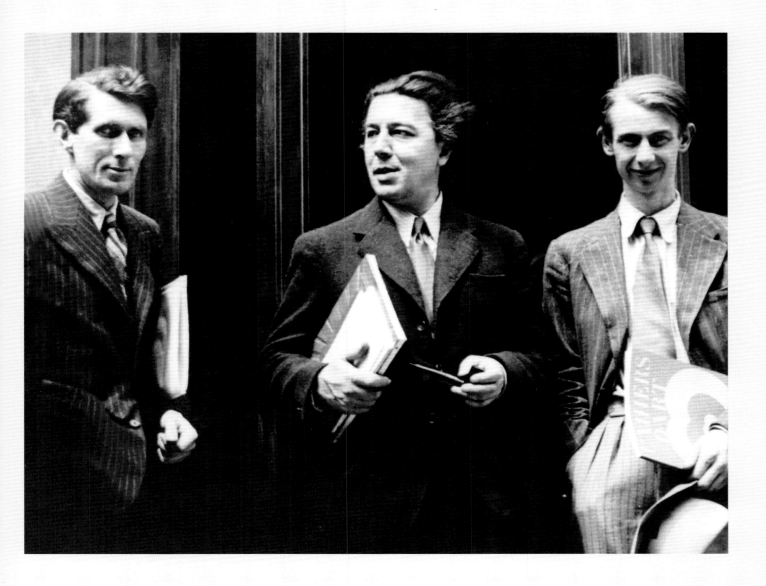

OPPOSITE: *Conversation between Rock and Flower*, 1928, oil on canvas, by Roland Penrose.
ABOVE: L–R Roland Penrose, André Breton and Humphrey Jennings at the opening of
the International Surealist Exhibition, London, England 1936.

Although today we tend to think of Surrealism in terms of the witty juxtapositions or dream-like images of the painters, the movement was born out of literature. It was the writings of the poets Guillaume Apollinaire, André Breton, Paul Éluard and others that inspired the painters Max Ernst, Joán Miró, René Magritte, Man Ray, Yves Tanguy, Paul Delvaux, Giorgio de Chirico, Salvador Dali and the rest of the pantheon of artists now associated with Surrealism. Pablo Picasso, never officially a Surrealist, was closest to the movement in his friendship with Éluard and his admiration for the poets. Roland Penrose was no exception. It was Breton's work that first came to his attention in about 1923, when he was leading a bohemian life as an artist in the small Provençal fishing village of Cassis-sur-Mer, and was Roland's first contact with the force that was to change his life.

During the last years of the First World War, a group of angry young men in Zurich mounted a series of protests, using theatre and literature to attack the society that had spawned such senseless carnage. They named their movement Dada, and their intention was to undermine and destroy everything, even their own art. Dada found sympathisers in New York, notably the anarchist painter Man Ray, and was particularly popular in Paris, where Breton, Éluard, Louis Aragon and Phillipe Souplaut invited the Dada leader, Tristan Tzara, to visit them in 1919. At first Dada caused uproar in the genteel Parisian literary circles, with its violent, revolutionary texts, music and drama, all of which seemed totally incomprehensible and were intended to provoke hostile reactions.

Five turbulent years later, Dada had virtually succeeded in its ambition of destroying itself – and in the process had cleared the way for a new movement. Surrealism was heralded in 1924 by Breton's *Surrealist Manifesto* and the first edition of the review *La Révolution Surréaliste*. Man Ray, who had moved to Paris and was now a photographer, Éluard, Aragon, Benjamin Péret and Pierre Reverdy were among the contributors. Their writings were interspersed with work by de Chirico, Ernst, André Masson, Robert Desnos and Picasso.

In contrast to the negativity of Dadaism, Surrealism offered its adherents a whole new way of life, an ideal for the future based on fairness and enlightenment, a hatred of materialism and a missionary-like desire to create change for the better through personal freedom and greater human understanding. The Surrealist code of behaviour rejected the bourgeois values applied to family, society and the formal concept of beauty. It also encompassed sexual freedom, which earned the Surrealists a reputation for great immorality but was based rather on their refusal to allow individual liberty to be controlled.

Beauty became the product of the accidental, the marvellous, the disturbing or the irrational – like the chance encounter of a sewing machine and an umbrella on a dissecting table, described fifty years earlier by Isidore Ducasse, the Count of Lautréamont in his poem Les Chants de Maldoror. The importance of dreams and the subconscious which had been recently brought to public attention by the work of Freud and Jung was also given great importance. Surrealist art came directly from the subconscious of the individual, and dreams were a valued source of strong and irrational images that shocked and surprised, and sometimes, when given a Freudian interpretation, informed about the fears and aspirations of the artist. In the 1924 manifesto, Breton proclaimed this definition of Surrealism:

> 'Pure psychic automatism, by which one intends to
> express verbally, in writing or by any other method,
> the real functioning of the mind ... based on the belief
> in the superior reality of certain forces of association
> heretofore neglected in the omnipotence of dreams,
> in the undirected play of thought.'

Some years later, when the two had become close Breton described Roland as *Surréaliste dans l'amitié* – 'Surrealist in friendship'. He was being characteristically enigmatic. Did he mean that it was a surreal experience for a bunch of radical left wing iconoclasts to have the shy grandson of an English Quaker banker as a friend? Was he referring to the fact that for most Surrealists quarrelling was more normal than being friendly and Roland was the exception who remained a friend of individuals from violently opposed factions? Or was it in recognition of the vital role Roland played in bringing Surrealism to England?

Roland's life began in the most conventional surroundings. He was born on 14 October 1900 into a family of strict Quakers. His father, James Doyle Penrose, from Wicklow in Ireland, was a portrait painter trained at the Royal Academy in London who achieved a moderate success. He met Roland's mother, Josephine Peckover, when he visited her home in Wisbech, Cambridgeshire

OPPOSITE: On the landing L-R hang portraits by Roland's father James Doyle Penrose of his father (also named James Doyle) and his mother Ann, Valentine Penrose 1925 and Roland as a child c1907. *The Queen of Sheba's ship* 1963 by Amancio Guedes stands beside a Chopi xylophone from South Africa.

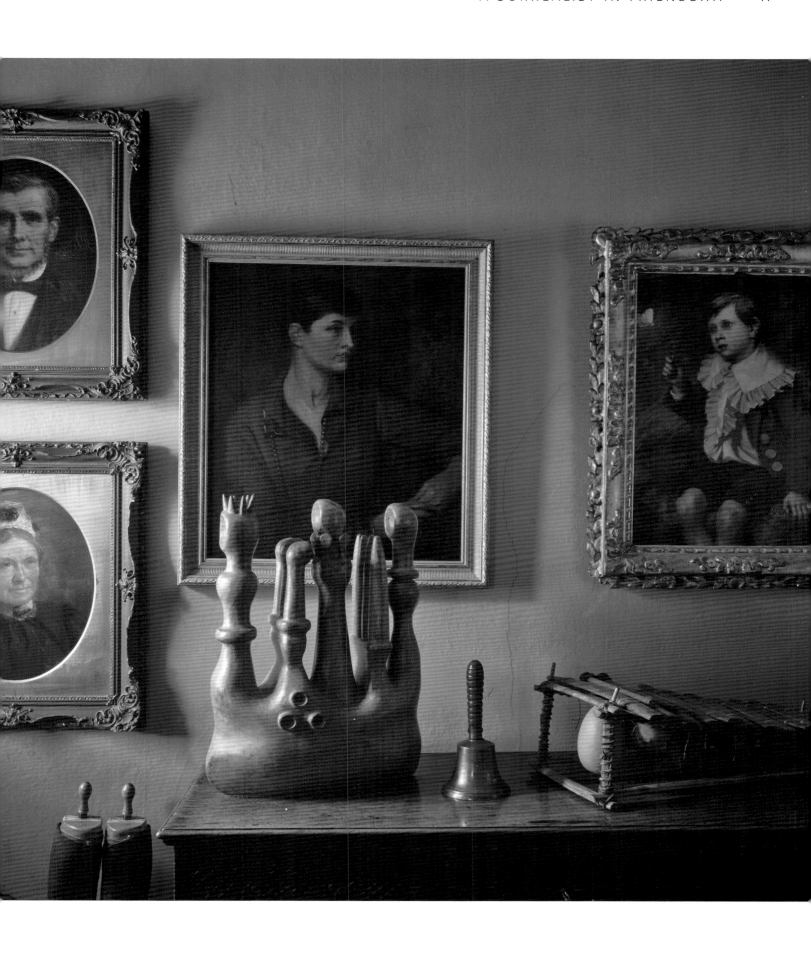

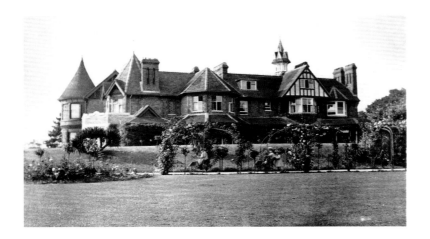

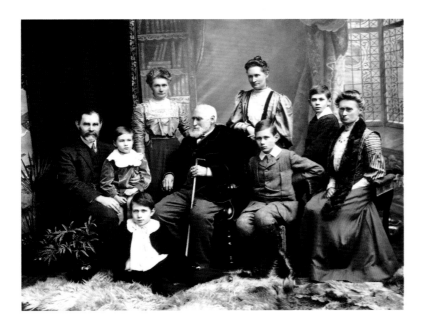

as a travelling portrait painter. Her ancestors' Quaker principles of honesty and industriousness had helped to establish the family as prosperous bankers, and Josephine's father, Alexander Peckover, became Lord Lieutenant of Norfolk and was awarded a peerage in 1907.

James and Josephine married in 1893 and bought a house and a studio in St John's Wood, London. Josephine's mother had died when she was young and her maiden aunts had brought her up with great rectitude but little maternal instinct, so the poor lady was always quite baffled and often horrified by the normal boyish behaviour of her four sons. Alexander, the first child, was born in 1896, followed by Lionel in 1898 and Roland's younger brother Bernard, known as Beacus, arrived in 1903. When Roland was eight, the family moved to Oxhey Grange, a large mock Tudor house near Watford in Hertfordshire, surrounded by an estate. James Doyle enjoyed settling down to the life of a landed gentleman, and continued to paint historical and religious themes. Josephine, a tireless campaigner for temperance and world peace, found the large house and garden ideal for parties in support of missionaries and visiting delegations of Quakers.

The routine of Quaker meetings on Sundays and household prayers twice a day, and the rejection of games like billiards and cards, any form of gambling, alcohol, dancing and all music except hymns, made for an oppressive atmosphere that the boys all eventually rebelled against in their own ways. Yet in his later years, Roland admitted that he would never have been such an ardent Surrealist if he had not been a Quaker first. As non-conformists, Quakers reject any earthly authority on spiritual matters and have a tradition of honourable dissent in the face of persecution. Roland also always held the Quaker belief that the 'inner light', the presence of God within a person, is universal. His insistence on seeing only the good in people gave great warmth to his friendship but occasionally let him down when he naively trusted those who exploited his generosity as the weakness of a soft touch.

LEFT TOP: James Doyle Penrose's studio at his home, Orwell Lodge, 44 Finchley Road, London, England c1909.
LEFT MIDDLE: The home of James Doyle and Josephine Penrose from 1908 to 1932, Oxhey Grange, near Watford, England.
LEFT BOTTOM: L-R James Doyle Penrose, Beacus, Roland, Aunt Alexandrina Peckover, Alexander Peckover, Josephine Penrose, Alec, Lionel, Aunt Anna Jane Peckover.
OPPOSITE: Roland Penrose aged eighteen.

Roland's sheltered existence came to an abrupt end in 1918. His brief war service took place during the last weeks before the Armistice, in the Red Cross ambulance unit led by the historian GM Trevelyan on the Piave front in Italy. The decaying dead that littered the beautiful plains of Venezia and the pitiable sight of starving and wounded prisoners deeply affected this gentle, sensitive youth of barely eighteen years. More assaults on his culture came as he discovered the acute blend of allure and embarrassment of his first striptease show, and the delights of drinking wine.

Roland could discuss none of these things with his parents, whose limited acceptance of the world's harsh realities increasingly isolated them from their sons in all but the formalized obligations of family life. Fortunately, the company of his two older brothers was a great source of strength, particularly when the three of them entered university in Cambridge the following spring. Alec and Lionel went to King's and Roland to Queens', to study architecture. Roland found Queens' an artistic desert, but his links to King's involved him with the Marlowe Dramatic Society, where he acted and designed scenery. It was through Alec that Roland met John Maynard Keynes, the economist and Bloomsbury intellectual, who probably introduced him to his fellow Bloomsbury friends, the artists Duncan Grant, Clive and Vanessa Bell and the critic Roger Fry. Fry was the man who in 1910 had introduced Post-Impressionism to England, exhibiting the works of Manet, Cézanne, Gauguin, and later Picasso, Matisse, Derain and Vlaminck,

all painters of seminal importance in the avant garde in general and to Roland in particular.

Up to this moment, Roland's experience of art had been typified by his father's figurative style, uncompromisingly Victorian in its stubborn refusal to look beyond bourgeois values. His first glimpse of the possibilities of poetic expression had come when he found books illustrated by William Blake in his grandfather's library, with their dreamlike scenes of fantasy, violence and hints of the utterly forbidden realm of sex. Fry provided Roland with a vital insight into the exciting developments of the European artists. At that time, their work was little known in England and, apart from Fry's immediate circle of friends, completely unrecognized in Cambridge.

The few remaining examples of Roland's paintings from this period reveal the first stirrings of his breaking out. Amid the well-executed but entirely conventional studies, a photograph of a mural he painted in Queens', showing two beasts of heraldic significance fighting, is depicted with obvious sexual overtones. In the intensely cloistered environment of Cambridge, Roland succumbed to the forbidden fruit of sex, through a homosexual relationship.

Roland graduated as an architect in 1922, but had no intention of entering the profession. Instead, he asked Fry's advice on how to become a painter. Without hesitation, Fry told him to go to Paris, advice Roland readily accepted. James Doyle Penrose, who had high hopes for Roland's career as an architect, was horrified. To Penrose, Fry's enthusiasm for Post-Impressionism made him seem a dangerous charlatan, and a traitor to his own well-respected Quaker family. However he eventually overcame his misgivings and, having made Roland promise to avoid the studios where nude female models were used, he sent him off to Paris, with a generous allowance of £300 a year, to study under the painters Othon Friesz and André Lhote.

Roland used to say that he changed his skin when he crossed the Channel. This was his way of describing the heady feeling of release from the constraints of his own culture that he always felt in France. When he arrived in France for the first time, he found himself stimulated by the style of André Lhote, who was strongly influenced by the Cubist works of Picasso and of Braque (whom Roland was soon to meet). Soon Roland's paintings began to show the bold fragmentation of Cubism combining with strong linear forms that suggest a link to his architectural training.

Roland described life in the studios of Montmartre as 'dazzlingly heterosexual', and in complete contrast to his life at

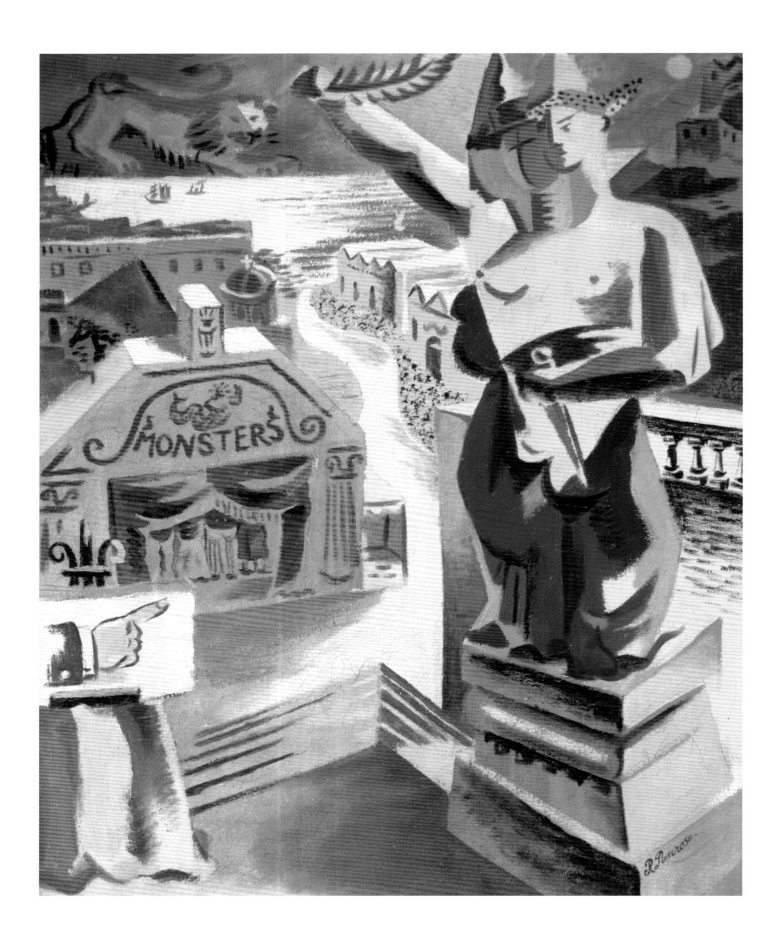

Cambridge and home, but he was too shy to sample the delights offered by the many free-spirited Parisiennes he encountered. His close friend Yanko Varda, a Greek artist, took charge and introduced him to his favourite brothel, where a sympathetic girl made her own successful contribution to his education. From that moment on he adored women, and they him. The eroticism, beauty and mystery of women became the most abiding fascination of his life.

Roland probably first heard about Cassis-sur-Mer from Duncan Grant or Vanessa Bell, as the village was already frequented by members of the Bloomsbury group who enjoyed the delights of Provençal life. In the summer of 1923, he went there with Yanko and impetuously bought Villa Les Mimosas. On the slopes above the town, the small but pleasant house stood discretely behind a high stuccoed wall capped with tiles. Its terrace overlooked a large garden, at the bottom of which Roland and Yanko built a studio. Here Roland began painting in earnest, though at this stage he did not take his work too seriously. Scenes of sea monsters or returning sailors show him playing with the influence of Cubism. He enjoyed the peaceful, carefree life and might easily have

OPPOSITE: *Monsters*,1925, oil on canvas, by Roland Penrose. The influence of Cubism combines with Roland's growing interest in Surrealism in this painting. The background resembles Cassis-sur-Mer with the Mediterranean beyond.
ABOVE: *Villa Les Mimosas*, 1923, Watercolour, by Valentine Penrose. The little tower afforded magnificent views out to sea, over the port and inland up the valley where the castle of La Couronne de Charlemagne looms on the horizon.
BELOW: *Road to Cassis*, c1924, oil on canvas, by Roland Penrose.

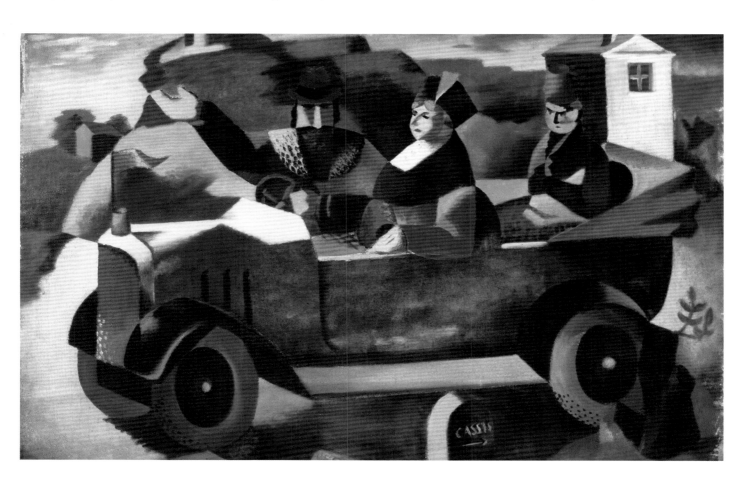

BELOW: *A mon Époux, Reconnaissance (Dit-on)*, 1925, mixed media, by Valentine Penrose. Thought to have marked the occasion of her marriage to Roland in December 1925. The title translates as '*To my husband, with gratitude (as one says)*'.
RIGHT: *Portrait of Valentine*, 1932, oil on canvas, by Roland Penrose. Valentine and her cat share the same untameable wildness and desire for escape.

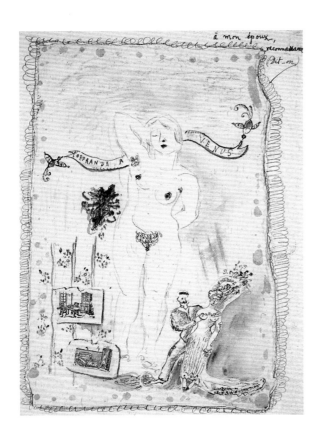

continued to paint quietly for many years, but for the sudden and unexpected arrival in his life of Valentine Boué.

Valentine had come to Villa Les Mimosas looking for a literary editor whom she had heard was staying with Roland. A Surrealist poet, her work had already come to the attention of Paul Éluard, and it was she who was to introduce Roland to Éluard and thus begin his lifetime commitment to Surrealism. That morning Valentine was strikingly dressed in a large black hat and a formal suit. She had dark brown hair and beautiful almond shaped brown eyes, set in a face that could only have been French in its oval perfection. Valentine was an embodiment of a Surrealist poetic muse. She had a natural air of mysticism, which was compounded by her fascination with Eastern philosophy,

her closeness to nature, and her understanding of the arcane, which included using her Tarot cards to foretell the future with disturbing accuracy. She had thoroughly rejected bourgeois values and was given to sudden, vituperative outbursts against anything she thought banal, a habit that terrified Duncan Grant and other friends of Roland's.

Roland later likened Valentine's entry into his life to being struck by lightning. They were married on 21 December 1925 at the Quaker Meeting House at Jordans, in Buckinghamshire, after a Catholic ceremony at Condom-sur-Baïse, Valentine's hometown in Gascony. Living all year round in Cassis-sur-Mer, Valentine was made desperately uncomfortable by the icy mistral that blew down from the Alpes-Maritimes for weeks at a time, so in 1928

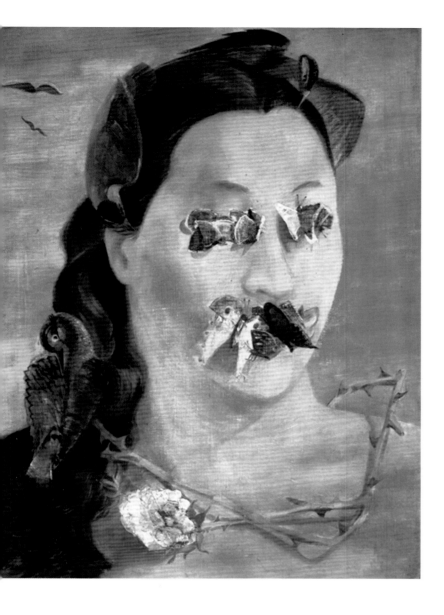

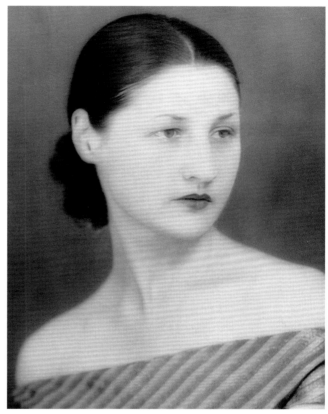

LEFT: *Winged Domino*, 1938, oil on canvas, by Roland Penrose. Roland painted this portrait of Valentine after their divorce as a loving postscript to their marriage. The birds and butterflies symbolise her closeness to nature and the colour of her face suggests her withdrawal to another world. The rose, a play on Penrose, suggests that love and pain are as inseparable as a rose and its thorns. Valentine had left for India so he used the photograph by Man Ray (below) as a reference.
BELOW: *Valentine Penrose*, Paris, France, c1933, by Man Ray.

they bought a flat on the Left Bank of Paris, near to the Louvre and the Montparnasse cafés frequented by the Surrealists. It was there that Valentine introduced Roland to Éluard, Breton, Ernst and Miró. Later he would meet Man Ray, Masson, Aragon, Dali and Jean Cocteau. It was not until 1936 that Paul Éluard introduced Roland to Picasso, the most significant friendship of his life.

Ernst was the most generous in his encouragement of Roland's work. He passed on a wide range of techniques such as collage (from the French *collé*, meaning glue), in which ready-made images of no particular medium are glued to a background; frottage, in which the paper or canvas is placed on a rough surface and rubbed with paint, crayon or pencil to pick up the texture of the surface beneath; and grattage, like frottage in reverse, in

which a freshly painted canvas is scraped with a knife or piece of glass to remove the colour. Roland took on these techniques and made them his own in work that was by this stage predominantly Surrealist. His first one-man exhibition was held in June 1928 at Galerie Van Leer in Montparnasse.

As Roland became more involved with the Surrealists, conflict arose between him and Valentine. Despite her passion for Surrealist poetry, she wanted her life's journey to follow an inner path of enlightenment, where all worldly matters including art would be renounced for meditation and study. Roland, on the other hand, wanted to seize life and all its excitements, and saw art as his own path to enlightenment. They tried hard to compromise. They sold Villa Les Mimosas and bought the

RIGHT: *Ox Cart in India*, 1933, watercolour, by Roland Penrose. Roland's friendship with Jean Hélion and Wolfgang Paalen, who were members of the Abstraction-Création group, clearly influences his work from this period. It is also possible he was avoiding Valentine's disapproval of his enthusiasm for Surrealism with work like this and the one below.
BELOW: *Arab Man*, 1935, oil on canvas, by Roland Penrose.

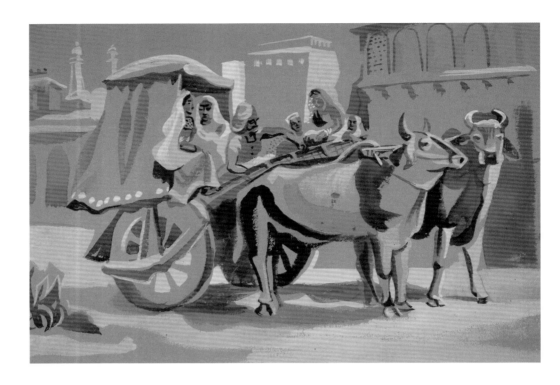

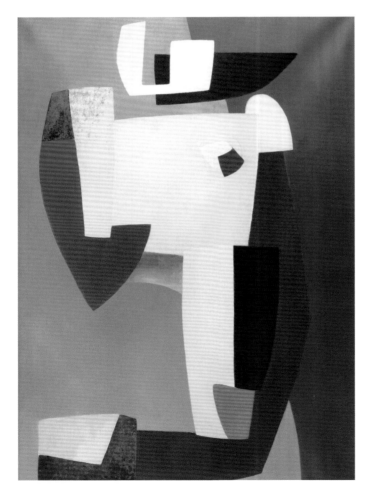

romantically beautiful Chateau Le Pouy in Valentine's native Gascony. Roland did all he could to make it into a palace for his muse, but the isolation and the harshness of the winters defeated them. In 1932 they travelled in India for five months. Roland's drawings show that – perhaps as a gesture of appeasement – he temporarily abandoned Surrealism for a direct, figurative style, which he followed with a series of abstract works influenced by his friendship with Jean Hélion, a member of the French Abstraction-Création group. But the differences between Roland and Valentine were too profound to be influenced by even these heroic efforts, particularly as Valentine remained stubbornly resistant in the belief that their problems were all Roland's fault.

By 1934 their relationship was strained to breaking point. Roland had inherited some money from his aunts and was able to finance Surrealist projects that interested him like the publication of Ernst's collage book *Une Semaine de Bonté* and Robert Bresson's first film *Les Affaires Publiques*. Valentine detested of both projects. Jealous of his friendship with Roland, she had come to dislike Ernst, and she regarded film as frivolous and a waste of money. In a sense she was right about the film – Roland lost his investment completely. More importantly, he also lost his health. In the autumn he developed a serious stomach ulcer, and had to return to London for treatment. Realizing that his relationship with Valentine could go no further, Roland separated from her in 1935,

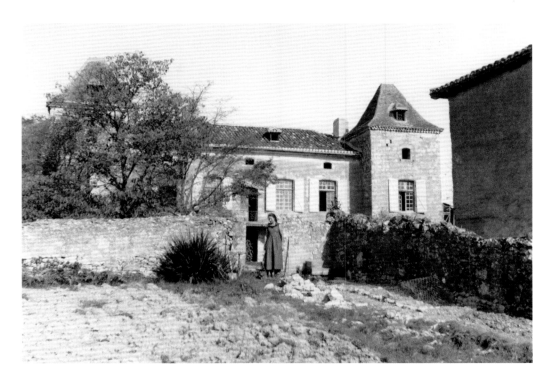

LEFT: Valentine in the walled garden, Chateau Le Pouy, France, c1933, photographed by Roland Penrose.
BELOW: Valentine at Cap Ferrat, France, c1931, photographed by Roland Penrose. Roland's photograph captures Valentine's determination to tread her own path which eventually led to their divorce.

sold Le Pouy and the Paris apartment, and settled in London. Valentine tearfully left to live in India. They were divorced two years later and, freed from formal constraints, came to love and understand each other like devoted siblings. Roland supported Valentine financially for the rest of her life.

Roland's freedom allowed him to commit himself fully to Surrealism. He made frequent visits to Paris to see old friends, and in Montparnasse chanced to meet David Gascoyne, a young English poet who was also a friend of Éluard. Gascoyne had just written the first book on Surrealism published in Britain, *A Short Survey of Surrealism*, which was ignored by most critics. Roland and Gascoyne found they shared the same evangelical zeal for bringing Surrealism to Britain, and agreed there and then to collaborate on what would be the first exhibition of Surrealist art in London, the International Surrealist Exhibition of 1936. Éluard, Breton, Man Ray and the Belgian art dealer ELT Mesens agreed to contribute loans of the European Surrealists. Back in London, Roland and Gascoyne formed a committee to organize the exhibition and select loans for the British Surrealist section.

Henry Moore, the sculptor, Herbert Read, the editor of the art review, *The Burlington Magazine*, Humphrey Jennings, the painter and filmmaker, Paul Nash, the painter and photographer, Hugh Sykes Davies, a Cambridge don, and William Hayter, the painter

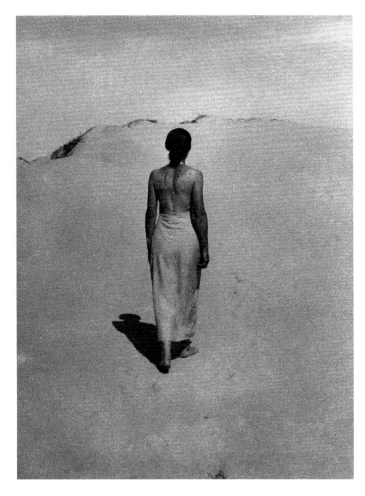

and printmaker, were among the first committee members. The difficult task of finding a body of work by British Surrealists fell to Roland, Read and Nash. The Surrealists were not then established as a group in Britain, so they searched for artists whose work accorded with Surrealist principles. Some, like the painter Eileen Agar, were delighted to become instant Surrealists; others, like the Birmingham artists Robert Melville and Conroy Maddox, objected strongly to the label, although later became recognized as British Surrealists.

When the exhibition opened at the New Burlington Galleries in June 1936, four hundred Surrealist works were on show. Twenty-seven of the sixty-nine artists were British, their work hanging alongside pieces by the foremost European artists such as Dalí, Ernst, Magritte, Man Ray, Miró, Picasso and Tanguy. Roland contributed three recent paintings, *The Freedom of the Seas*, *The Jockey* and *Oasis*; a collage titled *Beauty Prize* (1932); and his Surrealist object titled *Captain Cook's Last Voyage* (1936). More than a thousand people jammed the gallery for the opening by Breton. It was the

hottest day of the year, and Dali, who was attempting to give a lecture dressed in a diving suit, nearly collapsed from heat and suffocation. To the great satisfaction of the Surrealists, the press vehemently attacked the show, and the public flocked in. The Surrealist movement had been born in Britain.

By 1936, the threat of Fascism was growing rapidly in Europe. Although most people in Britain took little notice, a steady stream of young artists, writers and musicians were travelling to Spain

BELOW AND OPPOSITE BOTTOM: Roland's annotated drawing and an installation photograph of the 1936 International Surrealist Exhibition confirms the richness of the display. Roland Penrose's Surrealist object *Captain Cook's Last Voyage*, now in the Tate Modern, is in the centre.
OPPOSITE TOP: Diana Brinton Lee, Salvador Dali (in the diving suit), Rupert Lee, Paul and Nusch Éluard, ELT Mesens at the opening of the International Surrealist Exhibition, London, England 1936.

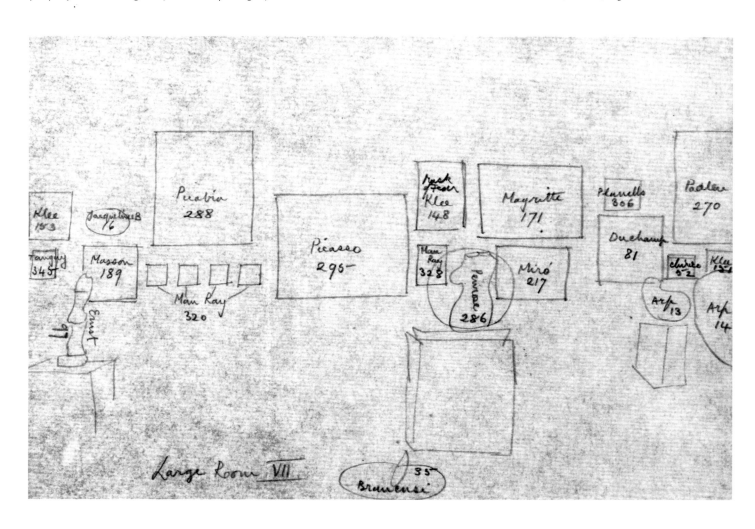

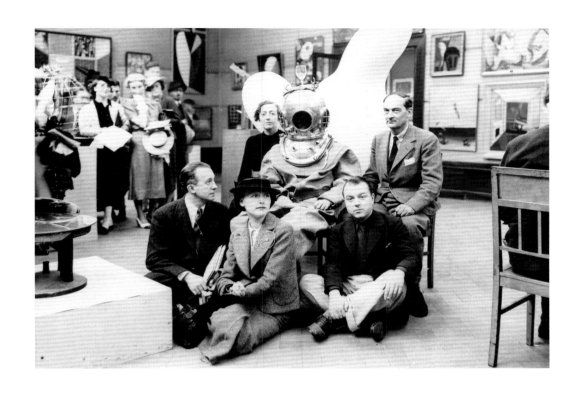

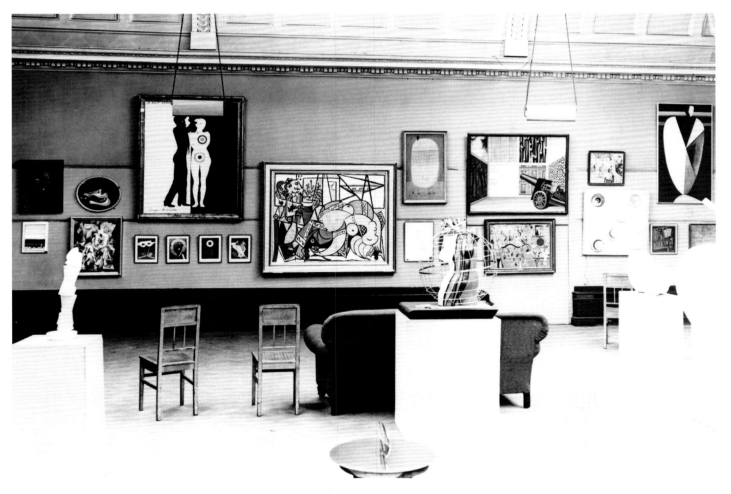

to fight on the side of the Republicans against Franco's Fascists. The Surrealists, for whom art, politics, and social reform were inextricably combined, became politically active against the British government's tacit support of Franco. Roland, with his Quaker principles of non-violence, decided to work on the public relations side. With a special pass from the Independent Labour Party, Roland, David Gascoyne and Valentine (with whom he was enjoying a

brief reconciliation after her return from India) left for Barcelona accompanied by the art publishers Christian and Yvonne Zervos. Their mission was to gather evidence to counter allegations that the Republicans were vandalizing churches and works of art. Their six week tour of Catalonia revealed that the Republicans had in fact taken better care of the nation's art treasures than the Church, and Roland and Zervos published the evidence the following year in *Catalan Art from the 9th to the 15th Centuries.*

On 21 June 1937, Roland was staying with Ernst in Paris. The word had got around that the daughters of Monsieur et Madame Rochas were, in the absence of their parents, holding a Surrealist ball in their ostentatious family home on Avenue d'Iéna. Max clad in the ragged costume he had used as a brigand in Luis Bunuel's 1930 film *L'Age d'Or* dyed his white hair bright blue. Roland coloured his right hand and left foot blue and wore Ernst's paint-splattered trousers. Many of Roland's friends were there, including Man Ray who at one point in the evening unaccountably punched Éluard. A head and shoulders taller than Man Ray, Éluard, instantly forgave his old friend, saying it was only natural for a small, courageous man to occasionally feel compelled to hit a tall man.

Amid the fracas, Roland was transfixed the sight of what he took to be a visiting angel. Unlike the other women dressed in wildly provocative costumes, his angel was wearing a dark blue cocktail dress that subtly accentuated her sensual figure. Beautiful blue eyes gazed confidently from a tanned face, surmounted by soft blonde hair that held the slightest tint of green. She radiated warmth and sexuality, intelligence and humour. Roland, shy at the best of times, was rendered mute and rooted to the spot, having had – for the second time in his life – the sensation of being struck by lightning. As he stood there paralysed the party broke up in chaos and his angel was swept away in a stampede of frantic guests trying to escape. Monsieur and Madame Rochas had returned unexpectedly and were in a blazing fury at finding their house filled with Surrealists. Max dragged the catatonic Roland out of the door. 'Who was she?' Roland demanded when he regained the power of speech. 'She is Lee Miller,' said Max, 'she's American – I know her well – let's invite her to supper tomorrow.'

LEFT: Roland Penrose, Paris, France, 1935, photographed by Rogi André. OPPOSITE: *Oasis*, 1936, oil on canvas, by Roland Penrose. Roland's interest in ethnographic masks may have inspired the mask-like shapes that appear in many layers, suggesting a multi-faceted personality.

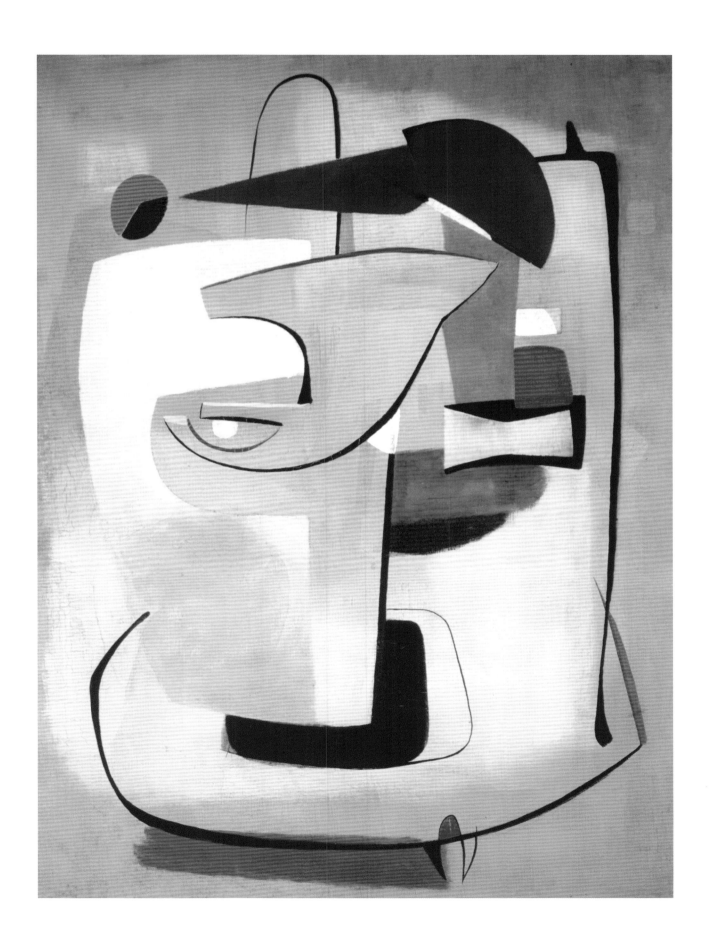

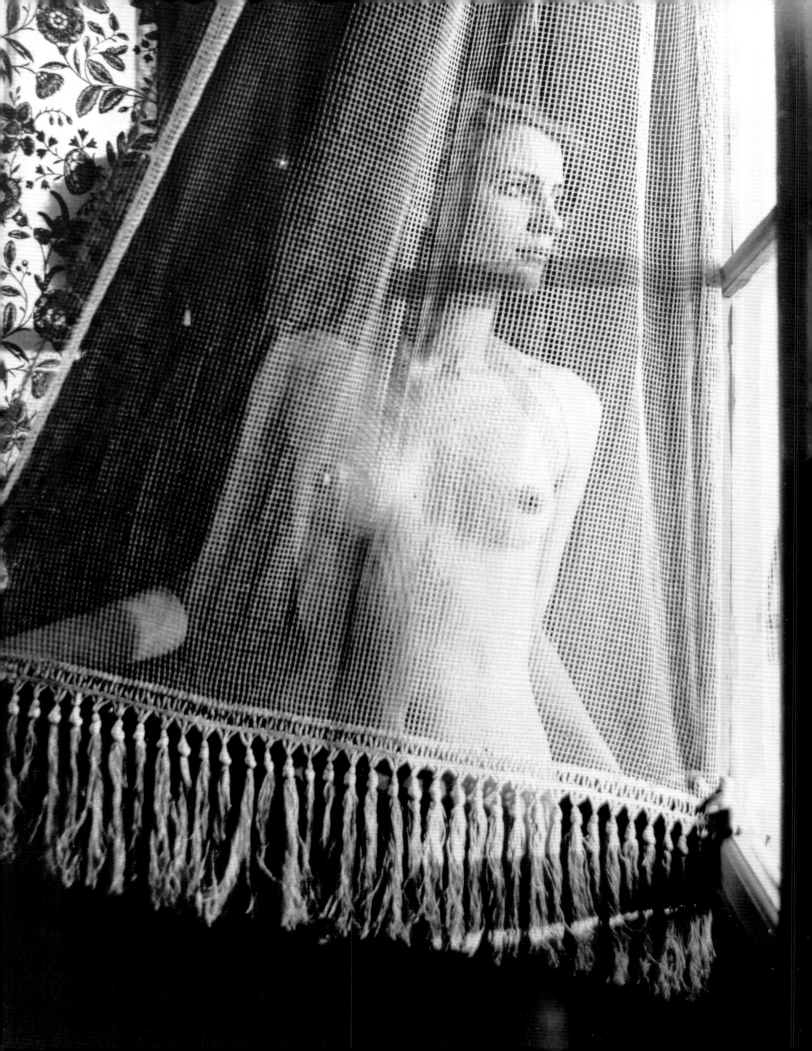

THE SURREALIST FROM POUGHKEEPSIE

The thing that makes one man's work finer than others is his honesty.

LEE MILLER QUOTED IN RUTH SEINFEL, "EVERYONE CAN POSE"
NEW YORK EVENING POST, 24 OCTOBER 1932

OPPOSITE: *Lee Miller*, Paris, France, c1930, by Man Ray.
ABOVE: *Portrait of Space*, Near Siwa, Egypt, 1937, by Lee Miller.

The fragile blessing of great beauty for which Lee Miller was celebrated for so long was not evident in her earliest years. Born in 1907, the child of Theodore Miller, an engineer, and Florence, a nurse, she grew up on a farm in the small, light industrial town of Poughkeepsie, in upstate New York. The stocky little girl who in family photographs stands square onto the world was mainly interested in outsmarting and out daring her two brothers, John and Erik. With encouragement from their father, the children built a railway down a murderously steep slope, catapults for firing giant snowballs and an aerial ropeway across a small gorge. The latter was deemed so dangerous that Theodore had to hire workmen to dismantle it.

Theodore was a remarkably progressive and eclectic engineer, whose hobby was photography. At first, the carefully captioned family albums were filled with photographs of marvels like 'a heavier than air flying machine', but these images were later thrust aside in favour of pictures of Lee, who was clearly the apple of his eye. The photographs trace her evolution from a dumpy tot, to a tomboy, to a willowy young woman who, rather disturbingly, posed nude for her father. Theodore's heavy-handed attempts at 'art' fail to disguise a very creepy element in the pictures, in which Lee looks submissive, uncomfortably torn between going and staying. There is no evidence that the photographic sessions were part of an incestuous relationship, but the images contain a sexuality that certainly crosses the usual father-daughter boundaries.

They are all the more extraordinary for the fact that as a seven-year-old child Lee was raped by a family friend. The details of the event were shrouded in secrecy and all but lost but it is certain that the violation left Lee infected with venereal disease. In those days, before the discovery of penicillin, the only cure was a series of excruciatingly painful douches, which Florence had to administer. Erik recalled that before the treatment he and John were sent out of the house and told to walk two blocks in an unsuccessful attempt to spare them their sister's screams.

Theodore and Florence were ahead of their times in consulting a child psychiatrist on how to ameliorate Lee's trauma. The man advised that Lee be told that sex is merely a trivial recreation, and that it is love that is the sacred key to life. Lee's parents were delighted when she fell in love for the first time, at the age of nineteen, with a popular local boy called Harold Baker. But one

day in July 1926, while they were out canoeing on nearby Lake Upton, Harold fell in the water and died. He had been suffering from a weak heart, and nobody had known. Lee was devastated, and tragically a similar episode took place a few years later. In 1929, another lover, a young Canadian airman called Argylle, crashed his plane and died after swooping low over the liner taking her from the port of New York. Perhaps as a result of these events, Lee was to find great difficulty throughout her life in expressing love for those she held dear, lest her love should prove to be fatal.

After the rape, Lee's outraged parents naturally became overprotective towards her, which later only heightened her sense of rebellion. As a youngster, Lee had quickly learned there were some advantages to be gained from the trauma of her experience, and she used the event to bend her parents to her wishes. She was thrown out of one school after another for rebellious behaviour, becoming known in the neighbourhood as the kind of girl with whom respectable mothers did not allow their daughters to associate. In 1926 Theodore and Florence, ever indulgent, hired two elderly Polish spinsters as chaperones and sent Lee off to Paris, in an attempt to civilize her.

When Lee arrived in Paris, she looked around and exclaimed, 'Baby, I'm *home*!' After the inhibited society of upstate New York, arriving in Paris was like being let out of jail. She wasted no time in ditching the chaperones, and enrolled herself in the Ladislas Medgyes Theatre School. Student life in the artistic capital of the world offered Lee the personal freedom she craved. Surrealism, an established force of rebellion against social constraint, helped affirm her rejection of convention and reason, and her celebration of the unfettering of her body and mind. She would have stayed a lot longer, had it not been for Theodore who, returning through Paris from a business trip to Stockholm, found Lee and dragged her home.

After Paris, Poughkeepsie had no chance of containing Lee. She announced that she wanted to become a painter, so her parents agreed to allow her to enrol in the Art Students League in New York. She retained her connections with the theatre by lighting some Vassar College productions, and appearing as a dancer in variety shows and nightclub productions. The parties were great and as a pleasure seeker Lee excelled – a beautiful, daring, highflier with the clean-cut sporty looks of the period, determined to enjoy everything to the full.

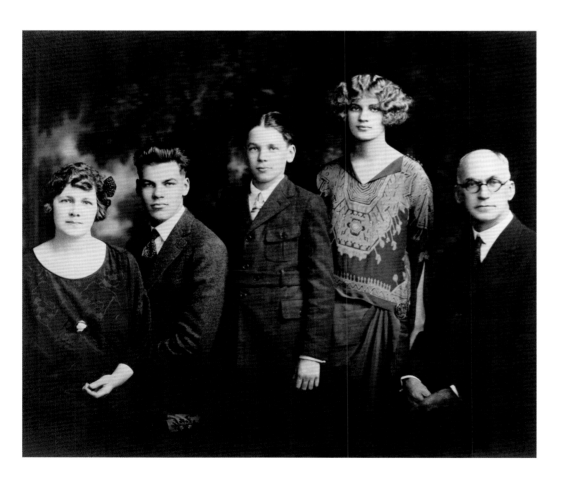

OPPOSITE LEFT AND RIGHT: Lee Miller as a young girl. The portraits suggest Lee enjoyed being photographed despite her usually outrageous tomboy behaviour. LEFT: L-R Florence, John, Erik, Lee (aged 16) and Theodore Miller, Poughkeepsie, New York, USA, 1923.

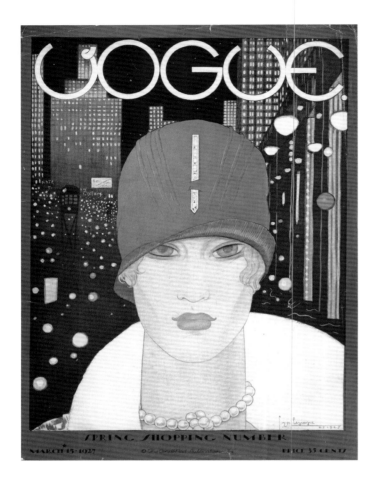

One day in Manhattan in early 1927, Lee's carefree life was nearly cut short when she stepped into the path of an oncoming car. The man who saved her life by yanking her to safety was Condé Nast, the publisher of *Vanity Fair* and *Vogue* magazines. Lee, overcome by fright, collapsed in his arms. Nast was enchanted by the ravishing creature who, thoroughly shocked, was prattling her thanks in French. He wasted no time in getting her round to *Vogue* studios. Her face, drawn by the celebrated fashion illustrator, Georges Lepape, gazing coolly from under a large cloche hat with the lights of Manhattan in the background, was on the front cover of *Vogue's* March issue.

Lee posed for the top photographers of the day, such as Edward Steichen, Arnold Genthe, and Nickolas Murray, and enjoyed a successful modelling career until her picture appeared in a nation-wide campaign advertising Kotex sanitary pads. The advertisement, which featured an elegant Steichen photograph of Lee in a ball gown and implied that she personally endorsed the product, was considered outrageous. Today the advertisement seems remarkably restrained, but this was the era when peep-toed sandals or bobbed hair were taken to signify loose morals and decent women did not publicly discuss things such as Kotex, let alone use their image to signify approval of the product. A row ensued that killed Lee's modelling career stone dead. No fashion house wanted their creations modelled by the Kotex girl, so, determined to start a new career as a painter, she left for Italy in the spring of 1929.

Touring the art galleries of Rome and Florence convinced Lee that every painting that could be painted had been painted. She found the process of painting tedious and lonely compared to the immediate and exciting experience of photography. Steichen had given her an introduction to Man Ray, and she headed for Paris, reasoning that the star of modern photography would be her best possible teacher.

Man Ray, born in Brooklyn in 1890, was the son of Manya and Melach Radnitsky, hardworking Jewish emigrés from Russia. His early work as a painter attracted the interest of Steichen, but it was his contact with the French Surrealist Marcel Duchamps, who was at that time in New York, that encouraged him to go to Paris.

LEFT TOP: *Vogue* Cover portrait of Lee Miller, New York, USA, 1927, by Georges Lepape, the celebrated illustrator.
LEFT BOTTOM: A version of the Kotex advertisement that ended Lee's modelling career in America.
OPPOSITE: *Lee Miller*, Paris, France, c1930, by Man Ray.

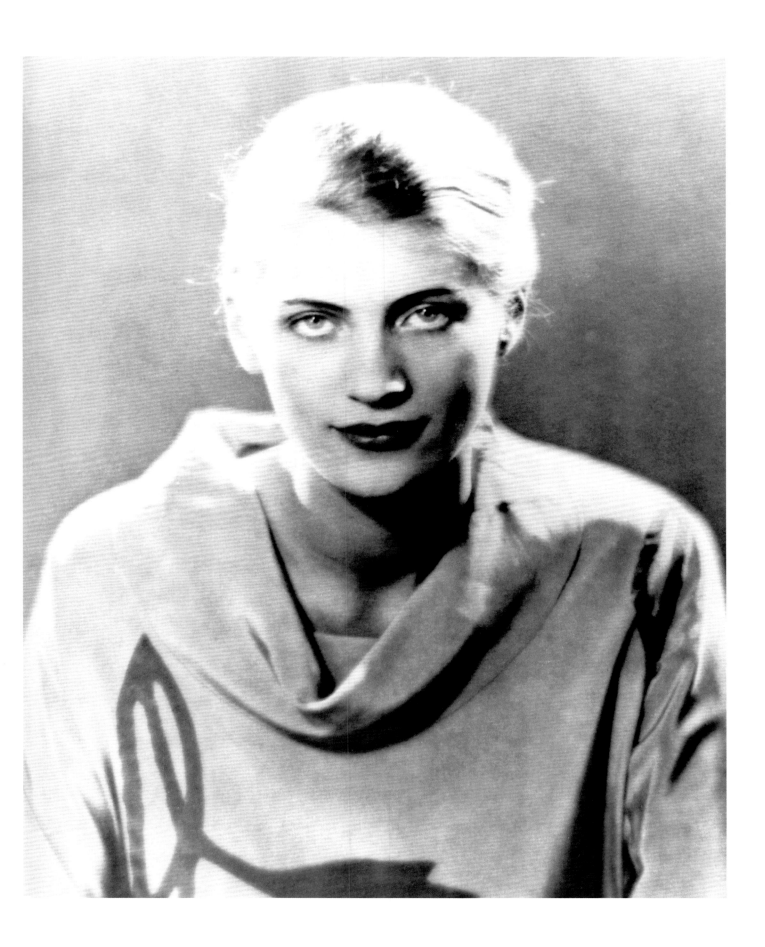

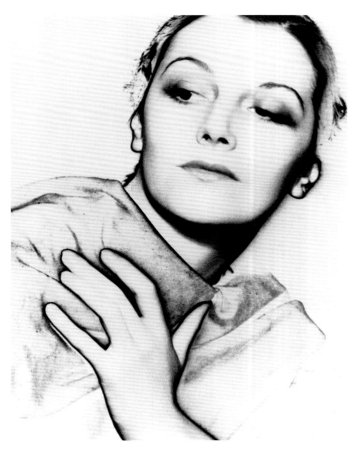

He arrived in 1921, having changed his name to Man Ray and irrevocably embraced the new persona that went with it. Man Ray himself was in effect one of his own creations.

Man Ray's Surrealist objects and paintings became widely known in Paris, but in common with work by his fellow artists sold infrequently, and for low prices. He began photographing portraits and then fashion to earn a living, and his inventive and original approach caused him to become known as the most exciting avant garde photographer in Paris.

When Lee arrived in Paris, she was told by the concierge at Man Ray's apartment that he had departed for his holidays. She was consoling herself with a Pernod in the Bâteau Ivre café, when suddenly Man Ray appeared, a short wiry figure with dense wavy black hair capping a benign, owlish face. Lee leaped to her feet and told him she was his new student. 'I don't take students', retorted Man Ray, 'and anyway I am off to Biarritz'. 'I know', said Lee, 'and I am going with you'. For the next three years, their highly fraught romance contrasted with their dazzling artistic achievements. Lee modelled for Man Ray and he taught her photography. Some of Man Ray's best known photographs and paintings date from this partnership, and the technique of solarisation became emblematic of Lee and Man Ray's artistic association. This technique, first recorded by the French scientist Armand Sabatier in 1862, produces a dark outline to tonal boundaries and was literally stumbled upon by Lee in the darkroom. A rat ran over her foot – she snapped on the white light, and in doing so gave the plates in the developer a second exposure. In an attempt to salvage them, Man Ray put the plates in a fixing solution, and was astonished to discover the resulting effect.

Man Ray's love for Lee drove him to the brink of suicide. As a Surrealist, he was a firm believer in free love, meaning that sex is not connected to love, and a person can go to bed with whoever they choose without being 'unfaithful' to their loved one. This tenet was particularly popular with the men, who tended to believe it applied only to them. Lee, however, felt that Surrealist ideals should be universal, and she had as many lovers as she pleased. Man Ray was wretchedly consumed with jealousy. To make matters worse, in 1930 Lee starred in *The Blood of a Poet*,

LEFT TOP: *Untitled*, Ironwork, Paris, France, 1931, by Lee Miller.
LEFT BOTTOM: Solarised Portrait (thought to be Meret Oppenheim), Paris, France, 1932, by Lee Miller.

a film made by Man Ray's arch rival Jean Cocteau. Man Ray's work seems to show his desire to control Lee by visually dismembering her body. In his photographs, her torso appears headless, unable to answer back. Her head, hands, legs, lips and eyes are scattered across further works, notably *Indestructible Object* – later titled *Object to be Destroyed* (1923–29) – a metronome with an image of Lee's eye pasted to the weight, which relentlessly marked the beats of her absences from his life.

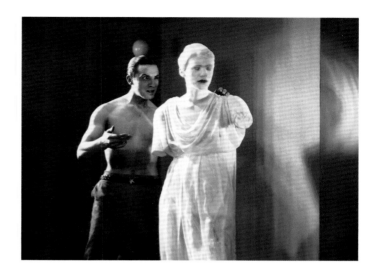

Lee learned fast and started her own photographic studio near to Man Ray's. Her early work shows evidence of a Surrealist eye in her use of unusual angles or strange juxtapositions, and the key element in her work was the *image trouvé*, or the 'found image'. The *objet trouvé*, or 'found object', was a well-established art form among Surrealists. An object, natural or man-made and usually valueless, was endowed with a life of its own by virtue of placement, minimal modification or titling. Similarly Lee used her camera like a cookie cutter to select scenes from life that then took on a meaning of their own. The style stayed with her throughout her career as she found different ways of playing with chance and rejecting conventional viewpoints to give us her most enduring images.

ABOVE: Enrique Rivero and Lee Miller in Jean Cocteau's *'Sang d'un Poète'*, Paris, France, 1930, by Sacha Masour. RIGHT: *Object to be Destroyed*, Paris, France, 1928, by Man Ray. BELOW: Man Ray, Paris, France, c1931, by Theodore Miller.

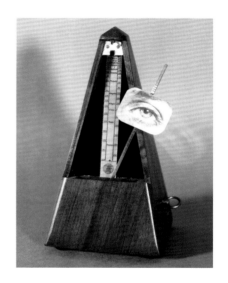

Despite the forcefulness of her Surrealist images, the mainstay of Lee's work was fashion and portraiture. To encourage her, and to give himself more time to paint, Man Ray began sending Lee some of his assignments, and soon she was shooting for top couture clients like Patou and Chanel with her work published in *Vogue*. She might have continued like this for many years, becoming well established and respected. But like all Surrealists Lee had consciously invited chance to play a major role in her life, and as usual something big brewed up when she was least expecting it.

In the early 1930's Nimet Eloui Bey, the wife of a rich Egyptian called Aziz, was widely celebrated as one of the five most beautiful women in the world. She posed for Man Ray and for Lee, who became friendly with her. Then Nimet's husband Aziz fell passionately in love with Lee, and after a brief affair summarily divorced Nimet under Moslem law. Nimet was utterly distraught, and Lee herself was thrown off balance. Suddenly her carefree, libertine lifestyle had become deadly serious. Man Ray, who had all along been consumed with jealousy for Lee's other lovers, took to carrying a pistol and dropping hints that he could not decide whether to shoot Lee, her lover or himself. At the same time he pressed Lee to marry him while Aziz added his own pleas for marriage. Hunted by demanding men, Lee escaped to New York.

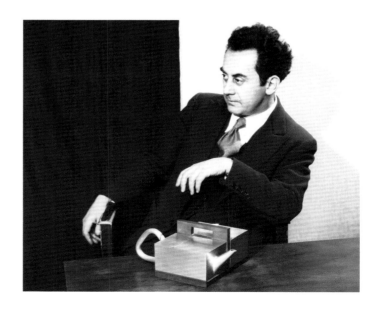

Man Ray spent the night of Lee's departure standing in the rain beneath the dark windows of her former studio, weeping and

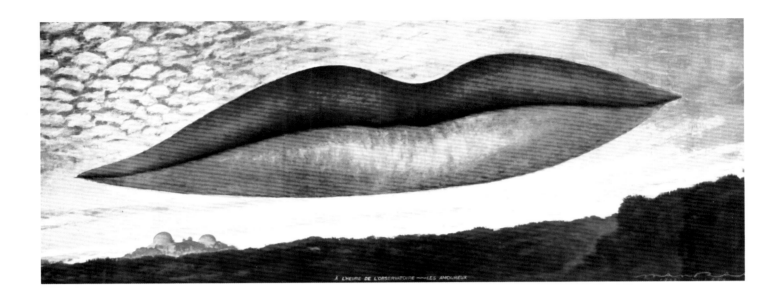

À L'HEURE DE L'OBSERVATOIRE — LES AMOUREUX

ABOVE: *Observatory Time - The Lovers*, Paris, France, 1934, oil on canvas, by Man Ray. Completed two years after Lee had left, this image of Lee's lips was Man Ray's final expiation of his grief for his lost love.
BELOW: Solarised portrait of Lilian Harvey, New York Studio, New York, USA, 1933, by Lee Miller.
OPPOSITE TOP LEFT: Lee Miller and Aziz Eloui Bey, Egypt, c1935.
OPPOSITE TOP RIGHT: Domes of the Church of the Virgin, Al-Adhra, Deir El Soriani Monastery, Wadi Natrun, Egypt, c1936, by Lee Miller.
OPPOSITE BOTTOM RIGHT: *Cock Rock (The Native)*, Nr Siwa, Egypt, 1939, by Lee Miller.

calling her name. He remained grief stricken for weeks, and then began painting a huge canvas. Working from a photograph over the next two years, he painted the image of Lee's lips, flying freely in a serene dawn sky above the Paris skyline, over the breast-like domes of the nearby observatory. The suggestion given by the lips of an entwined form of two lovers is confirmed by the title: *Observatory Time – The Lovers* (1932-34). The painting was Man Ray's final expiation of his grief. Hung in the 1936 International Surrealist Exhibition, it also led to Roland's first unconscious encounter with the spirit of Lee.

In November 1932 New York was in the grip of the Depression. It was a bad moment to try to start a commercial studio, but Lee succeeded. Young friends she had known before she left for Paris were by now wealthy, and they invested in Lee Miller Studios Inc. She still had contacts in the world of fashion and advertising, and her association with Man Ray opened a few doors, including that of the Julian Levy Gallery at 602 Madison Avenue, where she had two shows. Lee's younger brother Erik became her assistant, and soon the studio was in full swing. Erik found Lee's life of all night poker games and wild parties did not make for smooth running, and a lot of his time was spent soothing the ruffled feathers of clients whose work was late. Lee was always forgiven thanks to the quality of her work, and it became quite the thing for her to shoot the portraits of bright young Broadway stars, artists and members of the literati. Yet despite her success Lee was pining for her carefree life in Paris.

In the summer of 1934, chance intervened again. Aziz, arriving unexpectedly to negotiate a deal for Egyptian State Railways,

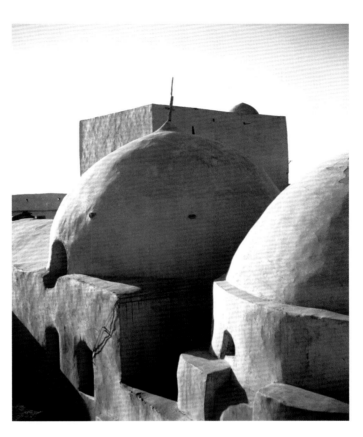

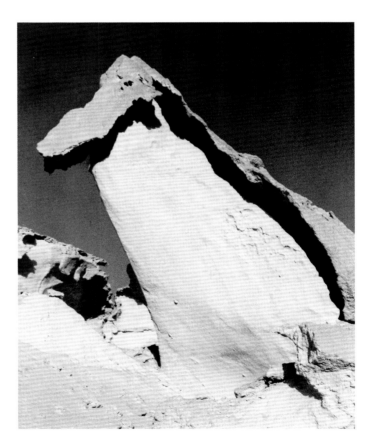

swept back into Lee's life. Within a few days they were married, the studio was closed and Lee was headed to Cairo, where she soon found she had simply exchanged one boredom for another. She made an effort to fill her role as Aziz's wife. She tried to learn golf, rode horses, and took part in endless bridge parties with the other expatriate wives. She called them the 'black satin and pearls set' and found their company overwhelmingly dull. To escape she began making long-range explorations of the desert with discreet, liberal-minded friends. Some journeys were no more than weekend picnics, but others lasted for weeks as they sought Christian monasteries and ancient ruins as far away as Siwa, Sinai, Aswan or Petra, in Jordan. They only had conventional cars, and skill and courage were needed to venture out across the sands, navigating by a sun compass and braving frequent sandstorms.

Lee had abandoned all her photographic equipment in New York except her Rolleiflex camera, which lay forgotten for more than a year until what she saw in the desert and the villages prompted her to bring it back into use. There was no commercial pressure behind these images; they were simply Lee's response to the scenes and the life she saw around her, which her Surrealist eye automatically translated into some of her most eloquent work. Some motifs recur, like the obstructed doorways that give scope for Freudian explanation, but most telling are those that challenge us to make our own interpretation. The enigma of Lee's Surrealist images invites us to explore, ultimately so we may discover things about ourselves. Why else did *The Native* (better known as *Cock Rock*) and *Portrait of Space* become Surrealist icons, published in *The London Bulletin* of June 1940. The latter

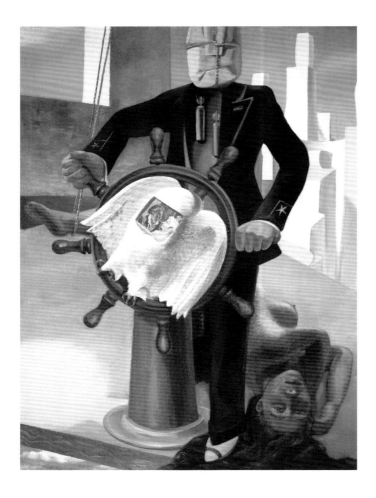

photograph is said to have inspired Magritte to paint his work *Le Baiser* (1938).

Aziz must have been a most tolerant husband. When he realized that Lee's yearning to return to Paris outweighed even the excitement of desert travel, he indulged her and her maid Elda with a trip to France, in the summer of 1937. On Lee's arrival, she met Julian Levy, who by inviting her to the Rochas party acted as the catalyst for her meeting with Roland. We will never know her first impressions of the dumbstruck, paint encrusted young Englishman, but she got on famously with him the next evening at dinner in Max Ernst's studio, and also the following morning, when they found themselves sharing similar hangovers and the same hotel bed.

Roland left shortly with Ernst to help him mount his exhibition at the Mayor Gallery in London. He wrote in a letter, 'Lee, my lovelee, I have slept and woken from a dream – shall I ever dream again anything so unexpected and so marvellous?' He pressed her to join him in Cornwall at his brother Beacus's house, which he had rented for a few weeks.

Lambe Creek, a lovely Georgian house, stands on the edge of a tidal creek off the Fal River, below Truro. To the astonishment of the locals it became a sort of surrealist summer camp. Lee arrived with Paul Éluard and his wife Nusch, joining Eileen Agar and the writer Joseph Bard, Max Ernst and his new love, the English painter Leonora Carrington, Man Ray, who by now was with Ady Fidelin, a dancer from Guadeloupe, and, for one day, Henry Moore and his wife Irena. This strange mix of nationalities and backgrounds were united in their love of Surrealism, which readily translated into delight with their surroundings and each other. They explored the nearby churches, woodlands and creeks, and the second-hand bookshops, junk shops and ship breakers of Falmouth. Roland bought a small ship's figurehead, which he painted and left as a gift for Beacus. They drove to Land's End, packed into Roland's Ford V8. The sun flashed through the clouds and shot a burst of fire from the prisms of the lighthouse lantern. 'Look, the lighthouse is alight!' cried Lee. 'That is not a lighthouse, it is a ham factory' declaimed Éluard. 'Ah yes of course, I see, it is obviously a ham factory' agreed Lee. The Surrealist celebration of nonsense and inutility was ever present.

It was such an amiable gathering no one could bear to part, so they decided to reconvene ten days later at the Hôtel Vaste Horizon, in the little hill town of Mougins, inland from Cannes. Picasso was staying at the hotel, at the start of his love affair with the painter and photographer Dora Maar. A few days before

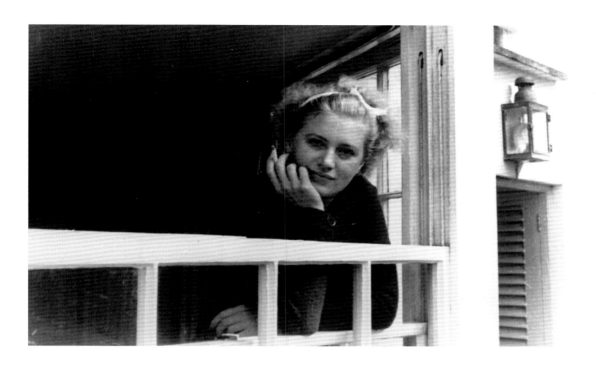

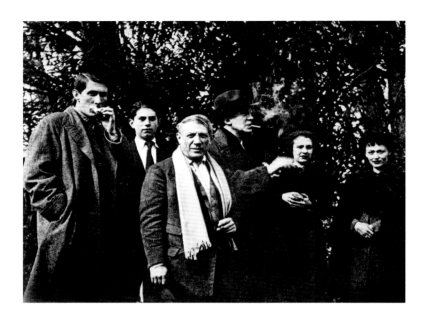

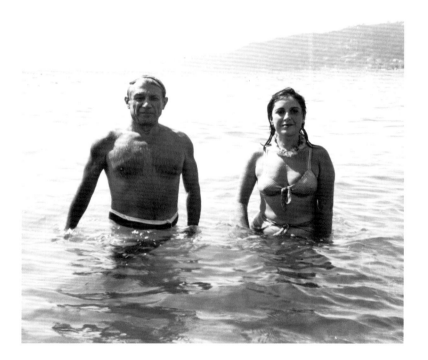

leaving Paris for Mougins, he had finished his giant canvas, *Guernica* (1937) – his visceral protest against the massacre by Franco's air force of the civilian population of the small Basque town of Guernica. Despite the constantly worsening news drifting over the border from Republican Spain, he wanted badly to relax.

Paul Éluard had introduced Roland to Picasso in Paris, early in 1935. They had motored out to Picasso's chateau at Boisgeloup where Roland had bought his first Picasso, the small but powerfully symbolic painting *Nude on the Beach* (1932). They had been friends since that day, with Roland visiting Picasso's studio during the painting of *Guernica*.

Picasso lived at the edge of life's limitations, possessing extreme capacities of creativity and destruction, and for the most part flagrantly disregarding convention and the feelings of others. Roland, in keeping with all Picasso's friends, became accustomed to having his devotion stretched beyond all reasonable limits by the sardonic and capricious side of Picasso's nature. He refused to allow the hurts to matter, so deep was his fascination with Picasso's work, which constantly stimulated and revealed new dimensions and perceptions. He loved Picasso – almost worshipped him – but years later, when he came to write his biography of the artist, *Picasso, His Life and Work*, he achieved a fine objectivity about the artist and his art, made more poignant by the intimacy of their friendship.

Even on holiday, Picasso could not live without working, and whilst seated at the table in Mougins his fingers would be constantly occupied making monsters, figures or compositions from corks, matchboxes or the foil from the top of wine bottles. In the afternoon, while others were enjoying their siesta, he would go to his room and paint, emerging with some outrageous creation like a picture of Paul Éluard dressed as an Arlésienne, breast-feeding a cat. His attention switched to Lee, and he rapidly painted a series of six portraits of her *a l'Arlésienne*. In one the froth of her green hair caps the bright yellow of her face, which portrays the sunny warmth of her personality and the brilliance of her intellect. Variations of the traditional Arlésienne costume cover Lee's large, firm breasts, which Picasso much admired, and in one version her chest contains a triangular form that may relate to Man Ray's metronome, ticking like her heartbeat.

With the noteworthy exception of the writer Gertrude Stein, Picasso often had sexual relationships with the women who modelled for his most striking female portraits. Lee would have certainly been willing as she adored Picasso, and Roland would have regarded sharing his loved one as an act of homage, in much the same way

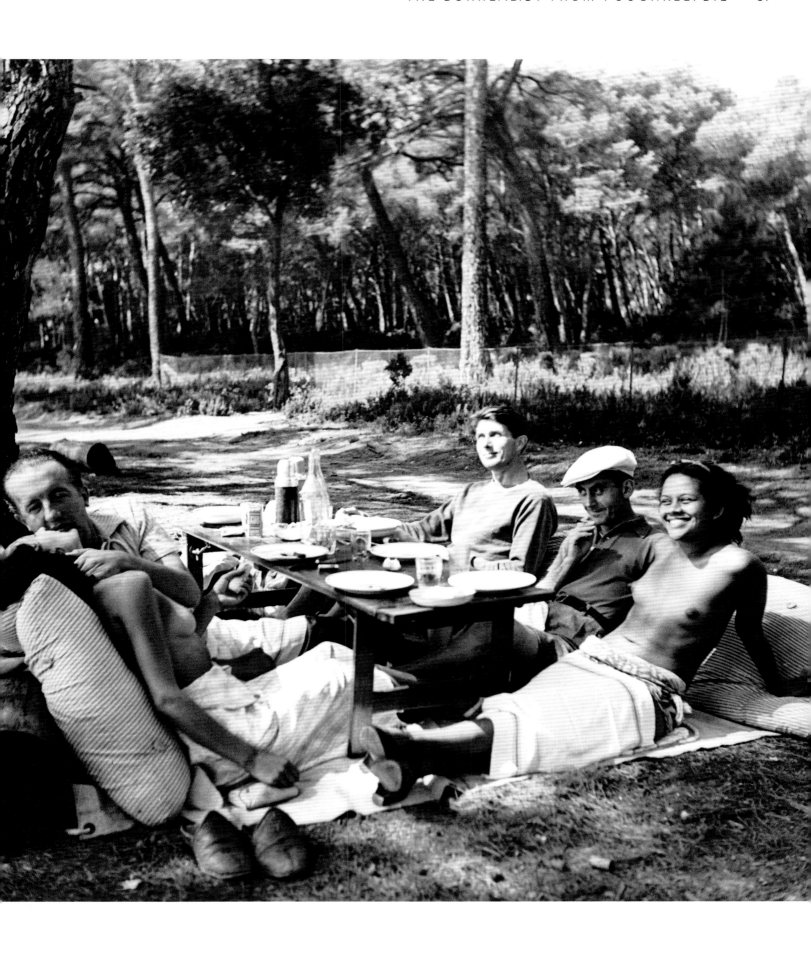

as Éluard encouraged Nusch to sleep with Picasso. At the same time, Roland probably enjoyed a liaison with Ady, and there were many temporary pairings among the others. The exchange of partners among the group was an easy extension of their Surrealist beliefs and their love for each other, made more natural by the relaxed ambience of sunshine and the delights of Provençal food and wine. Forty years later, Roland declared that he and Lee had never been unfaithful to each other – in his view, their many sexual adventures with others did not count as infidelity, since their love remained unaffected. It was a belief that endured, although at times it was stretched close to breaking point.

Roland's creativity was inextricably linked to his romantic life. The ups and downs in his relationship with Valentine can be charted through corresponding changes in his style. But it was Lee, it seems, who during their stay at Mougins, was the catalyst for his invention of the postcard collage. This signature style endured until the end of his life, and remains his original contribution to the art of the period. There is no way of knowing what triggered the idea; perhaps it was the effect of colour patches in the serried ranks of picture postcards on sale in the local shops. Borrowing from the Cubist's reduction of form to hard-edged, simplified shapes, Roland began using repetitive swatches of banal picture postcards to provide blocks of colour in his work. The cards were not chosen for their pictures, although the image often adds another layer of meaning to the work. The importance of the cards is their colour and tonality, which, when arranged in a pattern, transcends their original purpose. Other items, like tickets and fragments of printed material, or large areas of gouache or frottage, add to the composition. In later works no holds are barred, and we find bits of string, plant material, metal, and in one piece even a patch cut from an oil painting by one of his aunts. This work, *Magnetic Moths* (1938), is now in the Tate Modern, which would surely have gratified the old lady.

One of the most important works from this period is a portrait of Lee, titled *The Real Woman* (1937). On the right, a pencil frottage gives us a sensual picture of her, strongly sexual with the red glow of a sunset signalling the heat of her desire, and recording a direct contrast with Roland's experience of Valentine's more ethereal body. Here is a real woman who can be held, loved and enjoyed. The bird figure on the left can be interpreted as Lee's

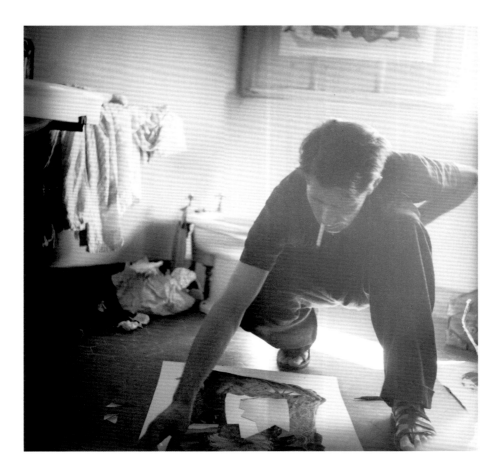

LEFT: Roland working on one of his first postcard collages, Hotel Vaste Horizon, Mougins, France, 1937, by Lee Miller.
OPPOSITE TOP: *Magnetic Moths*, 1938, collage, by Roland Penrose.
OPPOSITE BOTTOM: *The real Woman*, 1937, collage, by Roland Penrose.

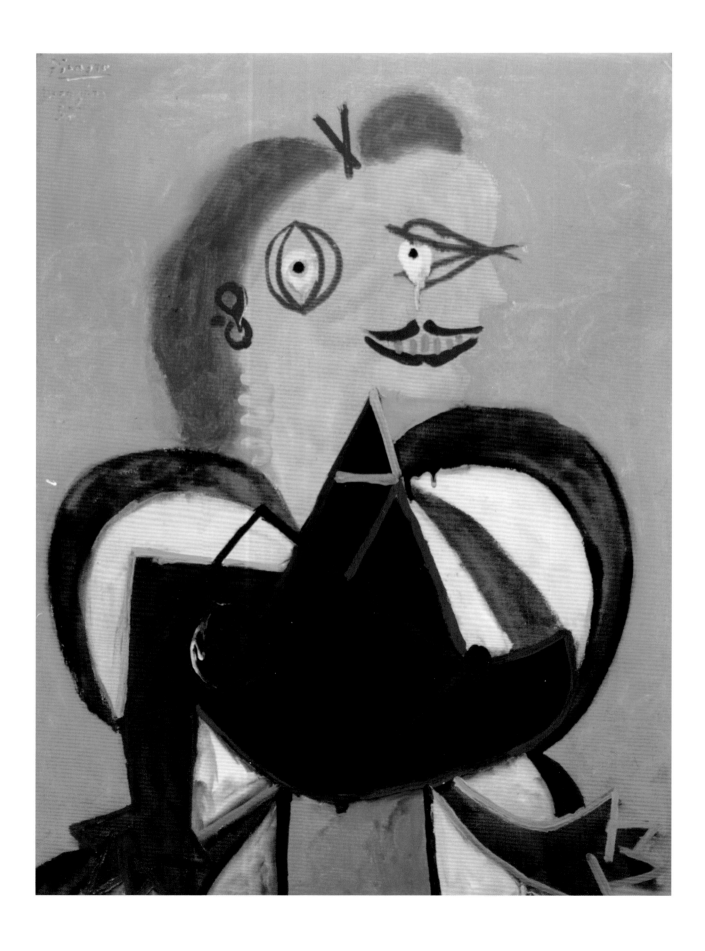

flamboyant alter ego. A fan of seven bright and colourful postcards of a nearby rocky headland forms her tail feathers, and a city fountain makes her breast plumage. Patches of gouache, frottage and coloured paper form the rest of the bird, its beak open, primed for a salty American wisecrack.

Summer ended, and Lee reluctantly returned to Aziz. Passing through Paris, Roland visited Picasso's studio in rue des Grands Augustines and bought the best painting of Lee, the *Portrait of Lee Miller* (1937), for £50. He shipped the painting to Lee in Cairo, causing astonishment among many of her friends, who could not understand how this mass of brightly coloured shapes could be a portrait by a celebrated European artist.

In January of 1938, Roland and Éluard were back in Picasso's studio. Picasso had continued to explore the theme of Guernica in a series of monochrome pictures, but on this day Roland was arrested by a small, vividly coloured canvas, the *Woman Weeping* (1937). This was Picasso's incredibly powerful conclusion to the outpouring of his agony over Guernica, a feeling strongly shared by Roland. Encouraged by the presence of Éluard, who had put Picasso in an amiable mood, Roland boldly asked if he could buy the painting. Picasso agreed, naming a modest sum, and Roland left the studio with one of the masterpieces of the twentieth-century art under his arm.

Following the death of his father in 1932, Roland had inherited a substantial fortune. His brother Alec was horrified that instead of investing it 'wisely', Roland bought two complete collections of modern paintings. First, through Mesens, he acquired thirty-four works from a Belgian collector, René Gaffé. They included Picasso's landmark Cubist pieces *The Woman in Green* (1909), and *The Young Girl with a Mandolin* and *Portrait of Uhde* (both 1910). Surrealist works included *The Jewish Angel* (1916) by de Chirico, and Joán Miró's *Nude* (1921) and *Head of a Catalan Peasant* (1925).

Then Éluard, who wanted to make better provision for Nusch and himself, persuaded Roland to buy the greater part of his collection. Over the years, Éluard had acquired many works as gifts from artists or in exchange for pieces he had written about them. For 129 paintings, objects and ethnographic works of art he named the amazingly low sum of £1,500, insisting that Roland must not argue about the price. Roland hesitated, feeling he was taking advantage of his old friend, and then accepted. He now owned more than forty works by Ernst including *The Elephant of Celebes* (1921) and *The Revolution in the Night* (1923). Among the six de Chiricos was *The Uncertainty of the Poet* (1913) and further gems included Miró's *Horse* (1927) and Magritte's *Threatening Weather* (1929). Surrealism was also firmly represented in the other works, by Tanguy, Arp, Paalen, Dalí, Hayter, Victor Brauner and Man Ray. Roland did not know that one of Man Ray's pictures, *The Artist's Abode* (c.1930), contains an image of Lee's head and slashed throat, painted during the aftermath of a dramatic row. The small house Roland had bought in 1936 at 21 Downshire Hill in

OPPOSITE: *Portrait of Lee Miller à l'Arlésienne*, 1937, oil on canvas, by Pablo Picasso.
RIGHT: Roland Penrose, Downshire Hill, London, England, 1939.

ABOVE: Lee's Packard car and the requirements for a desert picnic, Egypt, c1938.
BELOW LEFT: Roland Penrose, Egypt, 1939, by Lee Miller.
BELOW RIGHT: Lee Miller, Egypt, c1938, by Guy Taylor. Lee was having a lesson in snake charming from Moussa, son of the Great Moussa (who had recently died of snakebite).

Hampstead was crammed to bursting with one of the most important private modern art collections in Britain.

Roland's bed was seldom empty, but he still hungered for Lee. In the summer of 1938, they met in Athens, where Lee had arrived from Egypt with her stylish grey Packard convertible. They took a small ferry to the islands of Mykonos and Delos, and then returned to the mainland to head for the ancient theatre of Epidaurus, the site of the oracle at Delphi, and the monasteries of Metéora, perched on the top of sheer-faced rock columns. It was adventurous travel, over unmade roads, but they saw a country untouched by the modern world. No wire fences or queues of tour buses excluded them from the crumbling ruins, inhabited by scorpions and goats. They travelled north to the ancient port of Kavála, and on the island of Thassos they walked among clouds of butterflies in groves of venerable olive trees.

But the innocence and solitude of Thassos were of no protection against the inevitability of the fast approaching war. Roland and Lee wanted to experience as much of the old world as they could

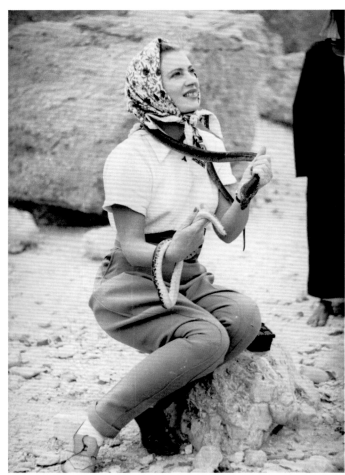

before it was too late. They continued north to Bucharest, where Hari Brauner, the brother of their friend, the painter Victor Brauner, organized a tour of Carpathian villages. Lee documented the notables, priests, peasants and gypsies of these small, isolated communities, and their time honoured pagan rituals for bringing rain or fertility, which remained a part of daily life despite the church. She photographed with care and sensitivity, as if the talisman of the captured image could somehow preserve these innocent people from disaster.

Roland travelled home by rail from Bucharest, leaving Lee to a few weeks of solo travel before she returned to Aziz. He was hurrying back to finalize the arrangements for an English tour of Picasso's *Guernica*, organized to raise money for aid to Republican Spain. Early the following year, Hari Brauner visited London with a troupe of Romanian Calusari peasant dancers, who nearly destroyed the floor of Roland's sitting room with their crashing footwork. Among those seeing the Romanians off at Victoria station was Beryl de Zoëte, a well-known authority on folk dance and an old friend of Roland's. When he heard she was heading for Egypt on a field trip, he jumped at the chance to join her expedition as a photographer, a role giving him cover to visit Lee.

Arriving in Cairo at the end of January 1939, he found Lee had left on a trip of her own. After an arduous journey, he tracked her down to Assyut, two hundred miles south of Cairo. Lee was delighted to see him and fascinated by the two gifts in his case. A pair of gold handcuffs inscribed Cartier became her preferred jewellery for many years, until they were stolen by burglars. More enduring was the manuscript of his illustrated poem *The Road Is Wider Than Long*, which remains at Farleys House. The photographs and calligraphed pages record their journey through the Balkans and of Roland's love for Lee.

For two months they ranged ever further with their desert expeditions. It is unlikely that Aziz was fooled by Roland's pretence of being a photographer, but it saved him from having to publicly confront the issue. He understood Lee was bored and unhappy with her life in Cairo. He could see she pined for the excitement of the world she had left behind in Europe, but more importantly he knew she no longer loved him. Aziz still loved Lee and realized the greatest gift he could give her was her freedom, but he told her that he would only let her go when she had found someone who could take as good care of her as himself. Although Lee, ever afraid of commitment, wondered miserably if she might not be jumping from the frying pan into the fire, she left Aziz for the last time in June 1939, and joined Roland in London.

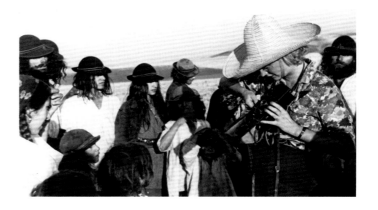

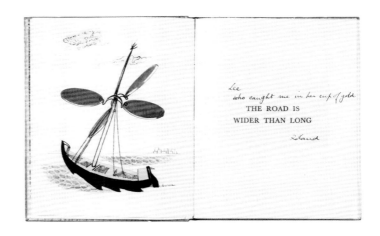

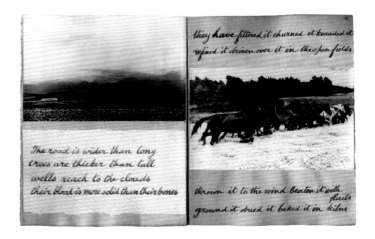

ABOVE TOP: Lee recording the lives of Romanian gypsies, Romania, 1938, photographed by Roland Penrose.
ABOVE MIDDLE: The title page of the first edition of 'The Road is Wider Than Long' with Roland's drawing and dedication to Lee 1939.
ABOVE BOTTOM: Pages from the original manuscript of 'The Road is Wider Than Long', 1938, by Roland Penrose.

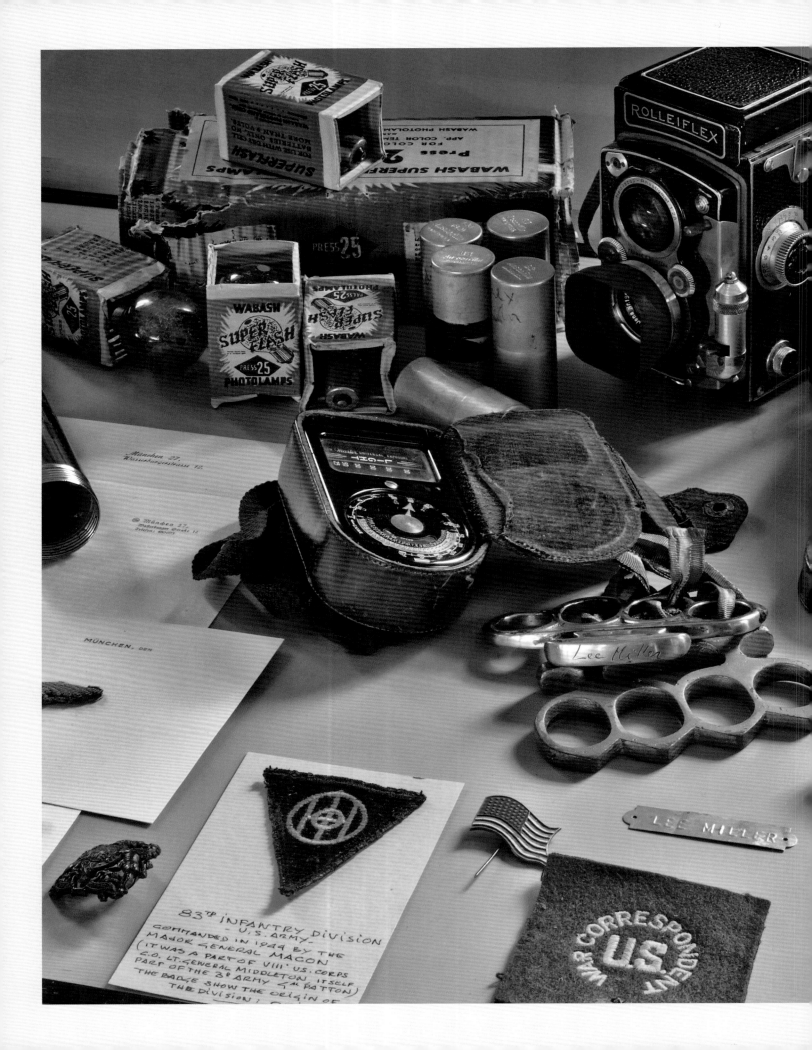

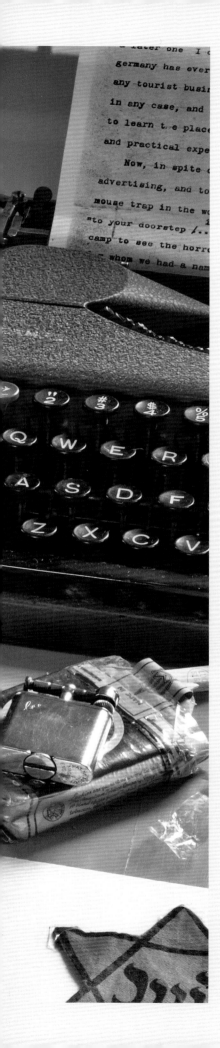

THE WAR

The moon there is not as she is in the street, even less; she is for the lost souls, the ramps whence the dead of London depart, whence the threatening aircraft approach.

VALENTINE PENROSE: FROM THE POEM DOWNSHIRE HILL, 13 JULY 1941

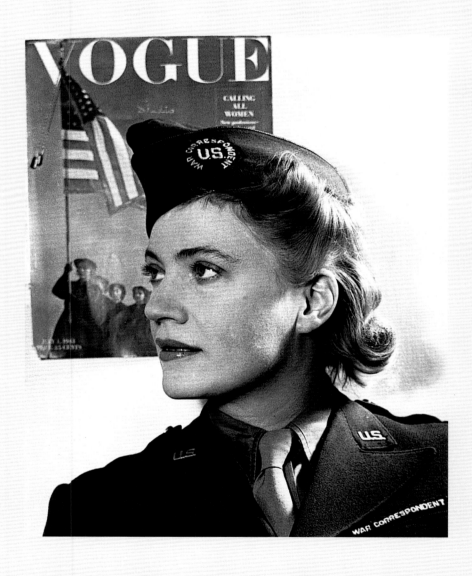

OPPOSITE: Items of Lee's equipment fill a showcase at Farleys House. Her despatch from Dachau is in the Baby Hermes typewriter, beside her Rolleiflex camera, light meter and flashbulbs. Some of her other war-time ephemera is displayed in front.
ABOVE: Lee Miller in uniform, *Vogue* Studios, London, England, 1943, by David E. Scherman.

When the liner SS *Otranto*, carrying Lee to Tilbury, docked on 16 June 1939, Roland was waiting, beside himself with excitement. He drove Lee back to Downshire Hill and then almost immediately on to the London Gallery on Brook Street, which he had recently bought, and which was run for him by Mesens. The current show was Picasso in Some English Collections, and he introduced Lee to the *Woman Weeping* and the other canvases from his collection that formed part of the exhibition. Then rather diffidently he led Lee a few streets away to his old friend Freddy Mayor's gallery on Cork Street. Freddy, a colourful figure known for his love of betting on horse races, had for many years shown similar flair in picking winners among avant garde artists, and his current show, an exhibition of Roland's work, had opened a few days earlier. Here Lee met Roland's perception of her in at least two of his works.

Roland had painted the small canvas of *Night and Day* (1937) as an idea for a fancy dress costume, but it was also a remarkably perceptive portrait of Lee. Her legs have the texture of earth,

parched and cracked; Lee was an earthy person, but her earth is in need of a good shower of rain. Her body has become the blue sky. Although Roland did not know that Lee had been raped as a child, he somehow sensed the dissociation that so often results from such a trauma, and depicted her absence from her own body. Lee's face is the sun, a metaphor of the warmth and radiance of her personality. Earth, air and fire are all present in the painting, but water is needed to slake the dry soil. Water often symbolizes emotion, and here its absence signals the discomfort that both Roland and Lee felt when confronted with displays of deep emotion, which they disparagingly called 'sentiment', seeking to intellectualize themselves above it. Roland includes some funnels in the picture, to safely dispose of any water that may chance to appear.

Good Shooting (1939), painted two years later, shows another perception of Lee. Here she stands confidently in sunlight, with her arms upraised against a brick wall pockmarked by bullets. She has no need of the chain to restrain her – she stands in this dangerous place voluntarily. Lee's head has become a placid lake scene, perhaps set in the Norfolk Broads. Perhaps Roland is signalling that although she gives her body to him freely, he will never have her mind. That will always be her own territory. The translation of its title in French, *Bien Visé* as *'Well Screwed'* perhaps denotes Lee as the target of Roland's desire.

Twenty-five other works including *Octavia* (1939) *The Veteran* (1938), *The Conquest of the Air* (1938), and some of his Surrealist objects, completed the show. JB Manson, a former Director of the Tate Gallery, wrote a scathing review in *The Evening News* titled 'This Modern Art Misses So Much'. After extolling landscape painting and the beauty of nature at some length, he declares:

> ... Much of this so-called ultramodern art is in itself a confession of failure ... we are offered something which we are told is an expression of the painter's personality. The kindest explanation, I suppose, is that the beauty of nature is beyond their powers and they just give it up. It may be possible to find beauty in corruption and distortion, but it is not the objects created by those who flounder in what has aptly been called 'sewer-realism' but the state of mind of the producers that is disturbing.

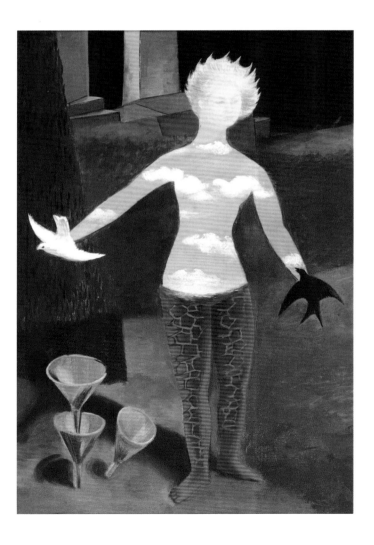

LEFT: *Night and Day*, 1937, oil on canvas, by Roland Penrose.
OPPOSITE: *Good Shooting (Bien Visé)*, 1939, oil on canvas, by Roland Penrose.

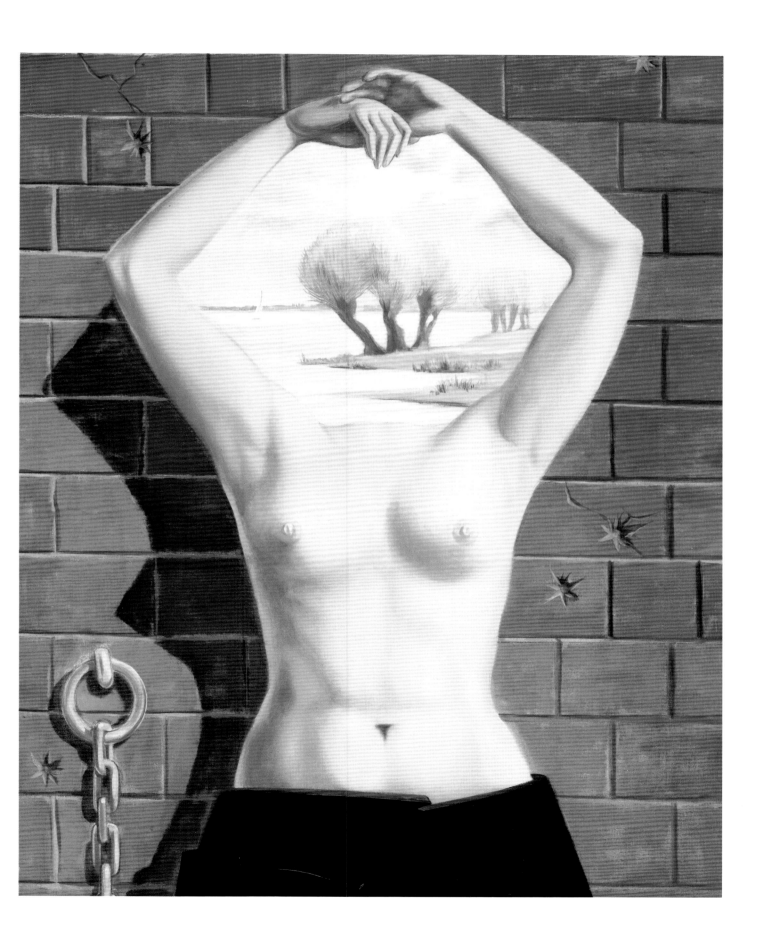

Roland was gratified. It would have been unbearable if the establishment had enthused over his work. The final ironic satisfaction was granted many years later when, after huge changes had taken place at the Tate, they purchased four works from the show that Manson had reviled. *The Last Voyage of Captain Cook* (1936), *Magnetic Moths* (1938) *Le Grand Jour* (1938) and *Portrait* (1939) are today valued works in the Tate Modern collection.

Instead of producing catalogues for the London Gallery shows, Roland and Mesens published a periodical known as *The London Bulletin*, which appeared regularly for two years. Surrealism inspired its mixture of painting, prose, photography, drawing and insulting remarks about the shortcomings of the Tate. Mesens was the editor, and Herbert Read, Humphrey Jennings, André Breton, Paul Éluard, and the writers Paul Nougé and Stuart Legg were among the contributors, writing short pieces on topics such as Degenerate Art, or Surrealism and Fashion.

Roland and Mesens also published *London Gallery Editions*, which in June 1939 printed *The Road Is Wider Than Long*. Roland gave number one of a special edition of ten to Lee. The illustration on the flyleaf was based on his object *Le Paradis des Alouettes*, and shows a small boat making good speed with two pairs of coloured pince-nez for sails. Perhaps, at long last, the intensity of the Wisbech aunts' severe gaze through their steel rimmed pince-nez had been set free upon the ocean. If this were so, they would have hardly approved of the dedication Roland wrote beside it:

Lee
who caught me in her cup of gold
Roland.

Roland used to enjoy the allusion to a woman's pubic hair as a 'cup', a reference to the triangular shape with a slender stem underneath formed by the line between the thighs. It was a theme frequently seen in Picasso's later work, and both men probably appreciated the associations that go with cups – such as 'loving cup' or 'cup of joy'.

In the face of the approaching war, public interest in art withered rapidly and, despite the success of the Picasso show, the London Gallery had to close at the end of July. The Mayor Gallery followed two months later. Roland and Lee left hurriedly for France, to see their old friends before the inevitable cataclysm began. They drove south, stopping near Avignon at Saint-Martin d'Ardèche, where Max Ernst and Leonora Carrington had taken a house.

Giant mythical creatures, sprung from Ernst's imagination and given shape as cement sculptures, had taken their positions

as protectors of the house and its garden. Lee photographed the creatures, as well as Ernst and Carrington, clinging bravely together. Ernst, being a German, was soon to be imprisoned as an enemy alien, and Carrington was to have a terrifying experience in a Spanish lunatic asylum before she escaped to America.

Roland and Lee found Picasso in Antibes, defying the threat of war and the military build-up in the port by carrying on with his painting. Days spent huddled around the wireless replaced the carefree hours of former years, until Hitler invaded Poland and the last vestiges of normal life were swept away. Roland and Lee arrived back in London to the wail of the air raid sirens.

Roland was still firmly a pacifist at heart, so he found himself a non-combatant role as a camouflage instructor to the Home Guard. In July 1943 he was given a commission and put in charge of the Eastern Command Camouflage School in Norwich, with

RIGHT: *Octavia (Aurelia)*, 1939, oil on canvas, by Roland Penrose.
OPPOSITE TOP: *The Conquest of the Air*, 1939, oil on canvas, by Roland Penrose.
OPPOSITE BOTTOM: *Le Grand Jour*, 1938, oil on canvas, by Roland Penrose.

LEFT: Lee demonstrating Roland's camouflage skills for a projected slide that ensured the avid attention of Roland's lecture audiences, 1942, photographed by David E. Scherman.
OPPOSITE TOP LEFT: Valentine, Downshire Hill, London, England, 1940, by Lee Miller.
OPPOSITE TOP RIGHT: Roland and his favourite cat Mrs DeValera, Downshire Hill, London, England, c1942, by Lee Miller.
OPPOSITE BOTTOM RIGHT: Lee Miller, Downshire Hill, London, England, c1943, by David E. Scherman.

other artist friends such as the painters Julian Trevelyan and John Lake, the stage designer Oliver Messel, the well-known conjuror Jasper Maskelyn and the couturier Victor Steibel.

At the beginning of the war a stream of letters from the American Embassy urged Lee to return to the USA, but she tore up all of them. She was acutely aware that her friends in France were in great danger, and she wanted to stay with Roland and do what she could for the war effort. During her time with Man Ray, Lee had modelled and shot fashion for French *Vogue*, so she applied for work at Vogue Studios in London. At first they gave Lee a cold reception. She had not shot fashion for five years and was considered passé, but soon the call-up created openings and she became a valued contributor. When Vogue Studios was bombed, Lee took to the streets, using scenes of wartime activity as backgrounds for the models. To alleviate the tedious routine of shooting handbags and shoes, she began photographing scenes of the Blitz. Her Surrealist eye immediately engaged with the many *images trouvés* she encountered daily in the wasteland of bomb damage. The bizarre photograph of a doorway filled with bricks was given a sardonic twist by its title *Non Conformist Chapel*, the name of the building. The shattered remains of a typewriter became *Remmington Silent*, the name of the machine – now truly silent although in Lee's photograph still communicating eloquently

on the wanton destruction of war. This group of photographs contains a black humour, characteristic of the indomitable spirit of Britain in those years. Perhaps because of this they were selected for a book titled *Grim Glory, Pictures of Britain Under Fire*, which, with a forward by the American broadcaster Ed Murrow, was used as wartime propaganda in the USA.

To Roland's surprise, Valentine turned up in London in 1940 at the height of the Blitz, having been unable to get into France on her return from India. He was even more astonished when Lee welcomed her with open arms, and insisted that she come to live at Downshire Hill. Valentine stayed for nearly two years, driving a car for the Free French forces by day and imperturbably writing poetry during the air raids by night. A further development to this Surrealist household occurred early in 1942, with the arrival in London of David E Scherman, a young American Time-Life photojournalist. He was already distinguished for his coverage of the sinking of the Egyptian passenger ship *Zam Zam*, on which he had been travelling to North Africa. Having recently been released from a German prisoner of war camp, his next assignment was to reinforce the London office of Time-Life. He met Lee at a party, and became friends with her and Roland. They invited him to move into Downshire Hill, and soon Lee and Scherman were covering

assignments together. The relationship became a *ménage à trois* with Roland's blessing; he was glad there was someone to look after Lee while he was away in Norwich.

Lee was becoming dissatisfied with the insipid prose linked to her photographs in *Vogue*, and when the opportunity arose she began to write her own text. Here she found the focus for a real power of expression that extended far beyond the scope of fashion assignments. Despite having written nothing previously, Lee was quickly established as a writer. However, the ease with which her text flows belies the agony of its creation: she described her words on the page as 'tears wrung from stone'. As an avid reader, Lee devoured books regardless of style or quality. If there are traceable influences in her style, they are probably John Steinbeck's excoriating social commentary and Willa Cather's conversational, flowing verbal pictures.

Lee became increasingly drawn to photojournalism and covered the work of American nurses and women searchlight operators, or events such as the filming of Henry Moore as he worked as a war artist in Holborn underground station. By the end of 1942 it was clear there was going to be an Allied invasion of Europe, and Lee chaffed to be closer still to the action. It was Scherman who suggested she become an accredited war correspondent. Just a few weeks later, Lee, thanks to her American

nationality, her status as a photojournalist and a little encouragement from Scherman, was issued with passes by the US army that gave her access to military areas. *Vogue* knew nothing of Lee's plans until after her accreditation came through, but were thrilled to find they had their own fully-fledged war correspondent, and thereby a greater sense of involvement in the war. Later, when they ran her reports from the battlefields of Europe, the layouts were unwittingly surreal in the juxtaposition of pictures of death and destruction with *soignée* women dressed in the latest modes.

At the end of July 1944, Lee flew into La Cambe, inland from Omaha Beach, the site of one of the D-Day landings a few weeks earlier. Her assignment was to cover the field hospital coping with wounded shipped to the rear, but typically she talked her way into visiting a front line casualty clearing station. The thirty five rolls of film and ten thousand words she filed on her return eloquently told of the dignified bravery of medics and soldiers, and the bewildered suffering of the civilians. Her articles dominated *Vogue* features for the rest of the war.

Lee's next assignment took her by landing craft to St Malo. The town was reported to have been captured by the US Army, but in fact the German commander Colonel von Aulock refused to surrender and hung on doggedly in the old pirate fortress, which they had modified by linking their gun emplacements with miles of tunnels through solid rock. Lee, pleased to have the medieval

style siege to herself, immediately offered her services to the US 83rd Division as an interpreter.

Several days of fierce fighting followed as the allied bombers and naval guns tried to soften up the German defence in preparation for a GI offensive. Before the assault, a group of Polish GIs asked Lee to kiss them for luck. Then she had to watch the machine gun fire slaughter the troops as they attacked the bare rock slopes of the citadel. The losses were agonizing and futile. The fortress seemed impregnable but everything changed following one of the first air strikes using a secret weapon, napalm. Lee scooped the napalm strike and later photographed von Aulock's surrender. In a photograph by Scherman, who caught up with Lee at that moment, the anguish on her face portrays the other side of heroism.

After St Malo, the race for Paris was on, and Lee entered the city on 26 August 1944, the day of liberation. She headed for Picasso's

BELOW LEFT: *Bridge of Sighs*, published in the 1941 publication *'Grim Glory'*, Lowndes Street, London, England, 1940, by Lee Miller.
BELOW RIGHT: Henry Moore taken during the filming of *'Out of Chaos'*, Holborn Underground, London, England, 1943, by Lee Miller.
OPPOSITE TOP: Lee Miller's Identity Card, 1942.
OPPOSITE BOTTOM: Lee with a group of GI's outside the Chapel of St Pierre D'Alet, St Malo, France, 1944, by David E. Scherman.

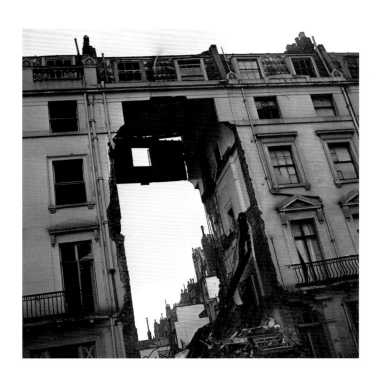

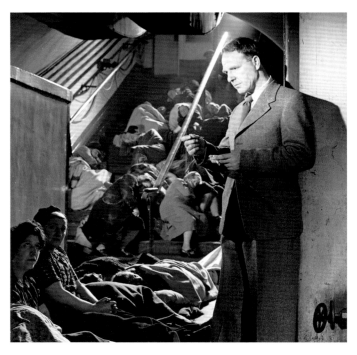

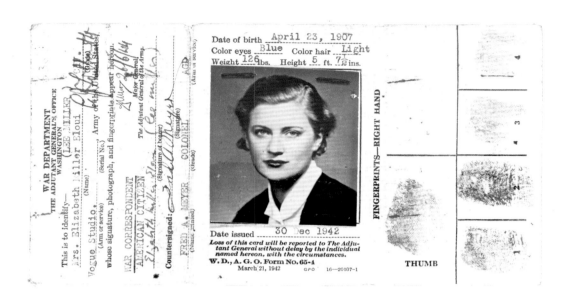

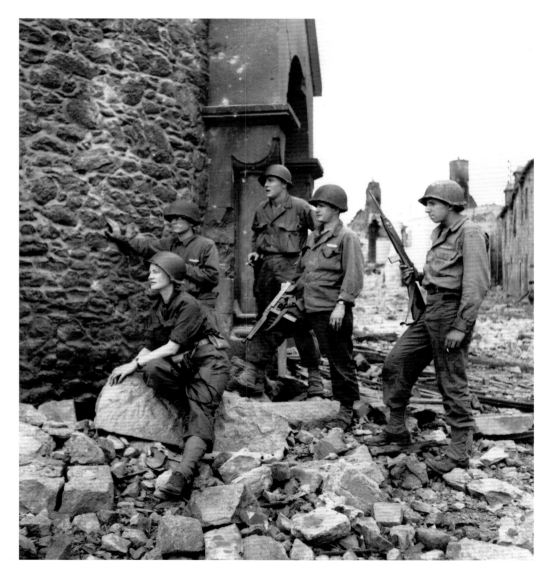

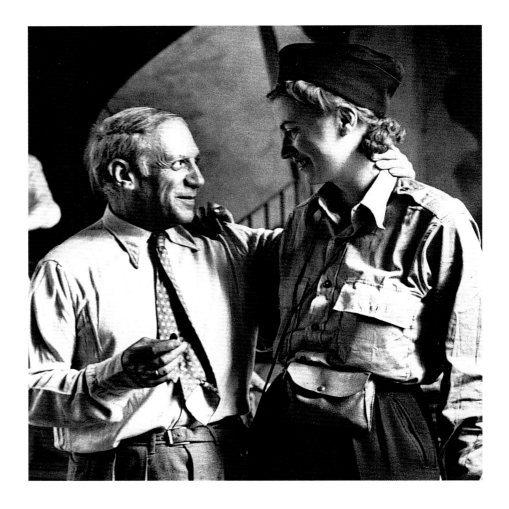

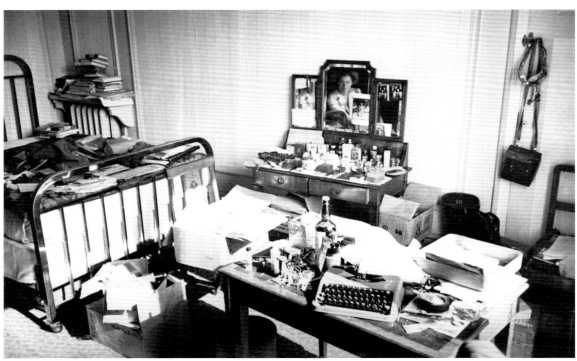

studio in rue des Grands Augustines. Picasso opened the door and swept her off her feet: 'This is marvellous,' he said, 'the first allied soldier I have seen is a woman and she is you!' Then he told her he would have to paint her portrait again because she looked so different as a GI. Picasso had continued to work through the war, but his refusal to collaborate with the Germans had largely prevented him from exhibiting, and life had been lean and fraught. Lee also tracked down Paul and Nusch Éluard, and other friends such as Louis Aragon and Elsa Triolet, Jean Cocteau and Jean Marais, Christian Bérard and Boris Kochno. But there were many friends who she would never find. Jews, dissidents, communists or members of the Resistance, they had become victims of the Nazi's systematic deportation and murder.

Lee and Scherman took adjoining rooms in the Hotel Scribe, the allied press camp. Lee's room quickly took on the appearance of a supply dump, with all manner of looted goods and captured German weapons as souvenirs or for barter, and jerry cans of fuel on the balcony. *Vogue* tried hard to persuade her to concentrate on fashion, but she kept slipping away to join her pals in the 83rd and other divisions who had adopted her as their own.

By the time winter came Lee was in Colmar, Alsace, covering the first leap across the Rhine. She followed the allied push into Germany, from Aachen to Cologne, Frankfurt, Ludwigshaven, Leipzig and the Russian-American link-up at Torgau, and then on to Weimar and Jena. She already knew of the deportation camps in France and Belgium, but it was inside Germany that the full extent and horror of the concentration camps became apparent. In April 1945, she wrote to Audrey Withers, the editor of *Vogue*:

> I've seen several, Ohrdruf among them. Now there will be Penig and I suppose the prisoner of war camp at Nuremberg. I don't take any pictures of these things usually as I know you don't use them. <u>Don't think for that reason that every town and every area isn't rich with them.</u> Every community has its big concentration camps, some like this for torture and extermination. Well I won't write about it now, just read the daily press and believe every word of it. I would be very proud of *Vogue* if it would run a picture of some of the ghastliness – I would like *Vogue* to be on record as believing.

Lee photographed Buchenwald, where she arrived five days after its liberation, but it was Dachau that particularly affected her. She was among the first people to enter the camp on 30 April,

OPPOSITE TOP: Picasso and Lee after the liberation of Paris, Rue des Grands Augustins, Paris, France, 1944, by Lee Miller.
OPPOSITE BOTTOM: Lee's room, number 412 at the Hotel Scribe, Paris, France, 1944, by David E. Scherman who described it as *'a cross between a pig-pen, a garage sale and a used car lot'.*
ABOVE TOP: *Hotline to God*, Strasbourg, Alsace, France, 1945, by Lee Miller.
ABOVE BOTTOM: David E. Scherman talking shop with a Russian cameraman at the historic Russian Link-up with the Allies, Torgau, Germany, 1945, by Lee Miller.

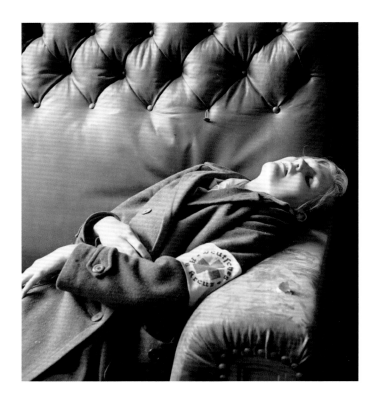

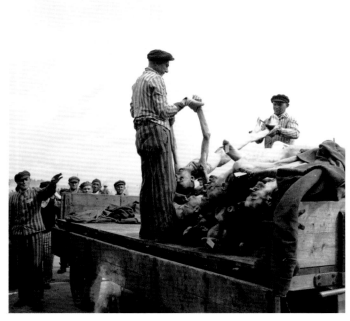

after it had been taken by the Rainbow Company of the US 45th Division. She rarely talked of the experience, but many years later she told my friend Chris Dinnis:

'We approached the camp in a small group of troops in jeeps. The road led through some forest, and the first thing we noticed was there were no birds or animals. It was a bad sign and the boys got nervous. Then we came across some dead SS troopers. They had been beaten to death, or strangled. It wasn't normal for men to be killed like this – and the boys got really jumpy. Then we found the wire. Behind it were masses of people in striped garb, silently staring at us. We could not understand why they did not respond or approach us. We realized we had found the camp, and searched for the entrance. It was held by some of our guys, and they let us in. Inside the prisoners realized we were Americans. They mobbed our jeep and picked up our guys and carried them shoulder high, running round the compound. They were so weak and exhausted that some of them dropped dead with the exertion, but others pushed forward and took over. It took a lot of shouting and some threats to restore order.'

Inside Dachau she found dead and dying by the thousands. At the far side of the camp, a train of trucks and boxcars stood in a siding. It had left Auschwitz-Birkenau a month earlier with 2,310 prisoners on board. The GIs found one survivor; the rest had perished from disease or hunger, or their corpses lay where they had been shot down trying to leave the train.

Scherman said that Lee retained a professional composure and her photographs of the camp confirm this, documenting the gas chambers, the morgue with its cordwood piles of unburned bodies, and the huts where the living lay beside corpses, too weak to move. Today her photographs remain as an indictment of one of the worst crimes ever perpetrated, evidence made unimpeachable by Lee's status as an independent civilian photographer.

After Dachau, Scherman said, Lee was never the same again. As she recorded the suffering of the dead and dying she must have been searching every face she saw, looking for her missing friends. She found none. Perhaps it might have made the

ABOVE LEFT: *The Burgermeister's daughter*, Town Hall, Leipzig, Germany, 1945, by Lee Miller. Burgermeister Alfred Freyburg's daughter committed suicide with her parents as the allies took Leipzig.
ABOVE RIGHT: Prisoners loading corpses onto a trailer, Dachau, Germany, 1945, by Lee Miller.

incomprehensible enormity of industrialised mass murder more understandable if she could have distilled it into a single personal tragedy. That night they billeted in Hitler's apartment in Munich, washed away the dust from Dachau in his bath and slept in his bed, at about the time he was killing himself in Berlin. But there was no triumph that could release Lee from the nightmare living on in her mind. A few days later, she and Scherman watched Wachenfeld, Hilter's home in Berchtesgaden, burn to the ground, and joined the looters hunting for souvenirs among the rubble. And then the war in Europe was over. Germany had surrendered.

In mid May, Lee and Scherman parted company. Scherman was probably the best friend Lee ever had. He understood her perfectly and loved her selflessly, yet he could not live with her as he found the agony of her creative process had become more than he could bear. Scherman returned to London and then New York, while Lee, unwilling to let go of the focus of her life, pressed on eastwards alone.

In Vienna she photographed children dying in a hospital devoid of drugs because black market racketeers had stolen them. In Bucharest she found that though Hari Brauner had survived his time in a forced labour battalion, most of the gypsies had perished in concentration camps and the village communities were wracked by political strife and economic ruin. In Budapest she witnessed the former fascist Prime Minister, Lazlo Bardossy, face

ABOVE TOP LEFT: Lee in Hitler's apartment at 16 Princeregentenplatz, Munich, Germany, 1945, by David E. Scherman.
ABOVE TOP RIGHT: Lee in Hitler's bath tub, Munich, Germany, 1945, by Lee Miller with David E. Scherman. Note the combat boots on the bath mat now stained with the dust of Dachau Concentration Camp.
ABOVE BOTTOM RIGHT: Hitler's house [known as the Berghof] on fire set by SS Troops, Berchtesgaden, Bavaria, Germany,1945, by Lee Miller.

the firing squad. If she felt any satisfaction of revenge, it was negated by her compassion for the thousands of refugees and displaced people who straggled across the whole continent. Their suffering affected her acutely and increased her sense of despair. It seemed to Lee that the war had been fought for nothing. Despite the sacrifice made by her brave soldier buddies and the victims of the Blitz, despite the dead of Dachau and the countless atrocities suffered by innocent people, the world was no better place. Corruption and injustice still blighted people's lives in a way that made the horror of battle seem noble by comparison. Man's inhumanity to man continued.

Roland wrote regularly to Lee, but she seldom replied. It was impossible for her to make sense of what she was experiencing, and relating it to her loved one in a different world was too difficult. For months Roland heard nothing, and he was reduced to begging Audrey Withers for news of Lee. Although he had had a succession of girlfriends, he had carried Lee steadfastly in his heart, but now her extended absence was taking its toll and he felt another woman beginning to occupy Lee's place. He wrote to her with an ultimatum – come home or we are finished – but Lee could not bring herself to reply. It was Scherman who jolted her out of her depression with a cable that simply said, 'GO HOME'. Having crashed and abandoned the big Chevrolet lent to her by Scherman, Lee begged rides on military transport back to Paris, where she met Roland on 16 February 1946. They returned to London together, uneasily picking up the threads of their relationship, aware of how much they had both changed.

A few weeks of rest restored Lee to physical health but her mental wounds were deeply buried, brushed over, for the moment by the relief of being home and the heroine's welcome she received from *Vogue*. *Pathé News* featured her return

RIGHT: Roland and Lee, Sedona, Arizona, 1946.
OPPOSITE: *Unsleeping Beauty*, 1946, oil on canvas, by Roland Penrose. Asleep in the Arizonan landscape, the fragmented body references the way Lee lived her life in a series of watertight compartments like those that protect ships from sinking.

and was the toast of both London and Paris. American *Vogue* invited her to New York, where she was fêted with a dinner and speeches in her honour. Roland accompanied Lee and together they enjoyed meeting young artists like the painter Wilfredo Lam and the sculptor Isamu Noguchi, as well as old friends such as the photographer Gjon Mili, Julian Levy and Alfred Barr.

Barr was the director of New York's Museum of Modern Art (MOMA), and had obligingly given a home to many paintings from Roland's collection, shipped to America for safety before the war. Roland was particularly glad to meet Barr again because, although he had reopened the London Gallery, he and Herbert Read were laying plans for a grander scheme that would become the Institute of Contemporary Art (ICA) in London. Barr's bold policies at MOMA gave Roland plenty of inspiration, and he was later to prove a steadfast supporter of the ICA. Most notably, in 1948 he lent Picasso's *Les Demoiselles d'Avignon* for the ICA's

second big exhibition, 40,000 Years of Modern Art, – a loan that would be unheard of today.

During the war, Max Ernst escaped from Europe by marrying the wealthy art collector Peggy Guggenheim, who organized his admission into the United States. Their relationship deteriorated rapidly, and the final blow came when Ernst met the young painter Dorothea Tanning. To escape the acrimonious fallout, they moved to the isolation of Oak Creek Canyon in Arizona. Roland and Lee flew there from New York to find them still building their wooden studio. For a week they enjoyed the grandeur of the mesas and the surrounding desert. Max, who felt a great affinity for Native American culture took Roland and Lee to watch the Hopi Indians perform a rain dance that culminated in a crashing thunderstorm. Later they swam in Oak Creek, and Dorothea and Lee tended the barbecue bare breasted, evoking memories of Lambe Creek. Lee photographed and Roland drew, later using this location

RIGHT: Roland in his studio, 36 Downshire Hill, London, England, 1947, by Lee Miller. OPPOSITE: *First View*, 1947, oil on canvas, by Roland Penrose. The culmination of a series of paintings inspired by Lee's pregnancy, this work shows Antony as a green lizard in the aqueous blue of Lee's womb.

as the source of inspiration for *Unsleeping Beauty* (1946). The separated segments of the sleeping woman's body may refer to his view that Lee's psyche was now fragmented by what we would today call Post Traumatic Stress Disorder. It was to be twenty years before the fragments would become reunited in full working order.

They flew on to Los Angeles where they were guests of Lee's much-loved brother Erik and his wife Mafy. Man Ray had lived in Hollywood throughout the war, and they visited his studio off Vine Street where he lived with his new love, Juliet Browner. They were later to marry in a double ceremony shared with Max and Dorothea, despite Man's protests that he had never done anything so 'rectangular'.

Back in London, Lee genuinely tried hard to interest herself in photographing fashion and accessories for *Vogue*. The contact sheets show how hard she found her new role, as shot follows shot of mediocre, forced poses, interspersed with an occasional flash of the old genius. Roland immersed himself in the running of the London Gallery, which, although it mounted an impressive series of exhibitions, was undermined by Mesens' excessive drinking and erratic behaviour, and piled up heavy losses. At the same time Roland was mounting a Herculean effort to get the ICA started. He refused to halt his crusade, although, in the face of the indifference to modern art shown by the Tate Gallery and other state-run arts organizations, he must have realized that it would only succeed at a huge personal cost.

Lee was on a *Vogue* assignment in Switzerland when she cabled Roland the news that she was pregnant. They were astonished, as medical opinion had declared Lee infertile, but in an unexpected way they were also pleased. They had both vowed

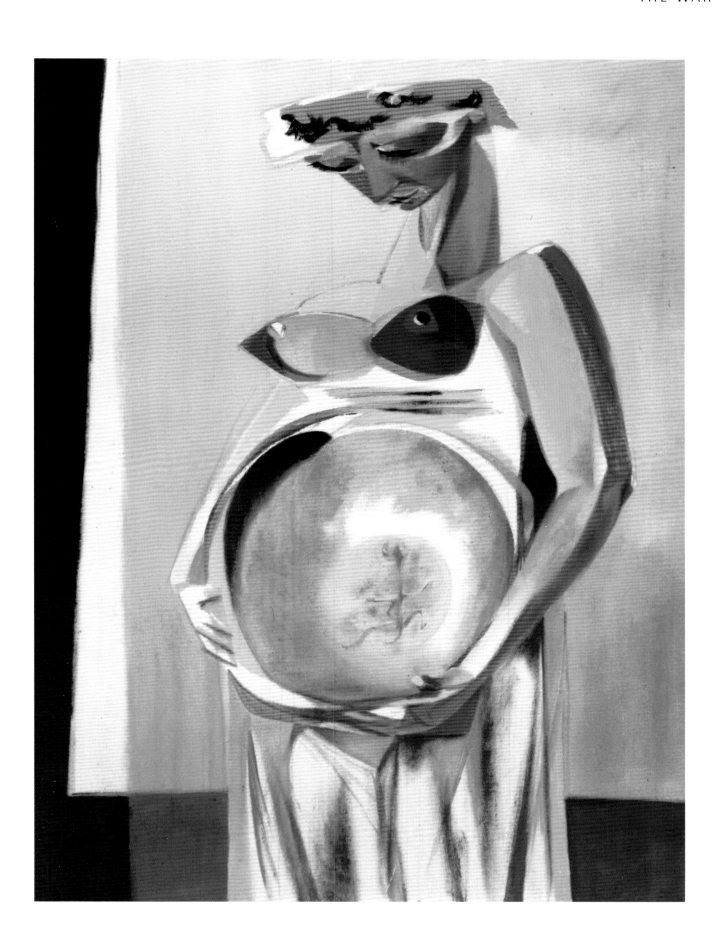

ABOVE TOP: Lee and Roland with *First View* painting by Roland, Downshire Hill, London, England, 1947.
ABOVE BOTTOM: Lee and Antony, London, England, 1948, photographed by Roland Penrose.

that the world was not a suitable place to introduce a child, but now the decision they would never have made for themselves was a *fait accompli*.

Lee's pregnancy was fraught with illness and a threatened miscarriage that confined her to bed. Aziz arrived in London and gave Lee his blessing and a Mohammedan divorce by solemnly intoning, 'I divorce thee' three times. Valentine was also there and in her capacity as a benevolent sorceress added her own good magic. Roland's spells took the form of a series of paintings where the round swelling of Lee's abdomen was variously populated with Greek temples and small figures. The final version was titled *First View* (1947). In a tranquil aqueous blue of inestimable depth, an animated green lizard stands poised to leap into the world. It was Roland's first and only portrait of me.

Roland and Lee married in May, and I was born by Caesarean section on 9 September 1947. Paul Éluard wrote a benedictory verse on a Man Ray photograph of Nusch, who had tragically died less than a year before. Then on a scrap of plywood he drew a bird and its chick, signing it:

La beauté de Lee aujour d'hui	The beauty of Lee today,
Anthony	Anthony,
C'est du soleil sur ton lit	Is the sun on your bed.

Paul Éluard
15 Septembre 1947

'Your face was bright red and you either slept or squalled a lot,' Roland told me. His own upbringing, which, in common with many families of that era, had been conducted by remote control, left him with few ideas about parenting. His first instinct was to hire help, and Lee was delighted to hand me over to Nanny Woodward. Although, paradoxically, she had steadfastly faced the horrors of the battlefield and of Dachau, motherhood appalled her. There was a very strong lioness-like protective streak in Lee and no one would have been allowed to harm me, but the day-to-day feeding and caring was not part of her natural instinct. Perhaps it was her early experiences of losing those she loved that made her such an unwilling mother, in case as a consequence of her affection, death should be visited upon me in the same way.

In the winter of 1946 Roland and Lee had moved across the street to the larger 36 Downshire Hill, but the return of Roland's loans to MOMA made them want even more space. Childhood memories of blissful

times spent on his uncle Robert's farm in Sussex, also made Roland desire a similar upbringing for me. Perhaps also influenced by Roland's pre-war visits to the Bloomsbury colony at Charleston, under the South Downs, they focused their search on East Sussex.

After several abortive viewings, Roland and Lee almost gave up. Then Harry Yoxall, the managing editor of *Vogue*, told them about Farley Farm, located in the beguilingly named hamlet of Muddles Green in the parish of Chiddingly, East Sussex. The port of Newhaven and the town of Lewes, with a good rail link to London, were close by, which pleased Roland who liked to contrast rustic bliss with frequent visits to the city.

During their first visit, the farm was so shrouded in thick fog that they had barely an impression of the surrounding land. They could see the place had been worked hard, and that shortages during the war had led to a daunting backlog of repairs and maintenance. Twenty-four Ayrshire cows stood in their stalls, and a few fowl scratched about in the yards. In farming terms it was typical of the Weald – a charming but difficult farm that was unlikely to ever be prosperous.

It was the house that caught their imagination. From the road its pleasantly-proportioned Queen Anne façade raised expectations of formal neatness. Instead they found the inside to be an oddly asymmetric assortment of rooms of different periods and styles, connected by long passageways. The expanse of interior walls and the smallness of the windows made the house perfect for hanging paintings. There was plenty of space for entertaining guests, and the surrounding garden, orchard and outbuildings offered exciting possibilities, including a studio for Roland.

The auction was held at the George Hotel in Hailsham on 16 February 1949. The price of farmland was at its post-war low, and bidding was slow. For £22,500 Roland bought two hundred acres, and the house, three cottages, two Sussex barns, a malt house, cart sheds, a pigsty and a cow byre. The bonus was still to come. Arriving at Farley Farm in bright sunlight, they were overjoyed to find a magnificent panorama, unmarred by buildings or roads, of the South Downs and their own woods and fields. In the centre of Downs was the Long Man of Wilmington, a giant figure who had been cut into the turf in prehistoric times. He is a solstice marker, and remains in the shadow during the winter until the increased height of the sun above the Downs in spring allows light to fall on him. Roland, who loved ancient mysteries, was ecstatic. Here was the house of his romantic dreams, within easy reach of London and Paris, under the arcane protection of the local deity, the Long Man.

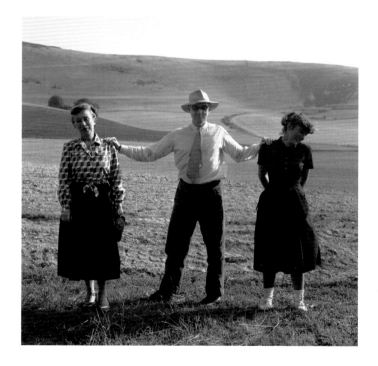

ABOVE TOP: Farleys House from the road, Muddles Green, Sussex, England.
ABOVE BOTTOM: Alfred Barr, wife Margaret and daughter Victoria, Long Man of Wilmington, East Sussex, England, 1952, by Lee Miller.

HOME AT FARLEYS HOUSE 1949–1959

Our first summer on the farm was a camping foray in a practically empty house ... We never stopped laughing and learning while dealing with crumbly brick floors, ice-less larder techniques and the construction of pelmets.

LEE MILLER, 'WORKING GUESTS', *VOGUE*, JULY 1953

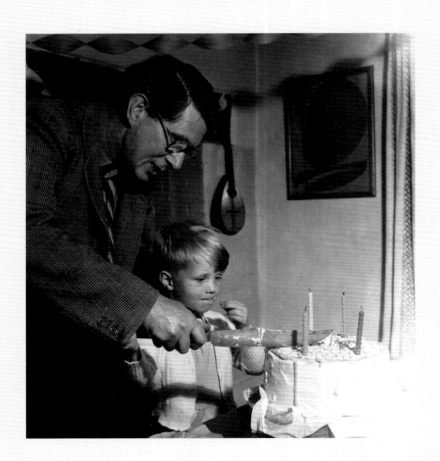

ABOVE: Roland helping to cut Antony's birthday cake,
Farleys House, Sussex, England 1951' by Lee Miller.
OPPOSITE: Farleys House seen from the road, Muddles Green, Sussex, England.

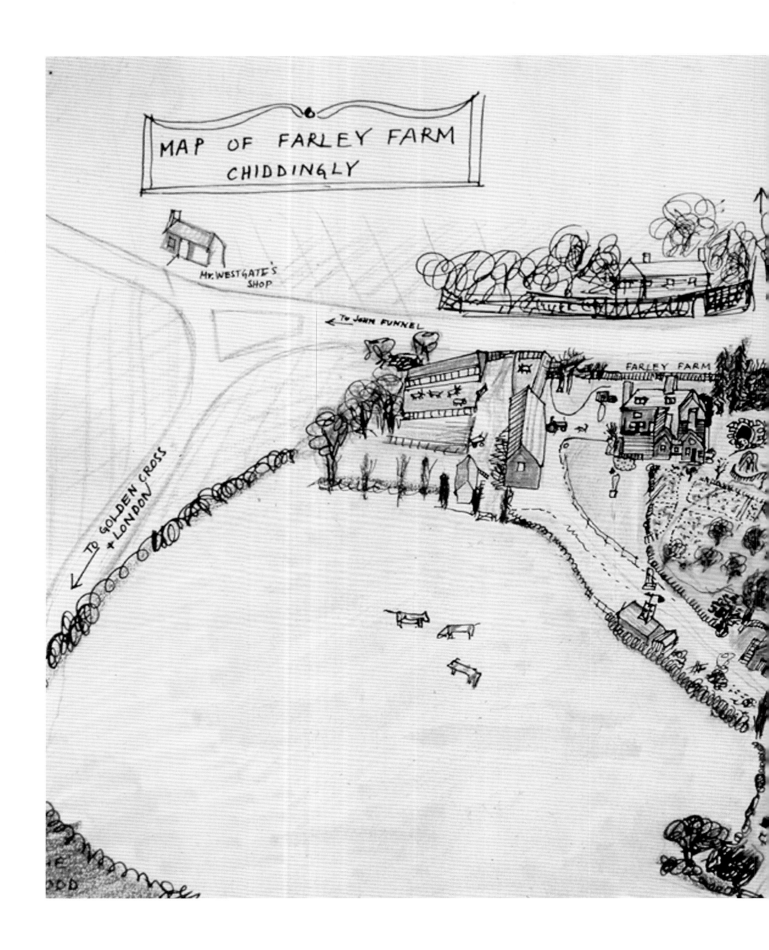

MAP OF FARLEY FARM
CHIDDINGLY

Mr. WESTGATE'S SHOP

To JOHN FUNNEL

FARLEY FARM

TO GOLDEN CROSS
+ LONDON

I have been told that I hated my first few weeks at Farleys. I was only a year and a half old at the time, so I have to rely on Roland's opinion. He said I could not stand the cold, and was frightened by the sound of creaking timbers and slamming doors when the gales blew. It was March 1949 and there was a tremendous post-war shortage of building and furnishing materials, so few rooms had carpets or curtains. It was to be several years before Lee could scrounge her requirements, even with all her contacts in the world of fashion. So the wind whistled through the old casement windows and the cracks between the floorboards, particularly in the sitting room, which was over the cellar. Fortunately the rest of the ground floor was made of brick laid on the earth in the old Sussex tradition, which although prone to dampness in the winter at least kept the draughts out. Decades of scrubbing followed more lately by waxing had given the surface a smooth and mellow texture, cool to bare feet in the summer. The kitchen was the constant focus of activity, particularly in winter when the warmth of the old Raeburn stove drew everyone like a magnet.

The purchase of Farleys was funded by the sale of 36 Downshire Hill. Roland and Lee bought a small two-bedroomed flat at 11a Hornton Street in Kensington, where they would stay during the week, returning on Fridays with more carloads of paintings or furniture. Once the household was established, I stayed at Farleys with the current nanny drawn for the most part from the vast ranks of women widowed in the war. Many had a sadness I never understood, but one, Gati, was memorably kind and cheerful. In the early days, the pivotal characters in my life were the farm staff and an adoring Labrador dog named Heather. They had permanence and reliability, except for Heather in thunderstorms. She would disappear and hide under the bed, quivering with fright.

Roland saw the potential of the modest farmhouse garden with its old orchard, but realized that years of work would be needed to transform it into the vision he had in mind. He took on Grandpa White, a wise old countryman from the village, but the work was soon more than he could handle, so Fred Baker was also hired. He was soon to be Grandpa White's grandson-in-law, and welcomed the prospect of a tied cottage on the farm as a home for him and his bride Joan.

LEFT: Map of Farley Farm, c1952, ink and watercolour on paper, by Roland Penrose.

Fred came from the 'make do and mend' generation. I remember the care he took of his tools, re-hafted with home-made handles, and used until they were all but worn away. In those days gardening was all handwork: digging, hedge cutting and scything the grass. Fred's solid sense of motivation kept him busy with minimal supervision, which suited Roland. A large portion of the adjoining field was taken in as extra space for vegetables; Lee was determined that food shortages would no longer spoil her table.

The cows were kept at the adjoining Willets Farm and Fred's brother Bill came to work there as a herdsman. They were unlikely brothers, Fred being tall and Bill short, with a weather-beaten face that cracked into a broad grin when you met him, a warning of an outrageous joke to come. My first encounter with this extended family was through Fred, who every morning arrived with unerring timing at half past seven to bring coal and wood for the Raeburn, and deposit two quart bottles of fresh milk on the kitchen table. The bottles were thick glass, closed with discs of cardboard that looked very professional, although their contents bore little resemblance

ABOVE LEFT: Ayrshire Cows going to be milked at Willets, Farleys House, Sussex, England c1950' by Lee Miller.
ABOVE RIGHT: View from Farleys House, East Sussex, England 1952' by Lee Miller. Seen from an upstairs window, the Downs stretch across the horizon and stooks of sheaves dot the fields..

to shop-bought milk. The taste of our milk varied with the season: sweetest in the spring and summer, with the occasional taint of buttercup, and faintly rank with silage in winter.

As I grew older, my horizons broadened and I wandered as far as the pigs in the yard and the nearby wood where they spent the summer, or across the fields to Willets to watch the cows being milked. During the six winter months, and for every milking, the cows stood or lay in their stalls, secured by a chain worn lustrous by the constant polishing of their necks. Above each stall a small board showed the cow's name, the date she had calved and other details. Our first year's heifers all had names beginning with A. It was B the next year: Buttercup and Blossom rubbed shoulders with Baronova, named after Nina Baronova the ballet dancer. Baronova was the stall mate of Cecile, after Paul Éluard's daughter from his first marriage to Gala. The cows knew their own stalls and would troop solemnly in from the fields. I would be allowed to squeeze in beside them to tip a scoop full of meal into the manger, and stroke their ears while they ate with loud snuffling noises. It was very personal. Bill and the other dairymen had a special bond with their charges, speaking kindly to them as they washed the taut pink udders and fitted the cluster of teat-cups. The foaming milk would then be tipped into churns in the dairy, each churn with a collar sending cascades of cooling water over it. After milking I would 'help' push the trolley loaded with

churns down to the road, where they would be lifted on to a stand to await the milk lorry.

Hedging, ditching, haymaking and particularly harvesting, with the stooking and carting of sheaves of corn, involved many people. Jack the tractor driver, George the stockman, Stan the pig man and Mr Shanks the foreman were the staff, later joined by Bill as tractor driver when another George became herdsman at Willets. There were also contractors for threshing and baling, who arrived with a magnificent array of equipment. During the harvest, Roland would help with pitching sheaves when he got back from London on Friday evening. Without the noise and isolation that machinery brings, everyone could talk and joke, and there was friendly rivalry, endless teasing and a sense of community in every task. With few chemicals and a minimum of machinery, a farm used to be a reasonably safe place for a small boy under the benign and watchful eyes of those who were part of this way of life.

A vast monument of a Suffolk mare called Gypsy worked at Willets. She must have understood German because the carter, a former prisoner of war called Willy Runcle, had a perfect rapport with her. Gypsy had a neat black moustache. In winter, when she pulled her two-wheeled cart, she would snort twin jets of vapour from her nostrils like a steam engine. However, Gypsy was soon to be retired by a pair of smart, navy blue Fordson tractors. They had to be hand cranked to start, and on a cold, damp morning were

impossibly stubborn. I remember shreds of skin peeling off Bill's hands as he furiously wound the handle. Tempers would rise, and plugs and ignition parts would be ripped apart and cleaned with a sack. Then more cranking and tinkering until finally the engine would fire, spluttering uncertainly at first and then settling down to a full-throated crackle. They ran on paraffin and even today the whiff of aircraft exhaust fumes evokes a memory of those recalcitrant tractors. In the evenings, when Bill or Jack brought the tractors back after a heavy day's work, the exhaust pipe would be glowing a dull cherry red.

The days were filled with a well-ordered, peaceful routine, regularly broken on a Friday evening when Lee and Roland would arrive with their guests. My favourites were Timmie and Terry O'Brien. Terry was a novelist and Timmie was managing editor at *Vogue*. I had a particular affection for Timmie. She had a great talent for mothering small boys, which perhaps related to her Jewish background. Together we went on long expeditions in farm woodlands filled with man-eating tigers, crocodiles and every other kind of hazard we could imagine. We defended stick

ABOVE LEFT: Heather the dog, Farleys Garden, Sussex, England c1950' by Roland Penrose.
ABOVE RIGHT: Grandpa White and Fred Baker in the greenhouse, Farleys Garden, Sussex, England c1951' by Lee Miller.

ABOVE TOP: Roland Penrose and Timmie O'Brien checking to see if the mushrooms they have found are edible, Farleys House, East Sussex, England 1953' by Lee Miller.
ABOVE BOTTOM: Valentine Penrose charms a grass snake she has found, watched attentively by Antony Penrose, Farleys Garden, East Sussex, England c1954' by Lee Miller.

fortresses against the hordes of hostile savages that wanted our jam sandwiches, but we always survived and returned triumphant.

Timmie was responsible for getting Lee to deliver her assignments on time and she was beginning to find it hard going, as Lee entered a downward spiral of depression and alcohol abuse. Today much could be done to alleviate the effects of post-traumatic stress disorder, but in the post war years, with countless thousands suffering in the same way, the solution was known as 'the stiff upper lip'. 'Just button up and get on with life' was a well-known piece of advice. And there was always the whiskey bottle to attenuate the senses. Lee, who was already a heavy drinker, turned more and more frequently to this solution.

Without knowing their cause, I quickly grew aware of the sudden mood swings that would change her from a warm and amusing person into one whose evil-tempered irrationality made everyone run for cover, myself included. I learned the best strategy was to keep out of the way, and fortunately life at Farleys afforded plenty of opportunity for doing just that. Outwardly Lee's condition did not show too much at this stage, and few understood the anguish she was suffering.

Valentine, soon to become a habitué was among our first visitors with Paul Éluard, who wrote in the visitor's book:

> A la suite de ces merveilles. J'invite les professionels du paysage irlandais ou frivolais, à me prouver leur gentillesse en nous montrant ce qu'ils voient par la fenêtre – ou sans fenêtre, avec le jour qu'on a en soi. Merci! Paul Éluard

> After such wonders. I invite Irish or frivolous professionals of landscape painting to prove their kindness to me by showing us what they see through the window, or without a window, with their inner light. Thank you! Paul Éluard

The phrase 'Irish or frivolous' in French has a pleasantly warm alliteration, *irlandais ou frivolais*, that perhaps refers to Roland's Irish ancestry. The Surrealists loved the poetic stream-of-consciousness writings of James Joyce, who had lived and worked in Paris in the 1920s, and they had a particular respect for his native country where poetry and literature were so deep rooted.

Éluard came alone to Farleys. His beloved Nusch had died in November 1946. Her health had been fatally undermined by the privations she and Paul endured whilst hiding from the Gestapo, who placed them high on the wanted list because of the anti-Nazi poetry and literature Paul tirelessly wrote and distributed during the war.

Max Ernst and Dorothea Tanning came to stay in Easter 1950, and then returned in August. Dorothea wanted to wash her hair but was put off by the colour of our tap water, which came from a well on the farm and resembled thin tomato soup because of the rich deposits of iron in the ground. She settled for water from the rain barrel, ignoring its odour of rotting leaves. Lee photographed Dorothea drying her hair in the sun; looking as if she had stuck her head on backwards, she resembled one of Max's collages. Max pretended to weed the rockery with an air of detachment born of familiarity with bizarre sights.

When Picasso arrived in November 1950, more than thirty years had passed since his last visit to England as the designer for the Ballets Russes. He had lived through two world wars as well as the Spanish Civil War – the cause of the particular heartbreak that found expression in *Guernica* and the series culminating in *Woman Weeping*. Committed to world peace, he was on his way to attend the peace conference organized by the Communist Party in Sheffield, not anticipating that the event would trigger a political storm. The British government, seeking to counter what they feared was Soviet Communist infiltration, made moves to discredit the conference, and Picasso's fellow French delegates were all refused admission to Britain. Picasso was horrified that the fact he was the only one to have been given a visa might indicate he had become part of the hated establishment.

When Roland met Picasso off the boat train at Victoria Station in London, he found his old friend in a state of high anxiety. Relentless attention from the press added to his misery, and he jumped at Roland's suggestion that they should leave London for Farleys. In an article titled 'Picasso Himself', published in *Vogue* in November 1951, Lee wrote:

> At the farm, Picasso found the world was very English; the landscape of Downs with Constable clouds and transparent backlighting, the prudish Long Man of Wilmington, the driving on the left, the red and white Ayrshire cows, black and white Wessex pigs, open log fires, whiskey and soda night cap, hot water bottles, cooked breakfasts and tea. He could scarcely know that besides modern pictures, an English farmhouse doesn't have rows of French sabots inside the back door, garlands of garlic, and furniture which lived its first hundred years in Gascony. But the tinned plum pudding on my menu, holly wreathed and flaming was indeed English, *very* English, and superb.

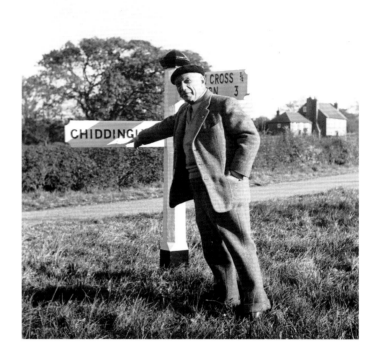

ABOVE TOP: Picasso pointing at the Chiddingly signpost, Sussex, England, 1950, by Lee Miller.
ABOVE BOTTOM: Dorothea Tanning and Max Ernst, Farleys Garden, East Sussex, England 1950' by Lee Miller. Lee and Dorothea, as fellow Americans and women artists, had a close affinity that complemented Roland and Max's friendship.

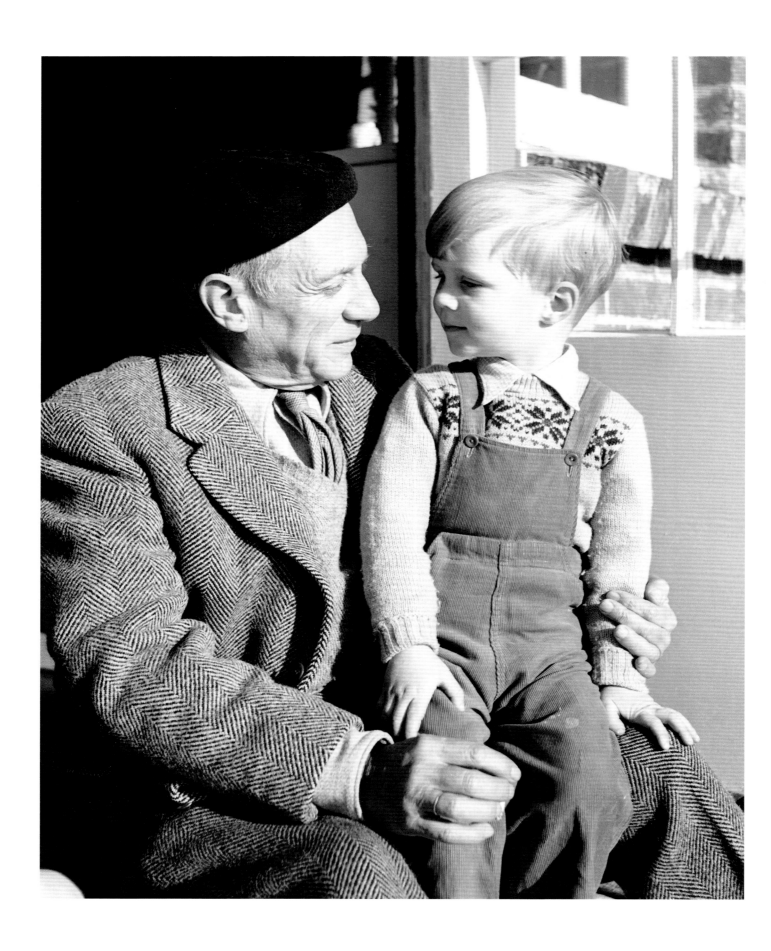

Not only can Picasso animate canvas, paper and bronze but everything in his orbit comes under a magic influence. The winter jasmine came in flower, the hateful stinging nettles disguised themselves with frills of hoar frost, even a great heap of trash and broken tiles produced a lovely form. The Tauro (Henry, our bull) pranced and preened like a chorus girl looking for a job. Heather, the large patient yellow nursery dog was so overcome with emotion that she messed on the grizzly bear skin in the guest room.

I soon discovered Picasso's Mediterranean warmth meant that he was good for cuddles and horsing around on the floor. I was only three, so I recall him as a series of abstractions – essences perhaps, such as he distilled into his paintings. His strength and the feel of his scratchy tweed jacket drift back to me, with the scent of his soap and the ever-present Gaulloise cigarette. In the same article, Lee recorded that Picasso and I 'became great friends, telling secrets in some secret language, finding treasures of spider webs and seed pods, roughhousing and looking at pictures'. The photographs in *Farmer's Weekly* were a source of mutual interest to us, and I am told we understood each other perfectly.

Picasso made only a brief visit to the peace conference and returned to London where he visited Roland and Lee in Hornton Street. In protest at the government's attitude to the conference, he refused to go to the exhibition of his work, *Picasso in Provence*, which the Arts Council had organized with Roland's help. To Roland's even greater regret, he could similarly not be persuaded to go to the ICA's newly-acquired premises in Dover Street, which were currently being refurbished by the architects Max Fry and Jane Drew. Lee continued:

> Suddenly Picasso decided to return to Paris via our farm and the Newhaven ferry. He called on Lady Keynes [John Maynard Keynes' widow] who was Lydia Lopokova in Diaghilev's Ballets Russes. She kissed and scolded him just like thirty years before and we took off into the country intending to shop for food and souvenirs ... town after town had its gloomy green curtains drawn for early closing. I was panicked like

any hostess would be. The farm larder had been cleaned out by our impromptu arrival with Picasso and his friends on the weekend. Shopping could wait until the next day, but what for dinner? Brighton, our last hope is fortunately eccentric and was open ... While Roland conducted a tour of the sights and interpreted a search for take home presents, with ration cards clutched in my hand I bought a complete menu in tin cans from the grocer's shelves. I was sitting smugly in the car when they returned laden with things I had scarcely realised were VERY English: among them was a peaked school cap each for Picasso and his small son Claude, Bournevita with a plastic mug of a sleepy man wearing a night cap lid, Kwells and postcards of the Pavilion.

Before leaving London Roland had grabbed the ICA visitors' book, and when Picasso was seated comfortably by the fire at Farleys, Roland asked him to sign it with a drawing. Alas, Roland was ill prepared. The only materials he could find were garishly bright poster inks and some rather indifferent brushes, but this did not matter to Picasso, who quickly filled two pages with a high-spirited drawing of three grasshopper bulls, perched on twigs bent like springboards. Then he took Roland's copy of *Góngora, Vingt Poèmes*,

OPPOSITE: Picasso and Antony Penrose, Farleys House, Sussex, England 1950' by Lee Miller.
RIGHT: Picasso lithographs hang in the dining area of Farleys House Kitchen, Muddles Green, Sussex, England'.

which he had illustrated, and covered the entire title page with an intensely colourful drawing of a satyr mounted on a horse.

The next time Éluard came to Farleys, in October 1951, he was with his new bride Dominique. We had been to St Tropez for their wedding in June. For me it was a bewildering process, which involved being cooped up in a damp-smelling room when I would have much preferred to be on the beach or admiring the all-day pageant of the Bravade procession, with soldiers and sailors in nineteenth-century costume firing blunderbusses in the street. Picasso and Françoise Gilot, (the young painter who was then his lover) were witnesses, and afterwards we all had lunch together.

Lee claimed I elevated Éluard to the same superhero status as Picasso, and attributed marvels to the magic duo. It was Éluard and Picasso who drove the huge floating crane across St Tropez harbour to position the vast concrete blocks of the sea wall. It was either Éluard or Picasso in a brass-helmeted diving suit who burst to the surface in a shower of foam to grab a crowbar from beside our feet. 'He was rude, he didn't wave to us,' I complained, as my helmeted hero returned to the depths.

A little over a year after the wedding, Dominique was a widow. In a letter of November 1952, Valentine described Éluard's funeral to Roland and Lee:

> I embraced Dominique on your behalf, and how she regretted not seeing you. Picasso was helping her by acting as big brother, and I have never seen anything so pale and frozen as her face. Then everyone went to Père Lachaise (Cemetery) ...we arrived at a spot very far off, over near Nusch, in a corner where the dead and deportees from the war are buried. Afterward, we embraced Dominique, Picasso, and Cecile, and we stayed there under the wind-tossed elm trees waiting—for what? But Paul's death is a birth, a thousand births for all of us. Still, he will be here, in his works and especially, even more, in our memories of him, his faults, his furies, and his magnificence.

Roland was deeply affected by Éluard's death. He later wrote in *Scrap Book*:

> Before the war I owed much to Éluard for his revelation of a new way of life, essential factors being freedom of expression, an unflinching challenge to all conventional ideas, the continuous test to which all moral concepts should be put by considering them

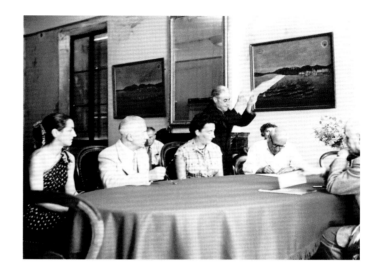

OPPOSITE: The front stairs landing. An illustrated version of the poem *Liberté J'Écris Ton Nom* by Paul Éluard hangs above the mirror, Farleys House, Sussex, England.
ABOVE TOP: Francoise Gilot, Paul Éluard, Dominique Laure and Picasso witnessing Paul Eluard and Dominque Laure's wedding, St Tropez, France, 1951, by Lee Miller.
ABOVE BOTTOM: Antony Penrose and Paul Éluard, Farleys Garden, Sussex, England 1951' by Lee Miller.

in reverse and above all the basic importance of the subconscious in all inspiration. This last idea had something I recognised as being akin to the Quaker belief in the "inner light" as the surest guide to truth. These ideas often emanated from Surrealism but it was above all Éluard's invincible faith in humanity that appealed to me, a faith that overrode the miseries of the time and remained allied to a militant hatred of all that hindered attempts to achieve a higher degree of justice among men and a more profound understanding of their human condition.

Despite his weekly absences in London, Roland knew enough about the condition of Farley Farm to see that things were not going well, and by 1950 he realized he had to have good manager to run the place. Strutt & Parker, the local land agents, offered him a selection of candidates, keen young men with glib assurances of their own abilities and the future performance of the farm. Roland did not like any of them and was in despair, until the recorder from the Milk Marketing Board recommended Peter Braden, the manager at a nearby farm that was for sale. They walked the fields together, and Peter gave Roland a straight opinion: the farm was in poor condition, the fences and gates were in ruins, and the livestock needed to be upgraded with a breeding programme. Roland took an immediate liking to this bear of a man whose gruff exterior hid a heart of gold. Peter, his wife Vi and their family moved into Willets in 1950. It was tough going at first, but over more than thirty years he guided and cajoled Roland into expanding the farm so that it retained its viability and survived the extreme tests of modern agriculture. In the years to come, Roland was to greatly value Peter's dedication. Valentine would say, only partly in jest, 'Roland has two gods – Picasso and Peter Braden.'

Peter's progressive approach sometimes got him into trouble. The Ayrshires had beautiful curved horns but they were a danger to each other and more importantly to the staff. So, with Roland's approval, Peter had the vet in to dehorn them all. When Lee caught sight of the herd walking past the house with their recently wounded heads, she was incensed. 'I wish I could pull all your teeth out, then you would know how these poor animals feel,' she yelled at Peter. He also learned never to take Roland near a wet patch in a field, because Roland would want to plant it up with poplars, 'like they do in France'. With wet land like Farleys, the whole farm could justifiably become a plantation, leaving no room for the cows. Running a farm for two Surrealists had its perplexing moments.

More importantly for my world, in 1951 Patsy Murray, an attractive young woman of Irish descent, arrived to look after me. Patsy was the best thing that ever happened to me. She had been

RIGHT: Patsy Murray with some of Heather's nine puppies, Farleys Garden, Sussex, England 1952' by Lee Miller. When they were let out they would escape in all directions at once.

employed for two weeks at first following the departure of my latest nanny, but she stayed, and virtually became my mother. Soon her own mother, Paula, moved in as cook and housekeeper, and Farleys stopped being a transit camp for itinerant nannies and took on an air of permanence.

Patsy's background made her ideally suited to life at Farleys. Paula had lived in a sort of commune run by the eccentric philanthropist, philosopher, physician and friend of Mahatma Ghandi, Josiah Oldfield. Patsy had been brought up on Oldfield's estate at Doddington in Kent, amid an extraordinary selection of people of varied nationalities and fortunes. Even as a small child, Patsy had not escaped Oldfield's almost crippling work ethic, doing endless household chores as well as walking two miles in all weathers to catch the school bus. While still a teenager she left and trained as a children's nurse and, eventually, on the recommendation of a friend, she arrived at Farleys.

Roland and Lee found Patsy un-shockable, good company and totally reliable. Soon she was running the household; and that suited Lee who, although she loved entertaining and cooking, wanted no part of the housework. Roland was right when he

acknowledged many years later, 'If it was not for Patsy, I would have never been able to keep Farleys'. The presence of Patsy also meant that he and Lee could go overseas for long periods, certain that everything would continue as normal at home.

Left to our own devices all week, and with no car, Patsy and I often walked to the Chiddingly Post Office Stores. The shop was run by the Robinson family, who came from Derbyshire, and it was the most wonderful Aladdin's cave of goods. Hessian sacks of potatoes, dried peas, beans and other bulk goods stood with their necks rolled down, waiting for their contents to be scooped into cones made of newspaper. Produce from the gardens of the village spilled from boxes on the floor and brooms and mops hung from above. Every conceivable item available awaited the customer. Patsy and I, with our basket, would walk there along the footpath, and old Mr Robinson would greet us with unfailing old world courtesy in his lovely north country accent: 'Hello Miss Patsy, come and take a seat. Hello, Master Tony, would you like a bonbon?' The magic phrase heralded the opening of a tall screw-topped glass jar from which I was allowed to select a sweet.

Mr Robinson would disappear without warning to France, where he steeped himself in opera. 'He finds tickets to shows I cannot get in to see', grumbled Valentine with admiration. Mr Robinson's son John did the delivery round, and it was not long before a Friday evening ritual developed, where John would bring Lee's weekend order and stop for a glass of wine, joining whatever company happened to be present. Other regular callers did not become friends in the same way, but were much valued. There was Mr Jupp, the baker, with his huge wicker basket, Mr Russell, the fishmonger, whose arrival would greatly excite the cats, and the

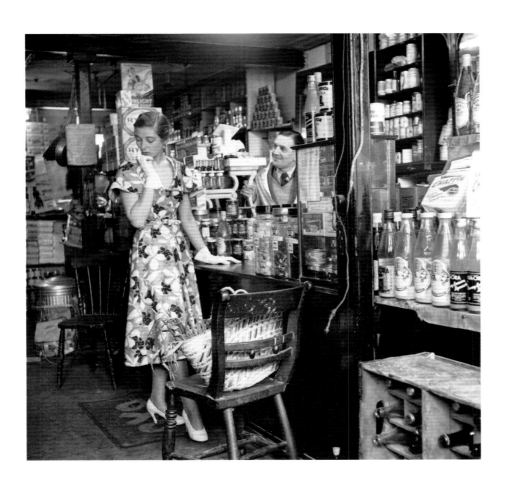

LEFT: Fashion shoot in Chiddingly Village shop with Mr Robinson behind the counter, Sussex, England, c1952, by Lee Miller.

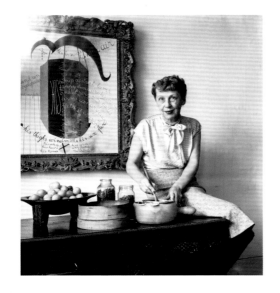

man from the off-licence in Hailsham. We got through a lot of his wares.

By now Lee's drinking was seriously impairing her work, and soon the only way that Timmie could get her to finish an assignment on time was to sit beside her as she worked through the night, soothing the tantrums and filling her glass. One of Lee's last assignments for *Vogue* was 'Working Guests', published in July 1953. Lee had frequently used the farm and the village as locations for fashion shoots, and now as various visitors from the art world appeared, she set them up in a series of spoof shots. The article claimed that the best way to refurbish a country house was to invite round your friends and put them to work. Roland and I were shown clipping the grass. Reg Butler, the sculptor and prizewinner of the competition run by the ICA and the Tate in 1953 for the *Unknown Political Prisoner* monument, was photographed slicing and salting beans with his wife, Jo. The painter Johnny Craxton pretends to prune a giant larch tree. The American cartoonist Saul Steinberg, over for his show at the ICA, resembled one of his own drawings as he wrestled with a garden hose. Richard Hamilton and

his wife Terry showed a talent for upholstery, Susana Gamboa, a registrar from the Tate, pretended to repaint the ship's figurehead that stood outside the door, and Roland's old friend, Alfred Barr, fed the pigs. This he felt was entirely appropriate, as in his capacity as director of MOMA he was accustomed to casting pearls before swine. Madge Garland, professor at the Royal College of Art, crumbled dried marjoram in a carefully set-up shot that included Roland's painting *Portrait* (1939), which had been rejected by the 1939 show at the Royal Academy because it contained the words 'sex' and 'arse'. Echaurren Matta, the Chilean Surrealist, wrestled with a house painter's ladder, and John Craxton, the British painter and ballet designer, later climbed the same ladder to prune the stately larch trees by the gate. Max Ernst and Dorothea Tanning were set up in the unlikely poses of gardener and electrician respectively. The final picture was of Lee herself fast asleep on the sofa in the sitting room.

Carrying the spoof to its conclusion, Lee wrote:

> I've devoted four years of research and practice to getting all my friends to do all the work. There is scarcely a thing, in or out of sight, from the woodpile to the attic water tank, from the chair coverings to the brined pork and the contents of the deep freeze, without the signature of the working guest ... There is really no trouble in getting a hand in the kitchen. Our housekeeper, Paula, and my son's nurse, Patsy, are welcoming and waiting to hear everyone's life and adventures since their last visit. Romances, wardrobes, murder trials and political iniquities are thrashed out in the kitchen, while four cats try to snitch unwatched delicacies, Heather the Labrador hogs the kitchen floor and the new kittens squeak for attention ... We're now in the last year of the first 'Five Year Plan' on the farm. Already I'm calculating the second. A vineyard should be started – it would be producing enough by the end of five years to give its own encouragement to the working guests for its annual up-keep.

The full text of this article shows the strain Lee felt. The flashes of wit and the wonderful poetic associations that made her war writing so vivid are still evident, but the piece degenerates into rambling. In the absence of war, Lee lacked a subject that polarized her thoughts. The trauma of delivering to a deadline was now

OPPOSITE: Visitors to Farleys photographed for Lee's article *Working Guests* in *Vogue*. Across from top left: Madge Garland, Professor at the Royal College of Art; William Turnbull, sculptor; Freddie Ayer, Wykeham Professor of Logic, University of Oxford; Reg Butler, sculptor, and his wife Jo; Richard Hamilton, Artist; Terry Hamilton, wife of Richard; Saul Steinberg, cartoonist; John Craxton, Artist; Alfred Barr, Director of the Museum of Modern Art; all at Farleys House, 1953' by Lee Miller.
ABOVE: Meanwhile Lee Miller the hostess has a good sleep, 1953, photographed by Roland Penrose.

LEFT: Diane Deriaz in her days as a circus performer, 1951.
OPPOSITE: *The Third Eye (The Eye of the Storm)*, 1950, oil on canvas, by Roland Penrose. In this portrait of Lee her head has become an eye, that may refer to the importance Lee placed on seeing and her use of cameras, which are monocular. It may also recall Lee's eye in Man Ray's *'Object to be Destroyed'.*

also spilling over on to Roland, who could no longer face the disruption. Secretly he contacted Audrey Withers and persuaded her to stop assigning work to Lee. Audrey, who for some time had been accommodating Lee's work more out of loyalty than necessity, agreed. Lee had run out of things she really wanted to say and was not too bothered about the drying up of her work. However, when she eventually discovered that it was Roland who had instigated the final blow she was deeply wounded. With one of her most important *raison d'être* removed, the strong undertow of depression dragged her down. She became almost impossible to live with.

It was not surprising that Roland found an immediate rapport with Diane Deriaz, the tall, attractive former girlfriend of Paul Éluard. Formerly a trapeze artist, Diane arrived in England looking for performing bears for her new circus act. She sought out Roland at the ICA, and instantly captivated him. Lee encouraged the relationship; it was not unusual for her to sanction Roland's sexual liaisons, confident that his love for her would not be affected. She would even welcome his girlfriends as guests, so there was nothing particularly startling about Diane coming to Farleys for the Christmas of 1953. Dominique Éluard was also there, as was her daughter Caroline, Max Ernst and Dorothea Tanning, Valentine, and Timmie and Terry O'Brien.

It was supposed to be a jolly house party and although no one could fully ignore the swirling undercurrents of tension, the guests maintained their libertine standards and refused to notice the ticking of the time bomb. The explosion came on Christmas Eve. There was a big scene at dinner, when Diane pretended to faint and Roland panicked, certain she was seriously ill. Valentine, with unusual pragmatism, pointed out that people on the point of death do not usually have nice pink complexions. Lee, however, was shaken to her core. She had suddenly realized that Roland had crossed the line and fallen in love with Diane. She took to her bed and refused to budge for the rest of Christmas.

Patsy and Paula were practically run into the ground, and by Boxing Day the normally even-tempered Paula declared that she would leave if one more person came into the house. At that moment a taxi arrived and out stepped Jimmy Dugan. Paula did not leave. Dugan with his experience as a photographer and deep sea diver was the right sort of person for a tight spot, and managed to restore some humour into the rather bewildered gathering. In the visitor's book he signed himself 'The Prisoner of Zenda', no doubt referring to the intrigue in the mythical Balkan kingdom of Ruritania, portrayed the previous year in a film starring Stewart Granger and James Mason.

In the absence of their hostess, and kept indoors by heavy rain, the guests made their own diversions. Terry O'Brien remembered in his diaries:

> Dorothea was reading some article about Australia and looked up to ask me what was a billabong ...

I drew the line of a river with a bend to the left, and then a big drawing of what happens when the river floods through to make a straight line, so leaving the curve isolated. 'There,' I said, 'that is a billabong.' Roland took my pen, added a nipple to the curve and said it was clearly a woman's breast. Then Max had a turn, drawing a straight line angled down left from the base of the breast. He said to me, 'Your billabong is Roland's breast is my mirror-R [A pun on the French word *miroir*].' Dorothea took back her magazine and drew a circular line around the outside of the R base, then completed it as a container, and said, 'There's your billabong breast mirror-R in my garbage can. Now let me finish reading this.'

Timmie found some lime green and blue felt, and began to make a skirt. Max dismissed her design as too plain: 'A woman has curves' he said, shaping his hand over her breast, and he sketched sweeping lines with dressmaker's chalk. Timmie in turn helped me make a pink dress for Heather the dog. It was not to Heather's taste and she refused to wear it, except briefly to please me.

Roland found himself increasingly infatuated by Diane, who, although she did not hurry back to Farleys after Christmas, became a regular feature in his life. He wanted to marry her and go to live in Paris, reasoning that Lee and I would be happy in America. In retrospect, the thought chills me to the marrow. I could never have survived Lee alone, without Patsy and the security of the farm's steady rhythm. Unexpectedly, Diane saved me. Her own preference and genuine desire not to harm me caused her to categorically refuse to marry Roland.

Not surprisingly, Lee became incessantly quarrelsome, making fights out of small issues instead of tackling the cause of her distress outright. Roland did try to encourage her to discuss things with him and express her feelings, but she refused. She was paranoid about mental illness and felt that if she really did let out her true feelings, it would be all that Roland needed to have her certified as psychologically unstable and committed to a mental hospital.

Roland did attempt to be a little more discreet, but at the same time a cruel streak emerged in him. He would say to Lee, 'I'm going to Paris for the weekend, and you are not coming', and Lee would retire to Farleys, try to interest herself in her new found passion for cooking, fail, get drunk and weep. In a first draft of an article published in *Vogue* in April 1953, publicizing the ICA exhibition The Human Head, Lee spoke from experience when she wrote, 'Humility,

which is not one of the greatest attributes of the human, is quite a different thing when applied as a whip, called "humiliating". In the early summer she left for an extended stay in America, uncertain whether she wanted to come back.

During their time apart, the love Lee and Roland had for each other somehow re-emerged, and Lee's return just before Christmas with crates of gadgets and kitchen appliances signalled a new rapprochement. Although their relationship remained fraught, they both made genuine efforts to get along, and the renovation of the kitchen was Roland's peace offering. Two rooms were knocked into one, and a larder and a parlour for Patsy and Paula were added on behind the house. A firm of shop fitters was hired to make the cabinets; in 1954 kit form kitchens were still many years away. Lee insisted on topping the rippled sycamore units with a new material, Formica, in pale blue. 'It's a kitchen for giants,' gasped Paula, as she admired the cupboards that stretched right to the high ceiling. Alas, the giant-sized warmth of Paula was soon to depart, a victim of cancer.

A solid fuel Aga replaced the old Raeburn stove, and its constant output of heat delighted everyone, the five cats especially. To everyone's amazement a dishwasher arrived. It was so badly designed that Patsy found it easier to do the dishes by hand and washing up after lunch became quite a ritual, with Roland puffing a

cigar whilst solemnly drying dishes and putting them away in the wrong places. Lee would of course have gone for her siesta.

Roland, who was impervious to extremes of heat and cold, could not see the need for central heating. Had it not been for his concern that the house was too damp for the books and the works on paper, I do not think he would have been swayed by Lee's pleas. When it was at last installed he soon found he enjoyed the warmth. It was also clearly better for the collection – although Roland on the whole was an art conservator's nightmare. He was always respectful of the works, but he believed they were to be lived with and enjoyed rather than treated as museum pieces.

Mrs Noah in my Noah's ark was different to the other painted figures, a wooden off-cut, with her features drawn in blue pencil. Under my supervision, she worked hard with Mr Noah caring for the animals. It was not until twenty-five years later, when I got her and her charges out of the attic for my own children, that I noticed writing on her base. 'Made by Picasso for his son Claude', it stated, in Roland's handwriting. Roland told me that I had traded my red Dinky Toy London bus for it. In the kitchen, Roland had the builders embed a Picasso ceramic tile in the wall above the Aga, and he regularly used Picasso jugs and vases for his flower arrangements.

Paintings by Picasso or Miró would be hung above fireplaces that smoked, and Ernst's *Elephant of Celebes* was placed over the sideboard in the dinning room, in danger of being splattered with fat as Roland carved the roast. A Man Ray paper spiral lampshade was thrown out after a few years when it became tattered and covered in fly specks.

The works of art that surrounded us were distinct characters. When they returned from a period away on loan they would be welcomed like long absent members of the family. They were loved, criticized, and even feared by some. 'Do you really like these things?' asked the man from the Ministry of Agriculture, 'They look like my worst nightmare!' Roland just smiled with a special twinkle of satisfaction in his eye. It was true, few people could be indifferent to the collection, myself included. I recall at a very young age exploring alone along the corridors until I came to Lee and Roland's room. There, high on the wall on the far side of the room hung Delvaux's *L'Appel de la Nuit* (1938). The painting's silent and gentle dreamlike quality filled me with such delight that I was transfixed – and then I was overcome with anxiety in case I should not be able to find my way back to the room when I wanted to see it again.

Not long after we moved to Farleys, some of our paintings that had been in store during the war at Dartington Hall in Devon were

OPPOSITE: A ceramic tile by Picasso is set into the kitchen wall above the Aga, Farleys House, Sussex, England.
RIGHT: *L'Appel de la Nuit*, 1938, oil on canvas, by Paul Delvaux.

returned. Roland hung them with enthusiasm, installing Picasso's *Portrait of Lee Miller* above the mantelpiece in the sitting room. He then took me in his arms and carried me through to see it for the first time. He always claimed with great pride that I recognized Lee, and gave an instant cry of delight, 'Mummy, Mummy!' Personally, I have never been quite sure if this was not actually a cry of terror at being confronted by the painting's garish colours and strange shapes.

At first, Picasso's cubist painting *The Green Woman* (1909) hung opposite Lee's portrait, but after she was sold Max Ernst's

Portrait of Valentine (c.1928) took her place and Roland's two wives were facing each other. He often used to say how wonderful it was that they got on so marvelously well, but he was deluding himself. Because he loved them both, he reasoned they loved each other too, but what he thought was perfect harmony was at times more of an armed truce. Each had her own unique part of Roland, and each had plenty she could criticize in the other. Lee would fume about Valentine's impractical side, and how incapable she was of handling money. Valentine's impeccably mannered and serene demeanour, backed up sometimes by her special brand of

indignant sarcasm, would make its own criticism of Lee's egregious behaviour. But it was true that underneath the tension they did have a very deep affection for each other. When Valentine suffered misfortune it was often Lee who rode to her rescue and when she was ill it was Lee who insisted she was comfortably cared for, over long periods, at Farleys.

The locals observed the frequent visits of Valentine, as she was always walking the lanes and footpaths. No secret was made of her being another Mrs Penrose and many conclusions were drawn from this, but we generally remained unaware of the reputation that was building up around us. Roland and Lee found early on that mixing socially with the local gentry was on the whole not a great success. Visitors could not always square the tales they had heard with the elegant politeness with which Roland always welcomed them. I remember a drinks party that took place when Ninette Lyon, the French food writer, and her husband Peter were staying. One of the more formidable ladies of the village trapped Peter in a corner. 'Do tell me, are you one of Mrs Penrose's lovers?' she enquired, her la-di-da voice penetrating every corner of the room. Lee overheard and exploded: 'Goddamn it! He's young enough to be my son!' The party ended soon afterwards.

Dawn Jackson was among the few Chiddingly people with whom my parents had a close affinity. Related to Beacus' new wife Annie, she had known some of Roland and Lee's closest friends during the war and was inured to outrageous behaviour. Pat and Jessica Collard, two doctors from Hellingly mental hospital, the vet, John Hooten, and our neighbouring sheep farmer, Bob Whitehead, also came into that category. In later years, Sir Walter Scott, a landowner from Ripe, the next village, became a much-valued visitor to Farleys; Roland saw him as a true countryman and loved his company. But most of our guests came from overseas and, in the early days, the taxi drivers at Newhaven harbour automatically brought any non-English speaking 'arty' types straight to Farleys. The artists Jean Dubuffet and Georges Limbour arrived in this manner at the time of the former's show at the ICA in spring 1955.

Nearly every year, just before Christmas, the ritual of the Bell Ringing Party took place. This was a gathering for the farm staff,

supplemented by the Chiddingly Hand Bell Ringers, our few local friends and any houseguests who happened to be present. Roland would mix a powerful fruit punch and the beer would flow freely. On one occasion Bill Copley, the American Surrealist, dressed himself in strands of ivy and wooed the lasses, claiming to be the Green Man of folklore.

It was expected that everyone should perform a party piece and it became the custom for Roland to write a play for which we would spend days making masks and props. Our repertoire included *The Rat Catchers Caught* and *Brigitte the Horse Cow*, whose udder produced bottled milk and who was accurately portrayed in the visitor's book by the sculptor Kenneth Armitage. Our finest work was a satirical piece poking fun at Lee's fondness for gadgets, titled *The Revenge of The Muddles Master*. A miraculous machine that was capable of producing everything from sausages to a snowfall fell in love with Lee's deep freeze and exacted terrible revenge on the mince pies when deprived of the object of its desire.

The hand-bell ringers would solemnly chime out their repertoire, the log fires blazed, and Roland's arrangements of holly, tinsel and candles, and the food prepared by Lee, Patsy and an army of helpers produced a most welcoming effect. The early parties were soon enough after the war for people to greatly appreciate a good feed and no one allowed the weird paintings to spoil their appetite. But more importantly, there was a genuine feeling of friendship that transcended all differences.

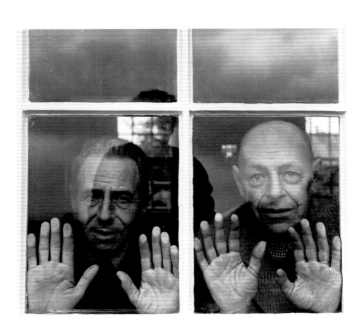

OPPOSITE: *Portrait of Valentine Penrose*, c1928, oil on canvas, by Max Ernst. RIGHT: Georges Limbour and Jean Dubuffet, Farleys House, East Sussex, England 1955' by Lee Miller. Writer Limbour and painter Dubuffet stayed at Farleys House at the time of the opening of Dubuffet's exhibition at the ICA.

THE GOLDEN YEARS

The contact with nature and the seasons is not only just a pleasure, but it seems to give me an understanding of the rhythms of life and the purpose of life. The fact that for instance an oak tree knows somehow to grow oak leaves every year is a mystery that I have never yet understood.

ROLAND PENROSE, 'BORN 1900', BBC TV, 1975

ABOVE: Christmas at Farleys House, at the table from L- R clockwise: Georgina Murray, Bettina McNulty, Roland Penrose, Lee Miller, Henry McNulty, Patsy Murray and Stan Peters, 1961.
RIGHT: Fireplace mural, Dining Room, Farleys House, Sussex, England.
The mural painted by Roland Penrose in 1950 became the protective deity of the house.

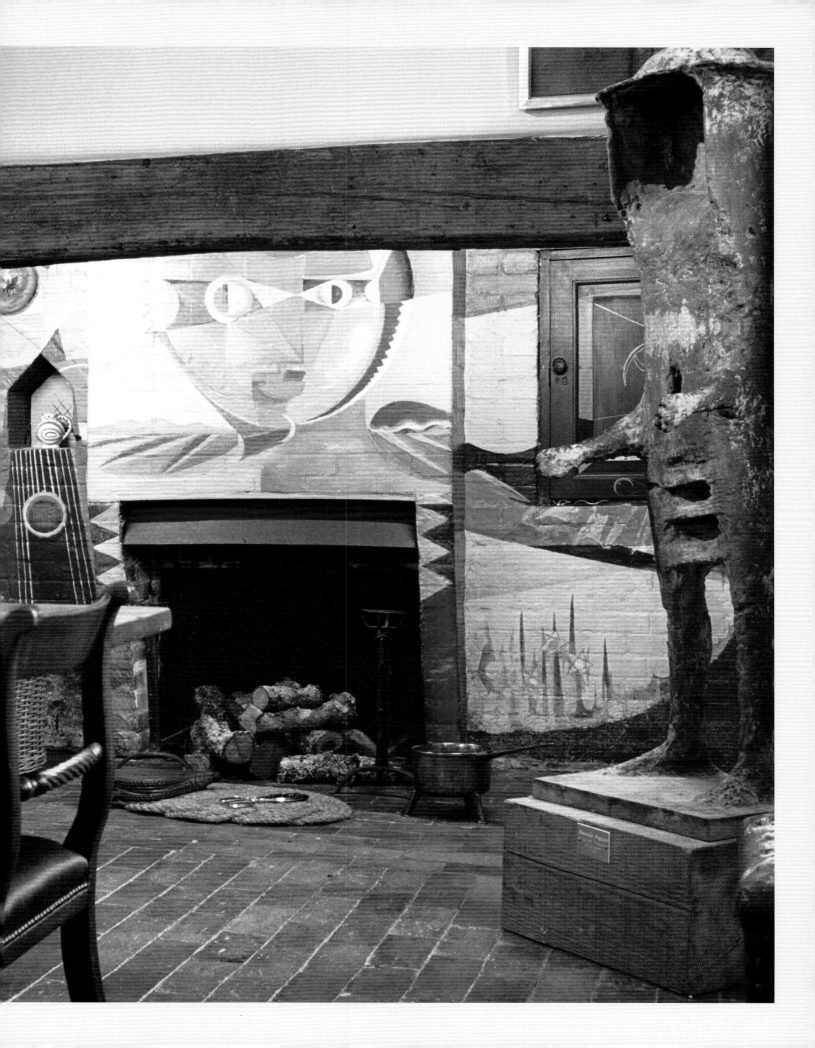

One autumn morning, Roland took me by the hand and led me down the road towards the dairy. I knew today was not going to be about cows. We arrived at the village school, where a girl with blond hair in plaits and kind eyes introduced herself as Shelly. 'Shall we play trains?' she asked. It seemed like a good idea, and with my hands on her waist we joined a long file of children puffing round the playground. 'Do you want to stay here?' asked Roland as we swept past. 'Yes, please,' I called back happily, puzzled why he looked so sad.

I was eight before I found out just how miserable schooling could be, when I was sent off to a boarding school staffed for the most part by hermit-like refugees from the outside world. The comfort and love of Patsy and the animals at Farleys was to be experienced intermittently from here on, interspersed with patches of unremitting bleakness. I found escape by entering a world of daydreams and in a series of illnesses that were real enough. Eventually they took me away, and I lived at Hornton Street while I attended a day school in London. As always it was rough being around Lee, but I could escape to Farleys at weekends, and it was exciting being present during the preparations for the 1960 Picasso retrospective that the Arts Council asked Roland to organize as a guest curator at the Tate.

Whilst Hornton Street was the meeting point for everyone concerned with the show, most of the real preparation took place at Farleys. Joanna Drew, the Arts Council exhibition organizer responsible for all the behind-the-scenes co-ordination, was a frequent visitor, together with Joyce Reeves, Roland's part-time secretary. Joyce was also a highly talented potter and many examples of her slipware dishes were in use at Farleys.

The dining room became their operations room, with the table entirely covered by a diagram of the galleries. Roland meticulously cut squares of graph paper scaled to the dimensions of the paintings, and arranged them on the plan. Then he would open the French doors and go for a stroll in the garden, returning to find the wind had rearranged his hang. This was the least of his problems, as the art historian Douglas Cooper was making mischief, jealous that the Arts Council had given Roland the job. Despite Roland's pleas, he refused to lend from his own collection of Cubist works and did his best to discourage other lenders. Fortunately Roland's reputation was such that few heeded Cooper and nearly all the key loans were secured, but the atmosphere of tension became quite corrosive. Roland assiduously avoided saying bad things about anyone, even including Cooper, for the most part, but I recall him being nearly reduced to tears of frustration when Cooper stated in the press that he had not been asked to lend his pictures.

Picasso was aware of the rivalry between Roland and Cooper, and at times enjoyed fanning the flames. On one occasion he gave Roland a signed copy of a poster that we always knew as the *Smiling Clown* (1951), which Roland immediately hung in the kitchen. I discovered from reading John Richardson's autobiography, *The Sorcerer's Apprentice*, that it was almost certainly a likeness of Cooper. For thirty years, Roland must have been unaware that the image of his arch enemy was leering over his shoulder while he sat at his own table.

The Picasso retrospective at the Tate in June and July 1960 was an outstanding success, visited by more than half a million people. The event established Roland as an organizer of major exhibitions, and the following year he was responsible for bringing the Museum of Modern Art's Max Ernst exhibition to the Tate. Ernst came over for the opening, which was greeted by enthusiastic revues. In the twenty-four years that had elapsed since his show at the Mayor Gallery, the opinion of the official art world had performed an about face. Now Ernst, the most provocative of the Surrealist revolutionaries, was being honoured by the Tate in an exhibition organised by Roland, whose own work had been so disparaged by the Tate's former director.

It is often said that the Surrealist movement died during the war, when the total unreality of war left no room for contrived unreality, but in truth the movement did not die, it metamorphosed. Although now honoured by the establishment it had once fought, Surrealism retained the power to shock, inspire and delight. In 1999, the writer and musician George Melly, who had once worked for Mesens at the London Gallery, stated, 'Surrealism is no more dead than a dead flower containing seeds'. Even a cursory glance at contemporary art, film making and advertising is enough to reassure us that those seeds are still germinating vigorously.

Ernst visited my workshop at Farleys, situated at the bottom of the garden in an old showman's caravan that Roland had bought for me. Seizing a battered brush and some dried up oil paint I had looted from Roland's studio, he painted two dancing bird figures on a piece of white board, signing it *Toni, Max*.

The next big show selected by Roland for the Tate was the Miró retrospective of 1964. A family tragedy prevented Miró from attending the June opening, and it was mid September before he arrived in London. He accepted the adulation that greeted him with complete modesty and courtesy, but it was clear that the festivities were a strain. He seemed more than anything to value quiet moments in the garden at Farleys, sitting with his wife, Pilar, and admiring the flowers and the distant view of the Downs with a contented smile. No, he did not want to walk in the woods or visit the Long Man of Wilmington; the flowers were enough. He had recently produced two magnificent boxed sets of lithographs titled *A Few Flowers For Some Friends* and *I Work Like A Gardener*, offering an illustrated journey through the mystic secrets of flowers and small creatures. Roland had acquired copies of both, which Miró signed with an affectionate dedication. Before leaving, Miró and his ceramicist collaborator, Artigas, between them filled a double page in the visitor's book with drawings.

Roland's last big show at the Tate was the Picasso sculpture exhibition of 1967. He and Joanna Drew worked their usual miracles, not the least of their difficulties being to persuade Picasso to lend the sculptures, most of which had never left his studios. But once he had agreed to let them go to Paris, Roland was able to coax him to let them continue to London and finally to the MOMA in New York.

Roland had become a sort of unofficial British ambassador to the court of Picasso, who was now living in Notre Dame de Vie, his large and secluded house near Mougins. He successfully interceded on behalf of the Tate for the purchase of the *Three Dancers*, and on behalf of a firm of architects for Picasso to design the huge sculpture sited outside the Chicago Civic Centre. Lee frequently accompanied him on these missions, which could be quite tense at times. Picasso would forcefully complain that they used to have fun on the beach, but now it was just one demand after another. Sometimes out of capriciousness he would refuse to see Roland, who would wait interminably in his nearby hotel for a telephone call that might or might not come.

Not every visit to Picasso was fraught. Roland told me how in 1963 he arrived at Notre Dame de Vie to find Picasso in the shower with a large sheet of paper. He watched Picasso as he crouched on the floor brushing Indian ink over the paper and then turned on the shower. After a moment he cried, 'Quick, grab this by the corners', and with Roland's help he lifted the paper and hung it on a washing line. As if by magic, a line drawing of a bearded man copulating with a woman appeared. Picasso had used a linocut to print the page with water-resistant white ink, and the Indian ink had only taken where the paper was bare. They continued to ink and wash the rest of the pile of prints, and as Roland left that evening, Picasso gave him a signed and dedicated copy. 'They look like they are having a good time', said Roland, eyeing the figures.

ABOVE: Roland, London, England, c1960.

'Who knows?' replied Picasso. Later the ambiguity was confirmed when he titled the work *The Rape* (1963). On another occasion, Picasso simply handed him the oil painting *Head of a Woman* (1962) as a gift, with a similar painting to sell for the ICA's funds.

Roland usually had the resilience to cope with the love-hate relationships of his Surrealist friends, but there was one incident that left everyone bruised. Roland and Lee's friendship with both Dora Maar and Françoise Gilot lasted beyond the period of their relationships with Picasso, and both women visited Farleys on several separate occasions. Works by Maar and Gilot hung on the walls until one day in 1964, when Roland took down all Gilot's works and hid them away. The cause was the publication of her book *My Life With Picasso*. Today it is seen as an important contribution to the understanding of Picasso's life and his creative process, but at the time it offended Picasso deeply. Roland unflinchingly condemned Gilot. I found this bewildering, as I recalled her kindness to me as a child, and it was so unlike Roland to turn on a friend, particularly a beautiful and talented woman.

Picasso had unknowingly been responsible for a major new development in Roland's career. In 1954, Roland had been approached by the publisher Victor Gollancz, and asked to write a biography of Picasso. Terry O'Brien recalled in his diaries that at first Roland was fearful of the task: 'They talk about a hundred thousand words!' he said, 'I've never written that number in all my life.' After encouragement from Lee and the O'Briens, he hurried to Collioure on the French Mediterranean coast, where Picasso was on holiday, to ask if he would agree to co-operate. His old friend was emphatic in his support, and for the next four years Roland made many research visits to the places in Spain and France where Picasso had lived, and to interview him in Notre Dame de Vie. Lee often went too, camera in hand, and a selection of her photographs formed part of the ICA exhibition *Portrait of Picasso* and illustrated the book of the same title that Roland published in celebration of Picasso's 75th Birthday in 1956.

ABOVE TOP: Picasso and Roland speaking French, Villa la Californie, Cannes, France, 1956, by Lee Miller.
ABOVE BOTTOM: Editions of biographies of artists such as Picasso, 1958 and Miró, 1970 written by Roland Penrose, appearing on his bookshelf, in Roland's study formerly Antony's bedroom at Farleys House.
OPPOSITE: Roland's desk in the room that was formerly Antony's bedroom. *Portrait of Valentine*, c1936, oil on canvas, by Wolfgang Paalen hangs above the desk and expresses the pathos of her life at the time of her seperation from Roland.

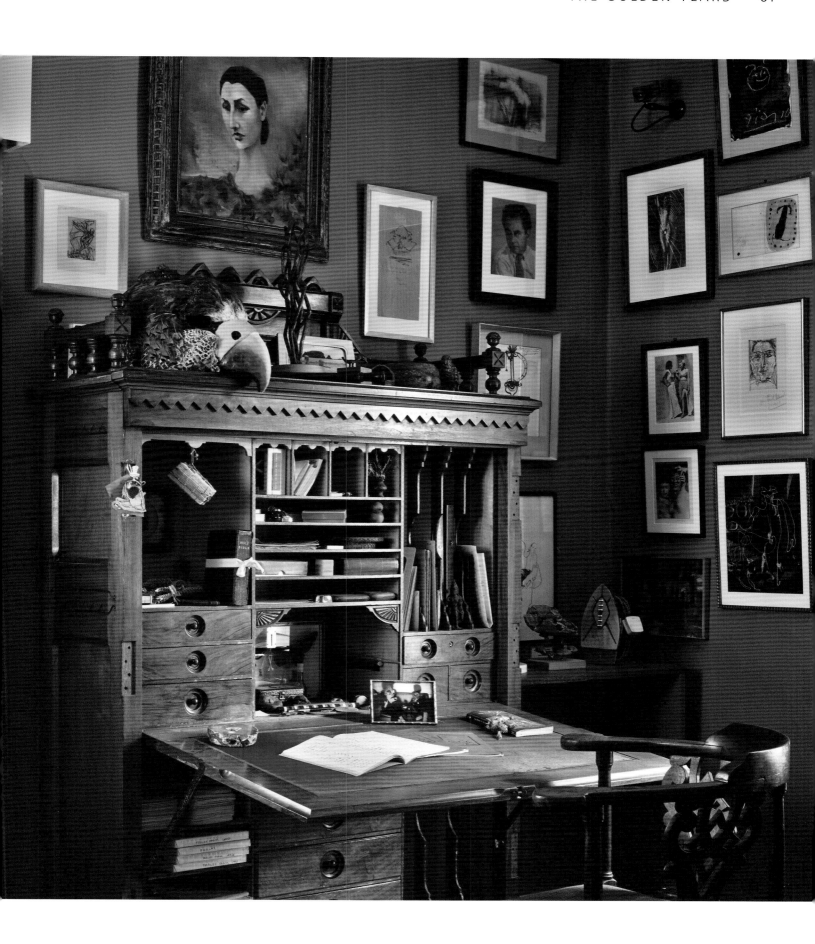

Being essentially sociable, Roland found the loneliness of writing quite crushing. Sometimes he avoided the distractions of London by staying at Farleys during the week. His study was beside my bedroom, and I was always conscious of his iron-willed concentration as he sat for hours on an uncomfortable chair, laboriously covering page after page in longhand. The smell of his French *Voltigeur* cigars would emanate from the study, a signal to give the place a wide berth, as he was politely intolerant of interruptions. Every afternoon he would break at 3pm to take Heather for a walk, whatever the weather. On his return, Patsy would bring him his ritual two wholemeal biscuits and cup of Earl Grey tea, fragrant with lemon and bergamot. In the evening after dinner he would work on into the night, with a large glass of whisky and soda beside him. The scrape of his chair, the rattle of the doors on the glass-fronted bookcase and the thump of another reference book on the desk would gently register in my consciousness as I drifted off to sleep.

Roland stuck to it heroically. As soon as Joyce Reeves had typed the manuscript, he would fill the spaces between the lines with more handwriting. Joyce and Terry O'Brien, both established novelists, helped Roland to find a more fluent style. They could not persuade him to include his own direct experience of Picasso, nor to overcome his natural discretion and respect to include anything beyond the bare facts of Picasso's personal life, but the man's work is discussed with great penetration and flair. Roland, being a painter himself, had a unique insight into Picasso's art, and he shares his deep love for it with the reader with a marked humility. Roland was no academic intellectual in the style of Cooper or Read, but he had a great ability to communicate his passion for and understanding of Picasso's work.

ABOVE LEFT: *Kidderminster*, 1937, by Roland was constructed from a carpenter's mitre block, top of walking stick, steel wall tie and vertebra of large marine mammal.
ABOVE RIGHT: *L'acte Gratuit*, 1980 (an act with no reason) Roland's work refers to a time when hip problems forced him to rely on taxis, seen supporting the four corners of his world.
RIGHT: In Roland's study the artworks L-R: *Untitled*, date unknown, coloured engraving, by Max Ernst; *Door of Humility, Church of the Nativity, Bethlehem, Palestine*, 1937, by Lee Miller; *The Pleasure Principle*, 1970, oil on canvas, by Conroy Maddox; *Daphne Gives Birth or Swallows a Tree*, 1973, mixed media, by Penny Slinger; *Untitled Collage*, c1982, mixed media, by Roy Edwards and *Untitled (Still Life with Glass of Wine and Bread)*, undated, mixed media, by Dora Maar hang above Roland's surrealist collection of smaller objects.

Picasso, His Life and Work was published in 1958 to strong critical acclaim. It was translated into many languages and remains in print to this day. Roland followed the book with a monograph on Miró in 1970, on Man Ray in 1975, on the Catalan painter Antoni Tàpies in 1978, and his own autobiography *Scrap Book* 1981, all of which achieved excellent reviews.

By contrast, Lee's photography had slowed to a virtual halt by the late 1950s, with only occasional photographs of artist friends like Tàpies marking the later years. Instead she flung herself into cooking, and made it into her own art form. The dishes she invented owed much to Surrealism – we had blue spaghetti, green chicken, gold meat loaf resplendent on a crimson plate, pink breasts made of cauliflower with bright blue borage flowers for nipples. Roland enjoyed laying the table and decorating it with flowers he picked from the garden or little curios brought back from his travels. Many visitors contributed their own speciality. The Italian painter Renato Guttuso demonstrated with finesse various pasta dishes. The architect Wells Coates was an aficionado of Chinese cooking, and for my benefit produced a bird's nest soup: a bowl of minestrone containing a nest made of twisted hay, complete with a clutch of bright orange eggs whittled from carrot.

In fine weather the lunch table would be laid outdoors on whichever side of the house seemed the most agreeable. The brick courtyard beside the back door was a good suntrap but prone to interruptions. A favourite spot was on the flagstone terrace outside the parlour or, if it was very hot, beside the lily pond Roland had created in front of the kitchen windows.

Indoors the usual family gatherings were held round the kitchen table, but larger numbers prompted the use of the dining room. The big pine refectory table was specially made and years of wax polishing gave the wood a soft lustre. It provided a strong counterpoint to the elegant chairs with their horse hair seats that came from Peckover House in Wisbech, the home of Roland's grandfather. It is interesting to think how grandfather Peckover would have viewed the intimate dinners with Roland and Lee's closest friends, where the women sat bare-breasted in the candlelight.

The sideboard and dresser was one of few provincial pieces that Roland brought over from France. Its shelves still hold an accretion of ceramics and other objects built up over the years. Picasso bullfight plates form the background to a row of kitsch

LEFT TOP: Lee Miller dehusking corn, Farleys Garden, East Sussex, England c1960' by Roland Penrose.
LEFT BOTTOM: Renato Guttuso, Farleys House, East Sussex, England 1950' by Lee Miller.

classical nudes, bought by Lee for Roland as a jesting acknowledgment of his love of women. The stoneware mugs, made by Joyce, held Roland's lunchtime drink of Guinness, and each bears the name of one of his favourite painters. The list is eclectic; each painter chosen for qualities Roland particularly admired: Goya for his pathos and passion; Uccello for his understanding of geometry and abstraction; Poussin for his romantic pageantry; Gauguin for the seductive voluptuousness of his Polynesian work; Blake, whose book illustrations first awakened Roland's imagination, for his mastery of romantic fantasy; and of course Picasso, who had all of the above. A huge wooden Polynesian ladle hung on the end of the dresser, and Roland teasingly convinced me it was the one that the cannibals of the South Sea Islands used for dishing out their missionary soup.

The yellow cover of *Farmers Weekly* inspired the colour of the walls, which in this north facing room created a constant suggestion of sunshine. In 1950, perhaps furthering this theme, Roland painted a mural on the inglenook fireplace. He had done a number of preparatory sketches, but when he came to paint he worked so fast and with such ease that those who watched him knew he had the exact image already in his mind. The sun, with his horns a definite masculine presence, is appropriately painted on the chimney breast above the fireplace, the expected source of warmth. He beams towards us not altogether benignly, a reminder that the sun can be a scourge as well as a blessing. The background hillside represents the South Downs, but the Long Man is not to be seen in his usual place. This is perhaps because he is personified by the sun, which would be appropriate as the Long Man is a solstice marker. Roland had been delighted to discover that at midday on midsummer's day the sun, seen from Farleys, is directly over the Long Man's head, and at midnight on midwinter's night, the mighty giant in the constellation of Orion hangs above him. On the left of the fireplace, the planets silently spin through space, and to the right a beautiful, feminine moon flirts with us as if through a window. In the niches on either side of the inglenook, female figures, each with a cornucopia for her body, portray fertility and abundance, the outcome of the fortuitous conjunction of the sun, moon and planets that is earnestly desired by all farmers. Roland had created our own household god to protect us from misfortune.

RIGHT TOP: Pink cauliflower breasts and other creations feature in the layout of Lee's food at Farleys House.
RIGHT BOTTOM: Lee's recipes at Farleys Garden photographed by Lance Downie.

LEFT: A sideboard that Roland brought from France stands in the corner of Farleys House Dining Room. Roland claimed the Oceanic ladle hanging on the end was used by cannibals to serve missionary stew. A Picasso bullring plate from the Madoura Pottery c1963 stands on the top shelf, flanked by rows of Kitsch nudes bought by Lee to tease Roland.

RIGHT TOP: Dining Room sideboard, Farleys House, Sussex, England.

RIGHT BOTTOM: A grade soceity figure from Ambrin Island, New Hebrides is shown in the Hall, Farleys House, Sussex, England

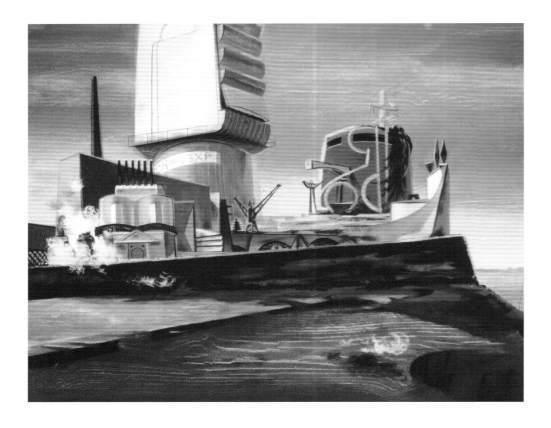

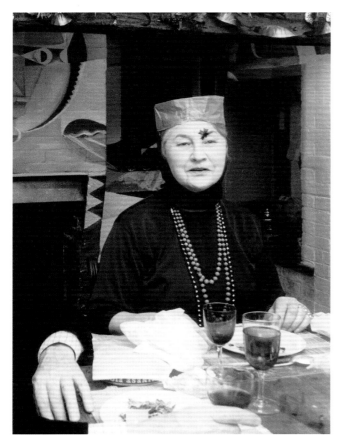

ABOVE: *CH3 OXHP*, c1932, oil on canvas, by Roland Penrose.
LEFT: Valentine Penrose at Christmas Dinner 1964. The star on her forehead covered a blister caused by an attack of shingles. Farleys House, Sussex, England by Lee Miller
RIGHT: The dining room fireplace at Farleys House depicting Roland's theme of the solar system with its silently rotating planets and a moon peeping in through a window (on the right) which is in fact a cupboard door.

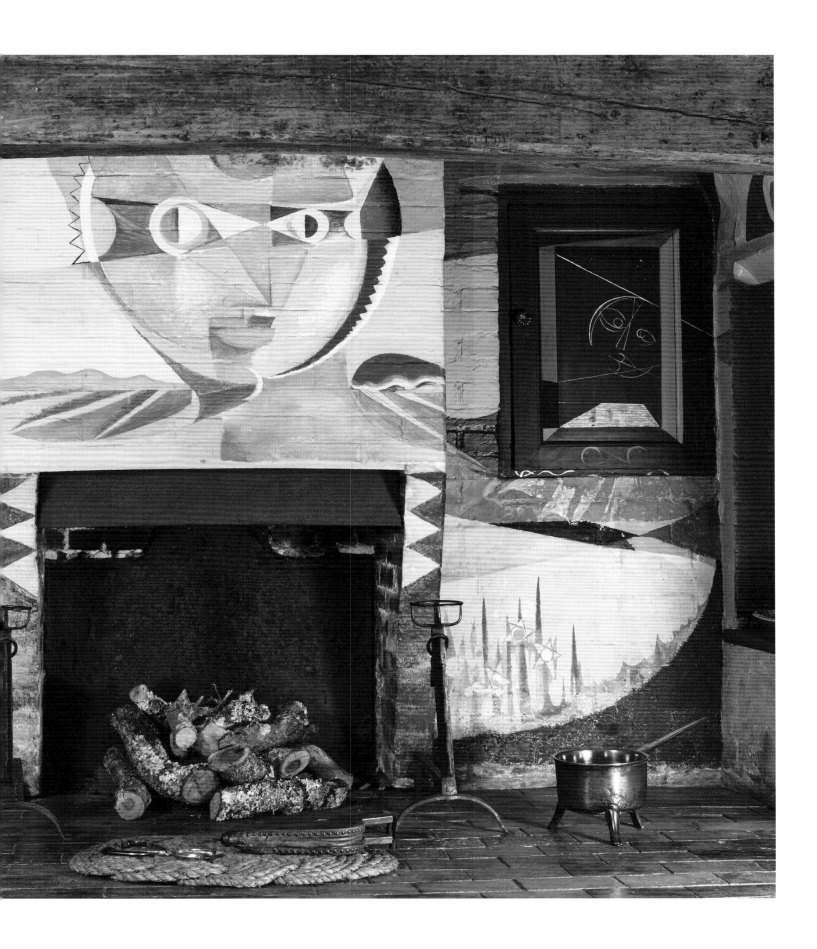

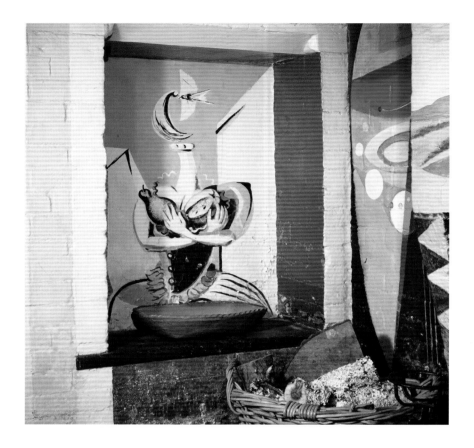

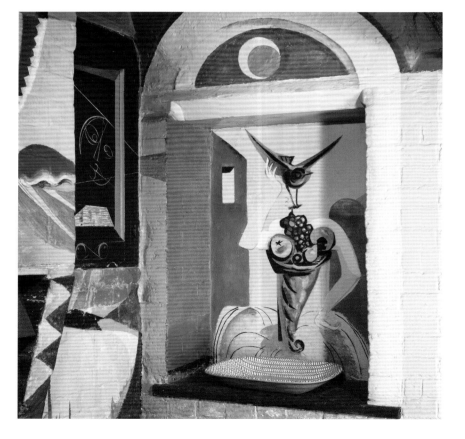

LEFT TOP AND BOTTOM: The two cornucopia figures either side of the fire place refer to the abundance that a fortuitous alignment of the sun, moon and planets brings to farming.

ABOVE: The bookplate Roland Penrose made for Lee's cookery library shows the midnight position of the constellation of Orion on midwinter's night and the midday position of the sun on midsummer's day above the Long Man as seen from Farleys House. The design reflects the theme Roland first explored in his panorama of the solar system in the dining room fireplace, with its silently rotating planets (opposite) and a sexy moon peeping in through a window, which is in fact a cupboard door (left below). On either side of the fireplace cornucopia figures (top left) refer to the abundance that a fortuitous alignment of the sun, moon and planets brings to farming.

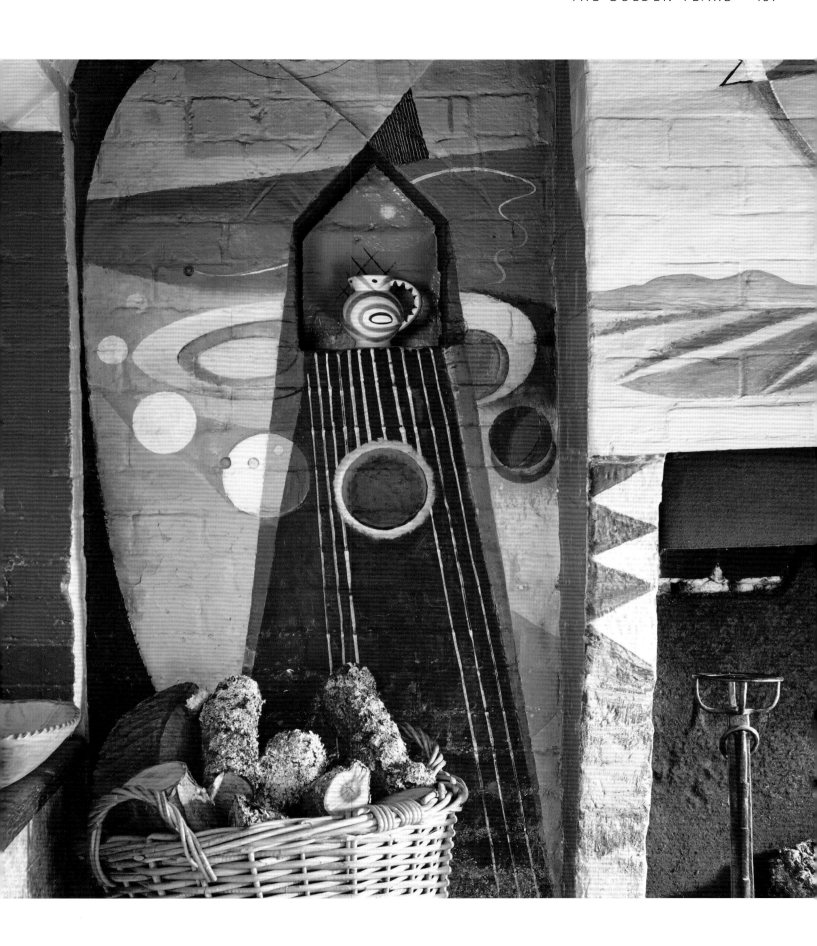

For the walls of the main hallways, Roland chose a sky blue – Roland's blue, as we called it, a tone that could be found recurring in his painting. He mixed the pigments himself, endlessly drying samples of wallpaper over the stove. Despite its brightness the blue set off the paintings amazingly well and gave otherwise dark areas a light, airy feel. The exception was the passageway to the kitchen, which Roland painted a dark brick red. With the worn brick floor, the colour created an intimate womb-like impression that on entering the passage made the distant brightness of the kitchen seem all the more inviting.

Few people arrived at the front door, which in some ways was a pity. Roland had a large porch constructed that became home to *Tonga Roa*, a Polynesian sea god from Rurutu Island, represented in the act of creating gods and men. Roland had obtained two plaster casts of the sculpture from the British Museum at the time of the 1953 ICA exhibition titled The Wonder and Horror of the Human Head. He gave one to Picasso, the other remains at Farleys.

BELOW: The façade of Farleys House seen from the road holds no hint of the strange objects lurking immediately behind the door in the front hall.
RIGHT: Inside the front door with the design by Roland at Farleys House, showing *Girl without a Face*, c1958, by Kenneth Armitage.

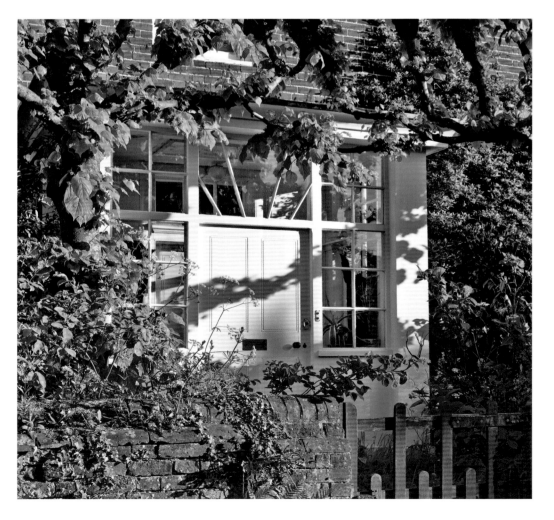

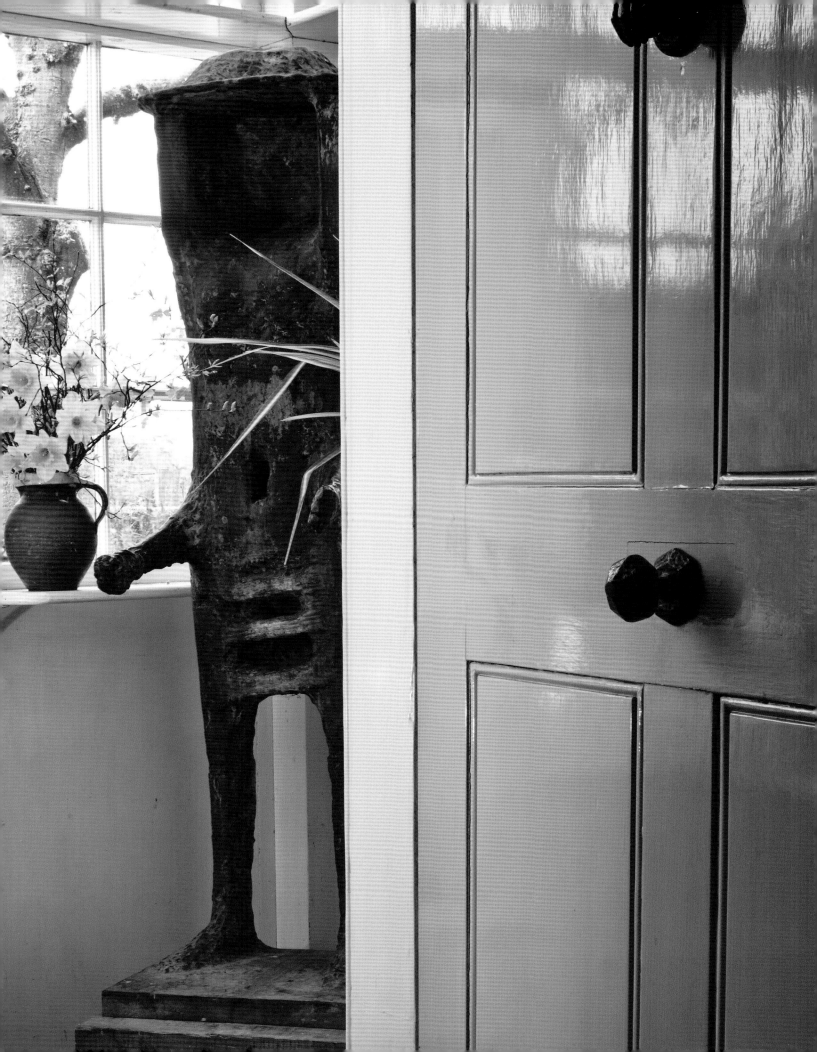

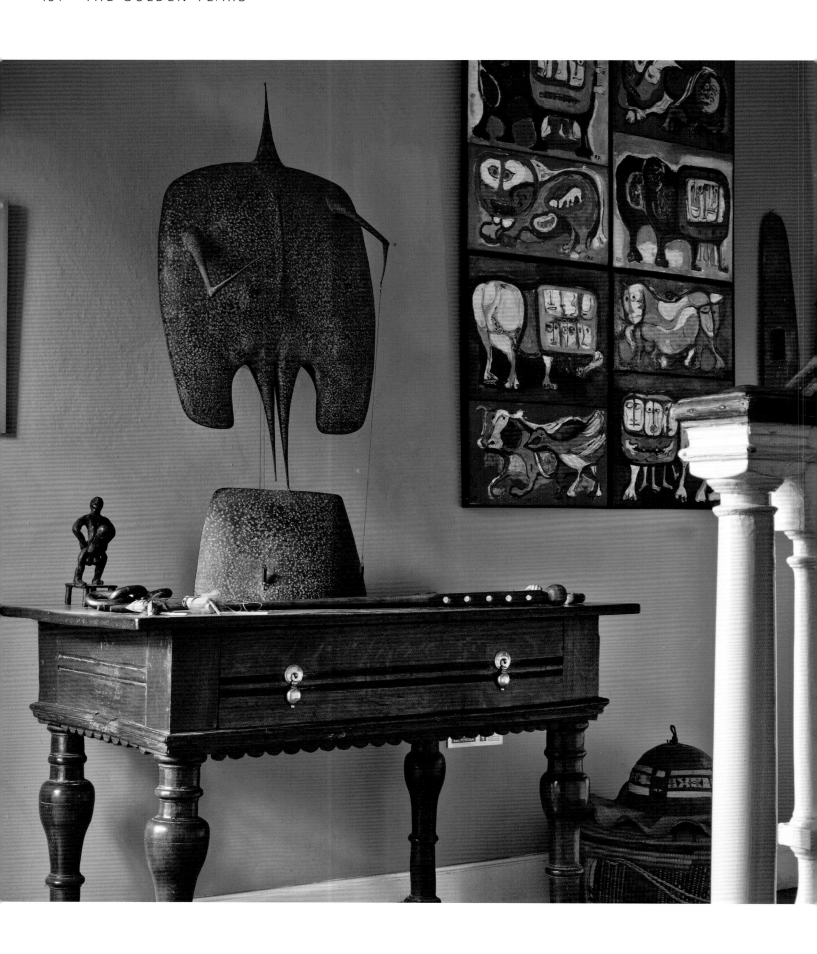

OPPOSITE: Front Hall, Farleys House, Sussex, England.
RIGHT TOP: The Collectors cabinet is housed in the passage presided over by an ancestral wooden plaque from Papua New Guinea.
RIGHT BOTTOM: It is the curiosity value of items such as the mumified rat that earns them their place in the collector's cabinet in the passage. Curios include a pottery chicken from Honduras, a Hopi Indian doll from Arizona, Bakota reliquary from Africa and a dead May-bug.

ABOVE: The groundfloor passage shows a number of ethnographic works from Africa, Pacific North West and Asia. Surrealists loved the different ways of seeing embodied in these works.

LEFT: *Roll and Pen Rose*, painted steel, by Julian Opie, a rebus of Roland's name, was a gift from the ICA on his eightieth birthday.

RIGHT: A life cast of Lee's torso, by Paul Hamann, sits on the sideboard below her portrait *Flight of Time*, 1949, oil on canvas, by Roland Penrose.

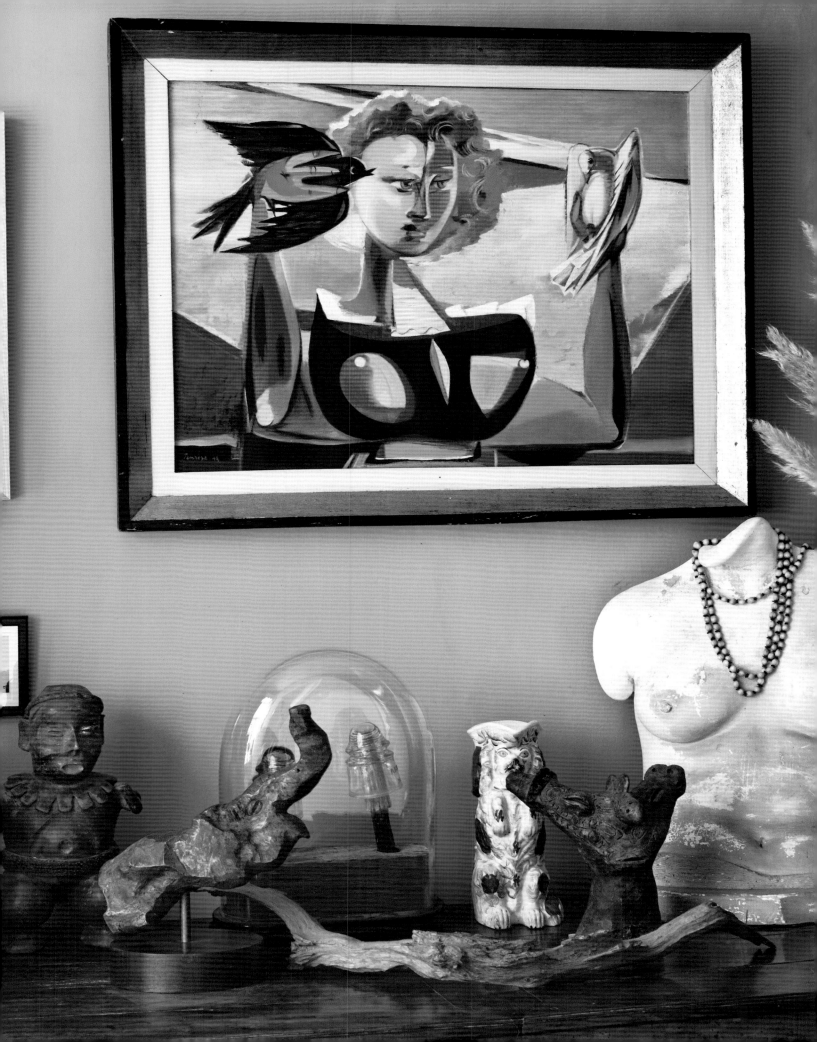

Visitors usually came to the back door, which opened into the old kitchen. The solid door had served for many years and needed the protection of the porch Roland built, which also housed a vast collection of coats, boots and Roland's sabots, bought in France. He used to slip them on to go out into the garden to cut flowers or simply 'take the air'. They made a pleasant clonking noise on the bricks, not unlike Gypsy's hooves.

The old kitchen housed Lee's vast deepfreezes. As the fire smoked badly, the room was generally considered too cold and uncomfortable for use except for the Bell Ringing party. In later years we installed a wood-burning stove and instantly the room became alive, a pleasant place for lunch or dinner.

Over the old kitchen fireplace was hung a vast wooden model of a cock salmon in the spawning season, which Roland enlivened one Christmas with spots of gold paper. One side of the door to the house was flanked by a row of stuffed owls perched above one of Yanko Varda's mirror mosaics, and the other by a ship's figurehead, who we called Iris. Visiting his brother Beacus in Cornwall shortly before the war, Roland found her in a ship breaker's yard in Falmouth. She came to stand outside the back door and several visitors who had dined well mistakenly greeted her. Roland told me she portrayed a Greek woman who had been brought before the magistrates charged with immoral conduct. Her defence was to bare her breast, and the magistrates unanimously acquitted her, on the grounds that no woman of such pure beauty could possibly be immoral. He pointed out that she stands with her breast bared, and a small scroll in her hand proclaiming her innocence. We now know that the ship that bore her was the HMS Evrotas, named after the Evrotas River which runs through Sparta and is also known as the Iris, which may give us a link to the Greek goddess Iris, the patroness of the rainbow and of communication. She was able to change her form and gender, and was revered by farmers, and in ancient sculptures she is usually shown with a bare breast and a scroll of messages. When Roland found Iris, the sun had reduced the red paint of her lips and toenails to blue, and he retained this colour in his restoration. Lee was so intrigued that she started wearing blue nail polish on her toes.

LEFT: The figure head comes from the ship Evrotas and was painted by Roland Penrose having bought her in Brighton c1945.
OPPOSITE: A wooden model of a salmon hangs over a pewter plate above the old kitchen fireplace.

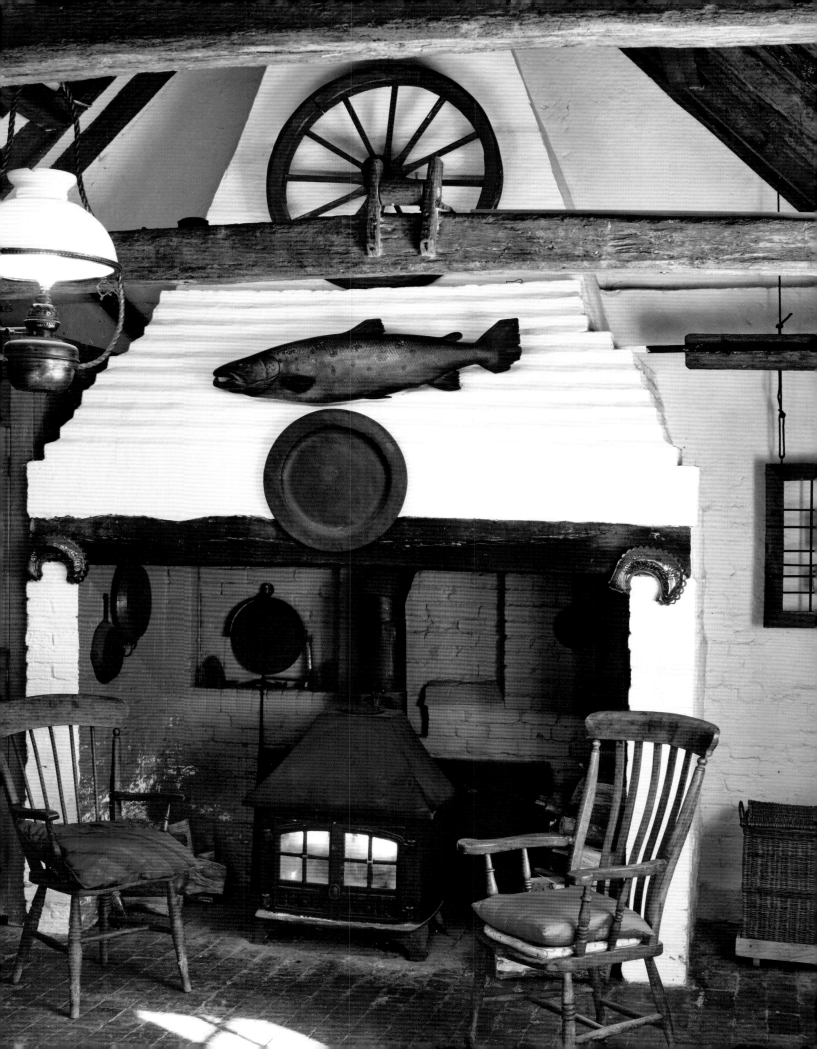

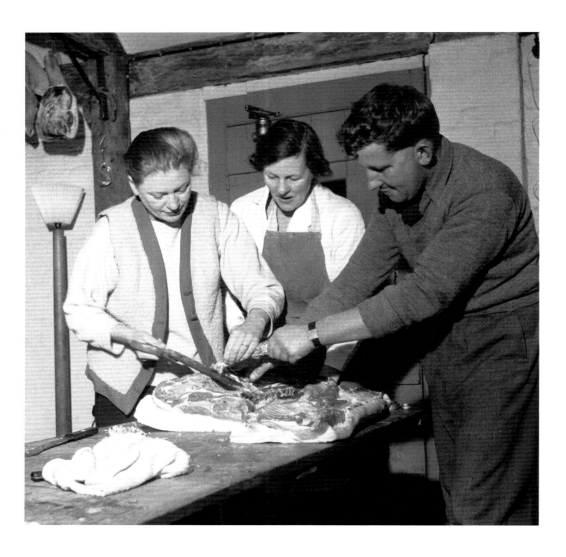

ABOVE: Lee Miller learning to cure bacon with Unknown and Peter Braden at Farleys House.
LEFT: Roland touching up the figurehead's paintwork in the days when she stood outside the back door, c1954, by Lee Miller.
RIGHT: *Cinque Femmes*, 1931, by Yanko Varda, a mosaic of mirrors set in cement hangs in the old kitchen below an array of stuffed owls collected from junk shops.

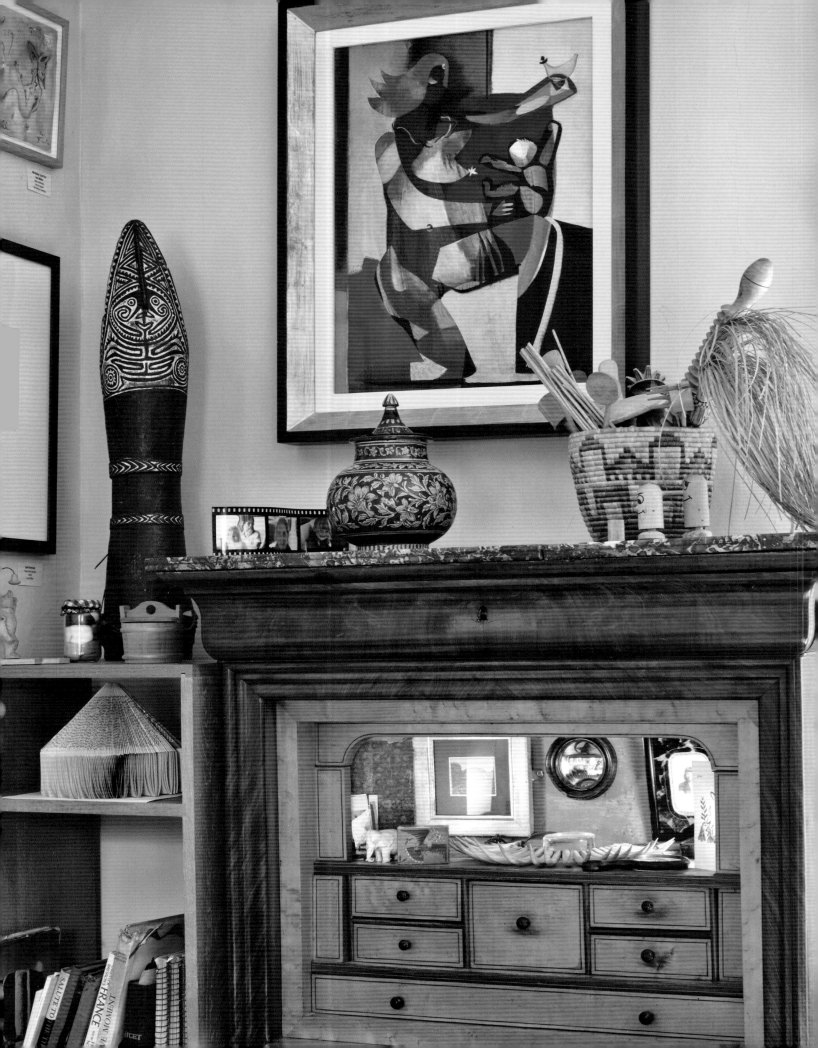

The back stairs were humbly constructed in oak, blackened with age and rendered creaky by the efforts of millions of woodworm. They led to 'our' quarters above the kitchen and dining room. Here Patsy and I had our rooms, as did Patsy's daughter Georgina, who came to live with us in 1961. The exception in this enclave was Roland's very small study, next to my room.

Soon after I was born, Roland painted a series of nursery pictures for me. One was a tree with branches populated by cats, one was a portrait of his favourite tabby Mrs De Valera (named after the wife of the president of Eire), and another was a dog whose intense pleasure with the bone at his feet had caused his tail to wag so vigorously it became a blur. A huge jolly face by the painter Sandra Blow hung on one wall, and a great favourite of mine was a large scene of Cassis port painted by a naïve painter, Maurice Vial. Mixed among the jumble of model aeroplanes was a tiny mobile by Alexander Calder, and a little sketch of dancers and a centaur drawn for me by Picasso was unceremoniously pinned to the wall.

For my curtains Lee used blue sail canvas, which was not subject to rationing. The walls were a pale 'Roland' blue, and half the floor was covered with red cord carpet, the remainder being blue lino with white streaks, a perfect sea for my Noah's ark. The big walk-in cupboard was a dangerous place, as at night goblins would sometimes come creeping out, but I knew they couldn't get me when I was protected by my long-suffering cat Matilda, who slept on my bed. Even the most extreme paintings were never as frightening as the goblins.

Second only to the kitchen, the sitting room was a centre of activity. To provide a break from his tiny study, Roland had a French writing desk with a drop-down front, which he used for his correspondence. He placed concealed lighting inside the bookshelf, giving it the appearance of a little theatre. There, in perfect scale, hung the miniature Max Ernst *Microbe Seen by the Naked Eye* (1946), and a photograph in a Victorian tortoiseshell frame of Valentine as a young woman, surrounded by *objets trouvés*.

In the opposite corner was Lee's desk, which to this day exudes the aroma of the cedar from which it is made. Lee's work became an endless reading of cookery books and accumulating of recipes clipped from magazines. 'How do you call this work, this tearing up of magazines and then going to sleep on them?' Valentine would snort, but it was important to Lee to find new ways of pleasing her guests. After decades of being buried under clippings and books, Roland relented and had a study built for Lee. Here she accumulated so many cookery books that on her death they formed a nearly complete library for Westminster Kingsway College to which Roland donated them.

In summer the French doors of the sitting room would be opened into the courtyard, where everyone would sit with a drink in the evenings. The ill-matched and frayed furniture, all second-hand, was chosen with little sense for creating a cohesive décor. A Spanish wicker rocking chair, with bright felt cushions, stood beside the velvet button-back chair that belonged to Aunt Algerina. The central table, a disc of polished marble, was supported on legs made by Grandpa White out of rough timber salvaged from a redundant building. Comfort was important, and two large sofas offered space for sprawling.

OPPOSITE: Inside the desk to the right hangs a photograph of Valentine as a young woman. A Fijian necklace made from *tabua* which is the tooth of a sperm whale lies in the foreground.
RIGHT: Roland at his desk in the sitting room c1954 making a design with rubber stamps for Antony and his friend, by Lee Miller.

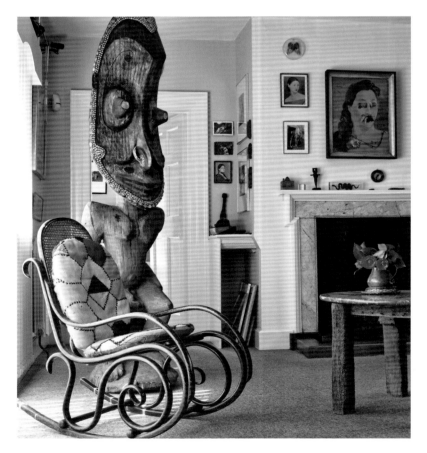

LEFT: Joan Miro signing the visitor's book at Farleys House, Sussex, England 1964' by Antony Penrose.

BOTTOM LEFT: Living Room, Farleys House, Sussex, England.

BOTTOM RIGHT: *First View*, 1947, oil on canvas, by Roland Penrose hanging above the sofa in the living room.

OPPOSITE: The visitors' book lies open on the coffee table in the living room.

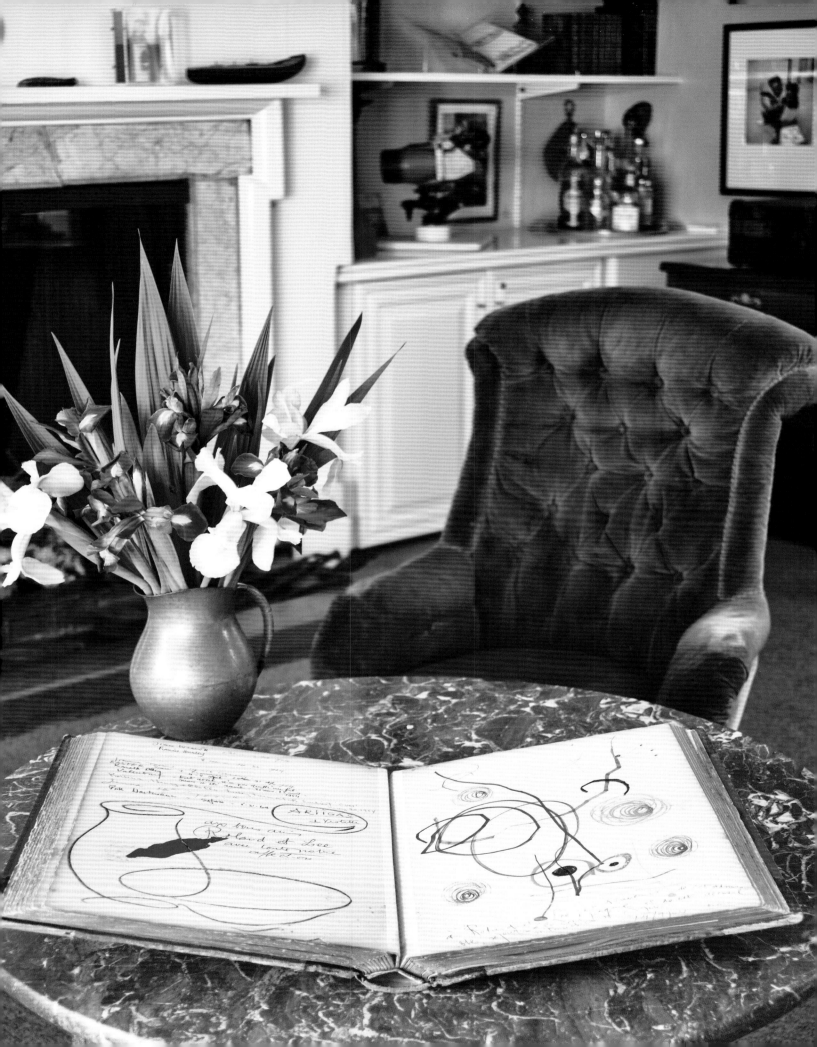

LEFT: Lee's desk in her library, built to house her growing number of cook books.
RIGHT TOP: Lee's cook books and cooking utensils in her library, Farleys House, Sussex, England.
RIGHT BOTTOM: The fireplace remains unfinished as Lee preferred it, in her library at Farleys House.

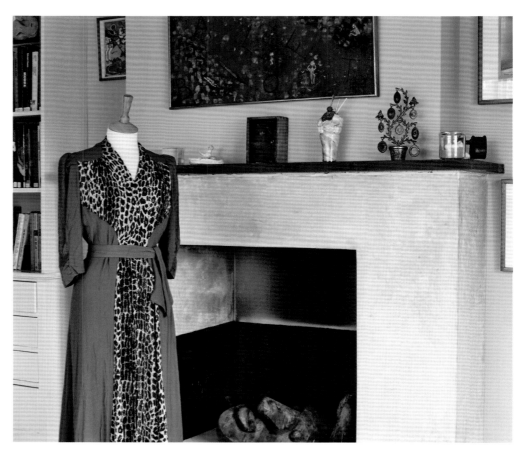

Friendly arguments were a feature of any gathering. Lee's agile mind allowed her to hold her own with Professor Freddy Ayer, the philosopher, or Professor Richard Gregory, who collaborated with Roland on the 1973 Illusion exhibition at the ICA. Sonia Orwell, George Orwell's widow, would become combative with the literary critic Cyril Conolly, known for his equal measures of intellect and rudeness. Guests returning from exotic parts of the world were especially welcome. I recall waking in the early hours of the morning to find the house literally rocking as Frank McEwen, the director of the National Gallery of Rhodesia, coached everyone in African drum and xylophone music. Artists, poets, anthropologists, medical specialists, museum directors, writers, actors and publishers gathered in an amiable mélange, refereed by Roland. He had a talent for making people feel at ease and usually managed to divert arguments that were getting too heated.

In a hot summer, the privacy and liberal atmosphere at Farleys would prompt visitors to peel off their clothes. The sculptor, Lynn Chadwick, bared all as he sharpened Lee's kitchen knives seated under a cherry tree, and Yen, the Tahitian wife of the French sculptor Philippe Hiquily, became a Gauguinesqe beauty, able to hide all behind her long hair if necessary.

Naked artists were not the only occupants of the garden, which Roland had steadily filled with sculptures. Henry Moore's *Mother and Child* (1937), which had caused a scandal before the war when Roland installed her outside Downshire Hill, stood comfortably on the lawn in front of the sitting room. Many years later, Roland was delighted to discover he had sited her beside a ley line connecting to the Long Man – Moore's mystic celebration of woman was appropriately linked to the archetypal figure of male fertility. Those who compare the Long Man's masculinity unfavourably to that of the Cerne Giant in Dorset could consider that the Long Man might be facing the hill, in which case the contours on which he is drawn suggest he is spread-eagled across a woman's pudendum on a vast scale.

Other female forms abounded in the garden. The warm maternal sense of FE McWilliam's *Woman and Baby* (1938) was pleasantly countered by his sensual *Kneeling Woman* (1947). She had stopped the traffic on Oxford Street during the 4,000 Years of Modern Art

LEFT TOP: Sculptor Phillipe Hiquily and his wife Yen, Farleys Garden, Sussex, England 1956' by Lee Miller.
LEFT BOTTOM: The sculptor Lyn Chadwick sharpening Lee's kitchen knives, Farleys Garden, Sussex, England 1956' by Lee Miller.

exhibition and caused the police to issue Roland with a summons for obstruction, and now stood peacefully in a bower of apple trees. Roland had probably met Kenneth Armitage's bronze *Girl Without a Face* (1959) when, as Fine Arts officer for the British Council in Paris, he had been responsible for Armitage's show there. The shy feminine sculpture came to live at the far end of the top lawn beside a gnarled oak much loved by Valentine. Next to the pond in front of the kitchen, William Turnbull's bronze *War Goddess* (1956) was an assertive presence, in contrast to the large marble figure of a woman in Greek classical style that Roland had bought from the sale of sculpture that once adorned the Crystal Palace in London.

Turnbull's *Weather Vane* (1952) surmounted the dovecote on the roof of the cart shed, which housed a flock of tumbler pigeons, but it was left to Michael Werner's *Fallen Giant* (c.1965) to contribute a major male presence, albeit a prone and shattered one. Apart from the delightful Germaine Richier *Bird Man* (c.1948) flexing his wings above the back door, the other male figures were in equally dire straits. In the vegetable garden, Nadine Effront's bronze memorial bust of the painter Oscar Dominguez stared with bulging eyes and huge nose from its base on an old tree stump. Dominquez, depicted with devil's horns, had been the *enfant terrible* of the Paris art scene, towards the end of his life stealing paintings from his friend and benefactor Marie-Laure de Noailles and replacing them with fakes he had painted. One summer's day the stump spontaneously caught fire and we were convinced Dominguez was up to more mischief.

A latecomer to the sculpture population of the garden was Sylvester Mubayi's *Magic Stallion* (c.1970). Roland had fallen in love with the deep sensitivity of this part-man, part-animal piece when he saw it at the Shona Sculptors of Rhodesia exhibition, organized by Frank McEwen at the ICA in 1972. Roland sited *Magic Stallion* on the lawn, where his wistful gaze over the Downs suggests his thoughts are of his homeland, half the world away beyond the hills.

Thanks to the dedication of Fred Baker, the surroundings of these characters had metamorphosed into a blend of controlled wildness and riotous formality. The annual bedding plants were chosen for a spectacular mix of colours, like an ostentatious crowd come to cheer on the summer, while the perennials that bordered the top lawn were stately old friends, good for flower arrangements. Between the top lawn and the orchard,

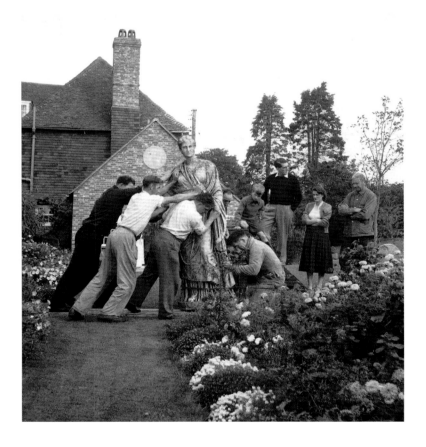

RIGHT TOP: Henry Moore positioning his sculpture *Mother and Child*, 1937, Hopton Wood Stone, 1952, by Lee Miller.

RIGHT BOTTOM: Fred Baker (centre left) assists the arrival of the neo-classical sculpture from the Crystal Palace, watched by Antony, Roland and Patsy, 1955, by Lee Miller.

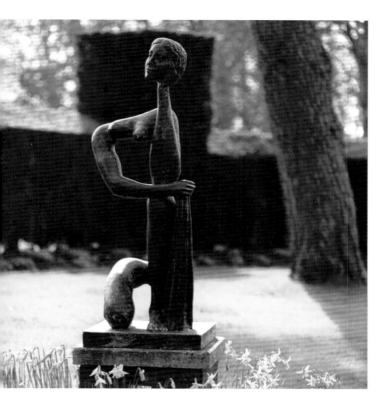

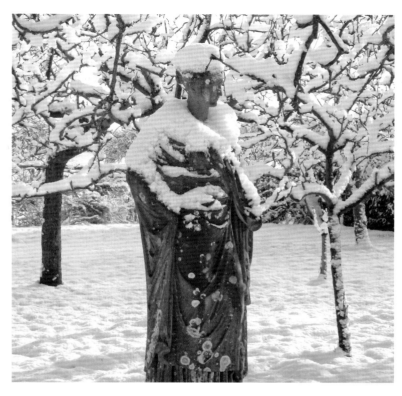

OPPOSITE: *Magic Stallion*, 1968, by Sylvester Mumbayi in the garden at Farleys.
ABOVE CLOCKWISE FROM TOP LEFT: A 1999 bronze cast of FE McWilliam's *Kneeling Woman*
inhabits the parlour lawn; The neo-classical statue in limestone covered in a fall of snow
photographed by Lance Downie; *Fallen Giant*, c1965, glass reinforced plastic by Michael
Werner lies among the apple trees and *Untitled*, wooden sculpture, 1954, by Roland Penrose.

Roland planted a yew hedge with curves like a sine wave, and a cherry tree tucked into each curve. Lee had a herb garden close to the house, and near the driveway a fish-shaped fishpond appeared, a dreadful hazard for those 'taking the air' at night.

The subject of Roland's only large outdoor sculpture gives us plenty to speculate about. A large acacia tree blew down and he had part of the trunk set upright in a concrete base. Working from a clay model, he spent many summer evenings with mallet and gouge, extricating the shape he wanted. A frightened man emerged, grasped from behind by a powerful birdlike creature that speared its beak down through the man's left eye. It is a painful image that gives us a glimpse of the counterpoint to Roland's normally optimistic personality.

A handsome oak tree that grew at the bottom of the garden inspired Roland with a sense of its longevity and endurance. He took it as the subject for a series of gouaches, the stem shown as an erect penis, blasting a milky charge skywards into its crown of branches. One hot summer's day, a bolt of lightning blasted the tree, scything jagged chunks of wood through the cornfield and the pasture vacated minutes before by the cows. The branches lay in a neat circle at the base of the naked, shattered stem. It was a cruel reminder to Roland of his own vulnerability.

LEFT: The gatepost at the entrance to Farleys.
OPPOSITE CLOCKWISE FROM TOP LEFT: *Vogue* model in front of the grain store, *Vogue* models carrying a straw basket and Model [Celia Thellusson nee Walsh] and Grandpa White for a fashion shoot at Farleys 1950. Sonia Orwell was a close friend of both Roland and Lee who has photographed her here as though she is giving Henry Moore's *Mother and Child* sculpture a ride in the wheel barrow in Farleys Garden 1953.

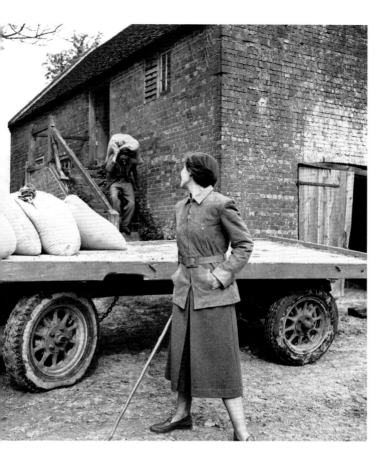

THE END OF AN ERA

If I had it all over again I'd be even more free with my ideas – with my body and my affection. Above all I'd try to find some way of breaking down, through the silence that imposes itself on me in matters of sentiment – I'd have let you, Roland, know how much and how passionately and how tenderly I love you.

LEE MILLER, WRITTEN WHILST AWAITING THE BIRTH OF HER SON, 9 SEPTEMBER 1947

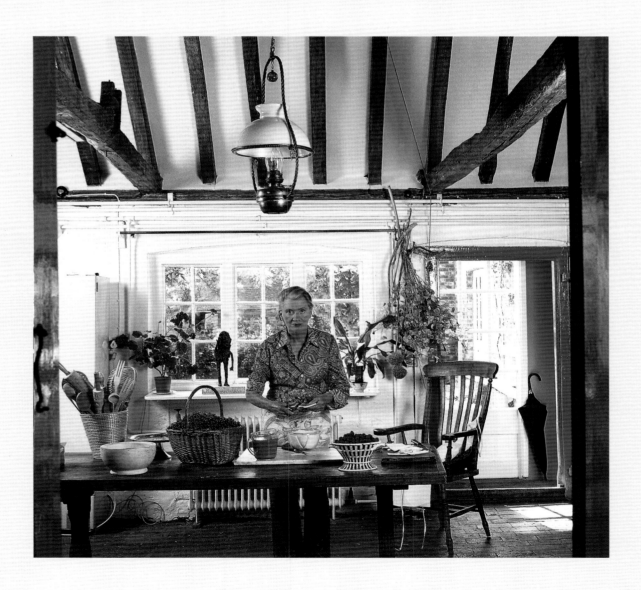

OPPOSITE: *How do you like Sri Lanka, Sir?*, 1981, collage, by Roland Penrose.
ABOVE: Lee in the old kitchen, photographed for House and Garden, 1973.

Roland painted *Don't You Hate Having Two Heads* in 1947, and it is almost certainly a self portrait. His body is clad in armour like a medieval knight, no doubt as protection against the wounding insults of Cooper and others, and a window into his abdomen reveals knots of internal tension. The tense argument between the figure's two heads almost definitely refers to his dilemma whether to continue on his path as an artist or to make his major commitment the development of the ICA. Clearly this was a difficult choice, but one that was finally decided by Roland's inherent diffidence about his work. In comparison with Picasso, Ernst, Miró, Man Ray and others of that pantheon, he judged his own work as hopelessly inferior, and settled for the enjoyment of promoting the work of those he saw as more talented than himself.

For the first few years the ICA ran on a shoestring, in rented and begged accommodation. It flourished, achieving groundbreaking shows such as 40,000 Years of Modern Art, which had the temerity to assert that primitive and ethnographic art is a

valid expression of human emotion and the mysteries of life, equal to the best the modern world had to offer. In 1950, encouraged by their success, the ICA invested in a permanent home in a large gallery on Dover Street off Piccadilly. Run by Dorothy Morland and her assistant Julie Lawson, the ICA established itself at the forefront of the contemporary art scene. Roland enjoyed mixing socially with the artists he was promoting, and many, such as the sculptors Kenneth Armitage, Bill Turnbull and Nicholas Schoffer, and the painters John Craxton, Jean Dubuffet, Richard Hamilton, Echuarren Matta, Phillipe Hiquily and Antonio Saura were visitors to Farleys. Notably absent in this roll call is Congo, the painting chimpanzee who had his sell-out exhibition at the ICA in 1957. Unfortunately he was confined to London Zoo, but his keeper Desmond Morris and Morris' wife Ramona became regular visitors.

Although Roland was deeply committed to promoting the work of young artists, his own heart remained with Surrealism and the work of his old friends, and at times this led him into conflict over the direction of the ICA. The faction that wanted the organization solely committed to the *avant garde* could not solve the problem of funding. It was the highly successful shows that Roland organized on Picasso, Ernst and Miró that brought in income and membership. Even more significant was that Roland and a few staunch allies dipped deep into their own pockets to fund the frequent financial shortfalls.

Against the odds, the ICA maintained its independence and established an international reputation. It was the next step that nearly killed it. As the lease on Dover Street neared its end, the search for new premises began in earnest. Some advocated a low cost solution like the conversion of a redundant church in an unfashionable area of London, but Roland, much encouraged by the Chairman for the Arts Council, Lord Goodman, bid for the lease of Nash House in Carlton House Terrace on the Mall. About £5,000,000 in today's terms was required to secure the lease and convert the building and Roland found himself in the position of chief fundraiser. Lee was steadfast in her support and gave her early Braque cubist painting *La Mandora* (1910) to a fundraising auction organized by Sotheby's. More than a hundred other works were donated by artists, collectors and dealers, and the similar success of a second auction a year later ensured the building was finished by April 1968.

The pattern of visitors to Farleys had changed. Instead of artists, who were fun and sometimes quite gratifyingly outrageous, we had more serious people, whom Roland hoped might become benefactors of the ICA. Roland was not a natural

OPPOSITE: *Don't you hate having two heads?*, 1949, oil on canvas, by Roland Penrose.
RIGHT: Roland and Cyril Connolly pictured in front of the new ICA premises at Carlton House Terrace on The Mall featured in *The Sunday Times* 17th March 1968.

17 MARCH 1968

● SHAWE-TAYLOR: "WAY OUT" MUSIC
● BRIEN ON HUMOUR
● RICKS: THE HEROISM OF KEATS

THE SUNDAY TIMES

The Institute of Contemporary Arts moves to new premises this month. CYRIL CONNOLLY (above with Sir Roland Penrose, the ICA chairman) makes a preview perambulation

ADVANCE GUARD IN ST JAMES'S

fundraiser and lacked the ruthlessness needed to 'put in the bite', and the recession of the early 1970s made gathering donations even more difficult.

But the main problems at the ICA came from within. Once a personal crusade, it had grown into to a major institution with all the problems of large-scale management and the strings attached to public funding. Now the conflict between the desire to mount revolutionary work and the need to appease the Arts Council as the principal funding agency reached crisis point. The new management team was on the whole incapable of keeping to the budgets set by the Arts Council, and within a few months of the opening at Nash House in April 1968 the ICA was lurching from one crisis to another. Lord Goodman summoned Roland and the current Director of the ICA more than once to reprimand them over programming where the compulsion to appear fashionable had overridden considerations of taste and quality, and about the severe financial losses. Roland felt that the fire for change that drove Surrealism, had become a commodity, and that the distinction between the exploitative sensationalism and work that had integrity was something many in the new management seemed unable to recognize. Despite his continued commitment to organizing exhibitions

and donations, Roland became viewed by many at the ICA as an old fuddy duddy who was risibly out of touch with modern art.

Seeking to introduce more business acumen into the running of the ICA, Lord Goodman insisted Roland should take the role of President, recently vacated by the death of Herbert Read This position brought a remoteness that was reinforced by the honours he received. He was awarded the CBE in 1960 following the Picasso exhibition and he was knighted in 1966 for his services to contemporary art. Roland's chameleon-like ability to transcend barriers and mix with all levels was now damaged, as he was seen by many to be firmly in the establishment's camp. His detractors could not see that Roland was still true to his Surrealist revolution, and by working through the Tate and the Arts Council he was in a gently subversive way bringing its fruits to a far wider range of people than could have otherwise been reached.

Much of this escaped me at the time. After an inglorious school career and a spell in mechanical engineering, I found my way back to farming and enrolled at the Royal Agricultural College at Cirencester in Gloucestershire. After graduating, I moved back into Farleys House with my girlfriend Bez, a horse trainer, and started

OPPOSITE: The fountain, c1963, copper, in the lily pond seen from the kitchen windows was built by Roland and Antony Penrose.
RIGHT: *Barbarella's Bra*, c1979, barbed wire, by Antony Penrose. Made as a birthday present for Roland who was satisfactorily shocked.

work on the farm. The essence of life at Farleys continued intact, though not without some major changes.

Patsy remained the central pivot of the home, but was now alone as her daughter Georgina was in Botswana, working on an aid project. Georgina and I had resolved the bitter jealousies aroused by her arrival at Farleys, and developed a special affection that endures to this day.

Lee and I had elevated our parent-teenager conflict to all-out guerrilla warfare. Deeply mistrustful of any truce, I ruthlessly repelled Lee's peace overtures. Paradoxically, she unfailingly made my friends welcome, and they adored her, often affording her respect and affection in ways I found altogether bewildering. Roland and I still bumbled on in an affectionate but rather distant way, neither of us really understanding the other, but enjoying doing things together.

One of our best joint projects was the fountain that stands in the lily pond in front of the kitchen. We made it during a period of reconciliation that followed a bad time in my school career. He made the maquette and, helped by a firm of sheet metal workers in Eastbourne, I built the fountain, with Roland doing much of the final detailing. It is made of copper, a metal that is kind and forgiving to work and has a quality of solid durability, symbolic of the relationship I began to build with Roland. In some ways I had a role as his squire. When required I would step into his world of art, and find myself in situations and places that so differed from my own chosen profession that at times I wondered if I was still on the same planet. I enjoyed these temporary flirtations with art but, at that point in my life, it was not a love match – although now art is as vital to me as breathing.

An event that shook us all to the core and changed our way of life fell at Easter 1969. While we were all enjoying a quiet break at Farleys, the news came through that 11a Hornton Street had been burgled. Roland, Lee and I jumped on the next train to London and arrived to find a scene of indescribable desolation, with empty frames and broken glass strewn around, the chaos calmly surveyed by Pee Cee, Lee's beloved cat. Twenty-six paintings including four by Picasso, and others by De Chirico, Ernst, Miró, Braque, Man Ray and Magritte had been stolen. The thieves demanded a ransom; they had calculated that the raid would earn them a payoff from the insurers. However Roland had not insured the paintings for their full value for theft, believing that no one would steal works so recognizable that they were unsaleable. The thieves had also not reckoned on Roland's moral strength. The Quaker in him came to the fore, and on BBC television's *Panorama* he boldly stated he would not pay a ransom. The waiting game became a war of attrition as the thieves tried to wear down Roland's resolve. Roland gave them just enough encouragement to buy time for the police to set up a complicated sting. When it came, the long-awaited operation nearly went badly wrong.

The thieves, accompanied by a secret informer and tailed by plainclothes police, arrived at the derelict building where the paintings were hidden, but when on seeing workmen there drove straight on. Meanwhile the workmen had started a bonfire for all the rubbish. Luckily they paused when they found the paintings, and took one round the corner to an art shop where the astonished owner identified Picasso's *Woman Weeping*. Roland learned of the paintings recovery from the front page of the *Evening Standard*. He was called to Chelsea police station where on finding the paintings locked in the cells for safekeeping he wept for joy. The police later arrested most of the gang, and some were jailed for our burglary and other offences. The informer was lucky to escape with his life, and the workmen got a reward.

A few days later I went to the Tate Gallery where Stefan Slabczynski, the well-known restorer, was tenderly administering

to the stolen paintings. He furiously pointed out their numerous cuts and bruises. 'The papers call the people who did this *professionals*', he spat, 'but look, they are worse than barbarians.' His incredibly skilful repairs soon had the paintings back to their former glory. The worst damaged was Picasso's *Negro Dancer* (1907). The thieves had hacked out a rectangle of canvas bearing Picasso's signature, presumably to send to Roland to crack his resolve. A few months later, Picasso re-signed the painting over the repair.

Our way of life was not mended so seamlessly. Suddenly security had become a serious issue. Some of the key paintings were now deemed too valuable to come home and remained in the Tate. Roland had always maintained that the value of the paintings was such that putting a lock on the door seemed ridiculously overcautious. In fact, in the early days, Patsy and I never used to lock the door when we went out in case someone needed to get in. Now locks, keys and burglar alarms (which initially were so unreliable they were virtually useless) dominated our lives. More regrettable was that Roland no longer felt able to allow his

ABOVE: Front page of the *Evening Standard*, 2nd July 1969 from which Roland learned that the stolen paintings had been recovered.
OPPOSITE LEFT: *The Junction*, 1938, oil on canvas, by Roland Penrose.
OPPOSITE RIGHT: Burgh Hill House was renovated by Roland and became the home of Antony and Suzanna in 1975.

collection to be so readily accessible. He had to learn an unnatural reserve instead of the warmth with which he had greeted requests by students and researchers to meet him or visit Farleys.

At a certain level, life at Farleys went along much as usual. Under Peter Braden's steady management, the farm had by 1967 improved to the point where Roland felt encouraged enough to double its size with the addition of neighbouring Burgh Hill Farm. Burgh Hill had run down to the point of collapse, but Peter soon pulled it round, and we now had two dairy herds of eighty cows and a small beef unit. The pigs and the pig man had departed some years previously, and we were now specialised as a dairy farm.

When I returned from Cirencester in 1970 with my diploma, Roland was immediately concerned that I had brought back too many bright ideas and would upset the established order of things. 'You and Bez should travel before you settle down,' he advised, 'go off and see something of the world.' I fitted out a Land Rover, planning a route that would take us overland to Australia. Our wedding was to be followed by our departure in the autumn, and all seemed set fair, until without warning Bez and I abruptly parted company. I was determined to go even if it had to be alone, but at the last minute I was joined by my cousin Dominic and Peter Braden's elder son Robert, who our Iranian friends later named Bozourg, meaning 'big'. We called ourselves 'Muddles Overland' after Muddles Green in the centre of the farm, and Roland lettered the Land-Rover's name *Que Sera . . .*, on its front wings.

Before our departure, I traced our intended route for Roland on a map of the world using pins with cotton looped round their heads. 'This will be handy for finding our way,' I joked, 'we'll just look for the giant pins and the thread of cotton.' Roland said nothing, but disappeared and returned with a canvas, *The Junction* (1938). An immense plant stands in front of a house that is sliced vertically to reveal a row of huge pins, following a road that recedes into the distance under a darkening sky. 'In some places you might find I was there ahead of you,' he said, prophetically. As it happened we unknowingly retraced much of his journey in India with Valentine.

Before I left, Valentine, who was staying at Farleys, read my Tarot cards. I had stopped asking her to do readings some years before because her accuracy unnerved me. She told me many things, some of which took years to fulfil, but most importantly she emphasized I would return to Farleys. Her words were of great comfort and became a protective mantra in times of danger.

Roland updated the map pins to track our journey across Europe and Asia to Islamabad, where the India-Pakistan war blocked our way. We backtracked to Iran and shipped to India, then to Malaysia, continuing overland to Singapore, and then via another sea voyage to Western Australia. By then we were broke and found jobs and a warm welcome on the wheat and sheep farms. After five months we were ready to move again, and Suzanna, a ballet teacher I had met briefly and fallen in love with before leaving England, joined us in Perth. The understandable apprehension Bozourg and Dom felt at having a woman join us soon disappeared in the face of Suzanna's warmth, courage and ability to cook amazing dishes over an open fire in the bush. We became a redoubtable foursome.

We enjoyed our journey too much to be able to stop. New Zealand followed, where Dom returned to England and we found Peter Comrie, a young British electronics engineer, to take his place. We all crossed to Peru, Suzanna and I making our own way by air as the freighter that carried *Que Sera ...*, Bozourg and Peter had a strict 'no women aboard' policy. Just before our departure, we married in Auckland registry office, notifying our startled families by cable after we were conveniently out of touch.

By the time we arrived back in England, after making our way up through the Americas to Canada, three years and three months had passed since Bozourg and I had left home. Now we folded our tents for the last time, and Suzanna and I set up home in Burgh Hill House, half a mile from Farleys.

Roland and Lee welcomed Suzanna as a daughter, and it was Suzanna who encouraged Lee and me to make friends. She would invite Lee to our home as often as possible, and slowly we came to understand each other. We would never have a usual mother-son relationship, but we found that like many enemies who become friends we had a lot in common, and came to enjoy each other's company. When Suzanna became pregnant with our first baby, it was Lee, the arch child-hater, who took her shopping for maternity clothes. Having a former fashion model help choose her wardrobe allowed Suzanna to look as though she had just stepped from the pages of *Vogue*, and Lee glowed with satisfaction.

Lee had won control of her drinking, and her passion for cooking and classical music had given her life new forms of expression. She travelled widely with her friend Bettina McNulty, the magazine editor, and brought back delicacies from all over the world to experiment with in her cooking. To her great satisfaction, she became known as a gourmet cook and her efforts resulted in feature-length articles in American *House and Garden* and British *Vogue*. Lee had

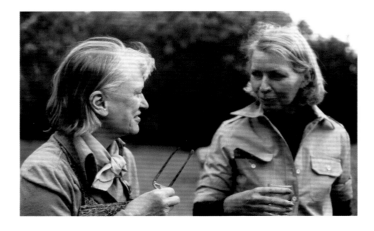

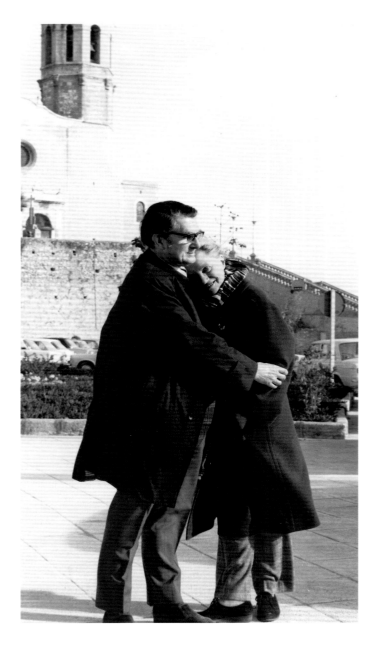

a cookery book under consideration by publishers in New York, and Mario Amaya had begun her biography. The cookery book was never published, and Amaya eventually gave up in frustration as nothing would induce Lee to talk about her own work, it signified that Lee had begun a new career.

Roland was as busy as ever, jetting round the world to lecture and organize shows. In 1975 he brought the Man Ray retrospective to the ICA, and the following year was responsible for another large ICA show: Max Ernst, Prints, Collages and Drawings 1919 to 1972. This was Roland's final curtain call at the ICA. By now he felt completely unable to relate to the people running the ICA and what he saw as their obsession with facile sensationalism. An exhibition of dirty nappies was the last straw, and he resigned. His natural dignity concealed his extreme sense of bitterness, but at Farleys we knew how much he grieved for his brilliant vision, which had gone so badly wrong.

Roland was devastated by Picasso's death in 1973. Although he tried to console himself with the truth that much of Picasso's spirit lived on in his work, the departure of this god-like figure from Roland's life created a wound impossible to heal. Max Ernst and Man Ray died in 1976, leaving further gaps in the already thinned ranks of his closest friends. But worse was to come when Lee found she had cancer of the pancreas. She bore her swift decline with remarkable courage. Her bedroom at Farleys became both a club and the command post for her last battle.

Patsy, well known for her compassion, cared for Lee with an understanding born of years of intimate friendship. She prepared the most tempting morsels imaginable to revive Lee's flagging appetite, and maintained the steady beat of the household. Roland, showing an unexpected tenderness and devotion, was never far from Lee's side, lovingly massaging her feet while he talked to her, making plans they both knew were impossible as the inevitable drew closer.

LEFT TOP: Lee and Bettina McNulty, Farleys Garden 1974.
LEFT BOTTOM: Roland Penrose and Lee Miller, Sitges, near Barcelona, Spain, 1972.
OPPOSITE TOP: Ami, Suzanna, Eliza and Roland, Farleys Garden.
OPPOSITE BOTTOM: Design by Roland for the poster for his Arts Council retrospective exhibition with a dedication to Suzanna, 1980.

Lee would phone her friends, inviting them to drop by and see her before she went, as if she were off on a jaunt. They would sit by her bed and she would have a drink with them from her well-stocked bar. On the bright morning of 27 July 1977, as Roland held her in his arms, Lee slipped away on her journey.

Some months later I got a post card from Lee in Mougins. Sifting through a stack of mail that awaited me on my return from overseas, I stopped dead at Lee's handwriting:

> Imagine picking ripe
> cherries and figs straight
> from the trees whenever
> you want them.
> Lovelee.

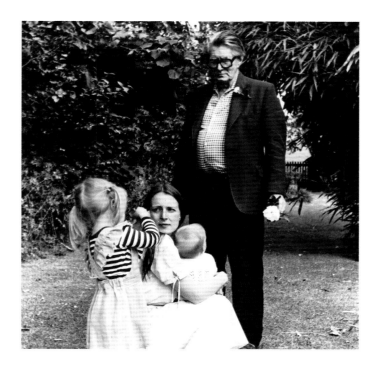

My senses reeled. For a moment, she was alive again, happily enjoying herself in the sun. Then I noticed the card was dated seven years previously. It had been lying around the house and had somehow become mixed in with my mail.

'Why are you crying?' asked Suzanna. I was still too emotionally cut off from Lee to realise how much I missed her, and it took me years to find out.

Valentine had been holding her own against leukaemia for years, but the following year she too died at Farleys, nursed by Patsy and Georgina, who was now home from Africa. Within a year Roland had lost both his wives, the two most important loves of his life. For months he withdrew like a traumatized child, and then slowly the loving attentiveness of Patsy and Suzanna began to coax him towards recovery. Suzanna and I had had our first daughter, Ami, just before Lee died and now, two years later, we had our second, Eliza. Sunday lunch together at Farleys became a ritual, and for the rest of the weekend Suzanna would entertain Roland and his guests at Burgh Hill. Roland's friends mingled with ours, met travelling, or drawn from Suzanna's world of dance. It was the 'Farley's Revival' period.

Joanna Drew, now Director of Art at the Arts Council, was responsible for Roland's first ever retrospective exhibition, which opened in 1980 at Kings Lynn in Norfolk and toured widely, visiting among other places the Fundaçio Joan Miró in Barcelona. The London venue was the ICA, where the show went well, with little evidence of the former hostility towards Roland. The management had changed, and the new director, Bill McAlister, was determined to heal old wounds and invited Roland to return to the ICA as Honorary President.

Roland's autobiography *Scrap Book*, was published in 1981 in

DRAWINGS · PAINTINGS · OBJECTS
ROLAND PENROSE
FERMOY GALLERY KING'S LYNN

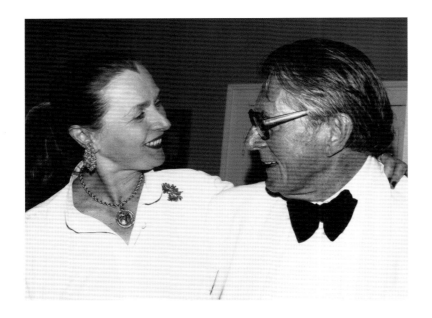

three languages. Major radio and television channels made documentaries about him, and the University of Sussex gave him an honorary doctorate. Roland somewhat unwillingly accepted this new role as a Grand Old Man. It was no compensation for the loss of mobility that followed a disastrous series of hip operations in 1979. The artist Sheila Donaldson-Walters gave him a pair of walking sticks brightly painted with stripes. He called them his 'party sticks', jovially trying to disguise his annoyance at having to use sticks at all.

A minor stroke made writing impossible, and for a while Roland became deeply depressed. It was Diane Deriaz who persuaded him to start making collages. She travelled with him to France and America, as well as to more exotic places like Kenya and Sri Lanka. He bought masses of postcards and in the studio he had converted from the old malt house at the

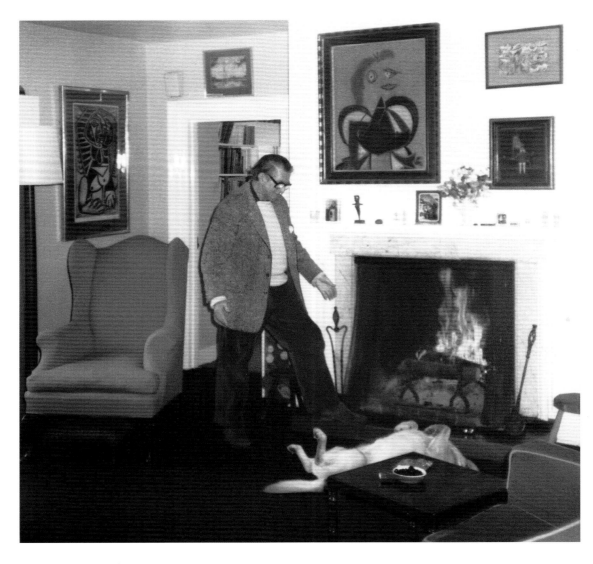

LEFT TOP: Diane Deriaz and Roland in his study at Farleys, c1980.
LEFT BOTTOM: Roland and his dog Tina in the sitting room, Farleys House, c1982.
OPPOSITE: *Seychelles No 8 (The Last One)*, 1984, collage, by Roland Penrose.

bottom of Farleys garden, he made a series of very striking works during the last four years of his life. In some of his strongest work he captured the heat and drama of Africa, and the luscious fecundity of Sri Lanka and the Seychelles. Images of birds, trees and beautiful women abound, capturing the essence of the wonderful locations and of his own spirit.

It is a wonderful achievement to have a show of new works at any age, but at eighty-two it has special significance. The show opened in the Galerie Henriette Gomis in Paris and then transferred to the Mayor Gallery in London, now run by Freddy's son James. The reviews were great and the works sold, with one bought by the Tate Gallery.

In the early spring of 1984, Roland and Diane visited the Seychelles and returned with a further series of collages, in preparation for his next show at the Gardner Arts Centre in Brighton. Then he was severely incapacitated by another stroke. In the last few days of his life, I helped him as with great difficulty he titled the Seychelles series. He named one *The Last One* (1984), because it was. A beautiful white bird soars freely, leaving behind the earth with all its delights, heading into a clear sky. The sky contains a form that may be reprised from Man Ray's painting of Lee's lips. In Roland's visual lexicon, these lips are always tilted vertically, suggesting a vagina. They appear in his paintings of Lee with a frequency that makes them alone a motif for her, and it is towards the lips that the bird is travelling.

Roland died at Farleys on the morning of 23 April 1984, Lee's birthday. Suzanna and I scattered his ashes in the garden he so loved, on the places he had previously scattered the ashes of Lee and Valentine.

THE HOUSE TODAY

Soon after Lee's death, Suzanna discovered a vast collection of her negatives, photographs and manuscripts stored in boxes in the attic. Many dated from her early days in Paris, but it was her war dispatches that immediately captivated me. Her compassionate and incisive prose showed a side of Lee I had never seen, and which I could not reconcile with the useless, neurotic woman I had known.

With Roland's support we started sorting and archiving the material, much encouraged by Valerie Lloyd of the Royal Photographic Society. The publishers Thames & Hudson heard about our find and, as a huge act of faith in the material and myself, commissioned me to write Lee's biography, *The Lives of Lee Miller*. Roland was fascinated as although he and Lee had known each other for forty years, she had told him very little about herself, particularly concerning her childhood and war career. When *Vogue* heard what we were doing they generously turned over to us all the remaining Lee Miller files in their archives and Erik Miller gave us many of Lee's photographs from the New York period when he was her assistant. Roland died when I was half way through the writing and if it had not been for the help and encouragement given to me by David E. Scherman, I don't know how I would have completed the task.

Assembling and running the Lee Miller Archives would not have been possible without Carole Callow, a photographic printer who became our curator. The Archive occupies five rooms on the first floor of Farleys, including a dark room where Carole makes all the prints and a climate controlled store holds the negatives and vintage material. Our first registrar was Arabella Hayes, soon to be joined by my daughter Ami Bouhassane.

With Farleys House becoming a museum in its own right we have grown at a rate we could never have imagined. Ami, who is now my co-director has a core staff of ten people keeping track of 60,000 negatives, 20,000 vintage prints, manuscripts, ephemera and maintaining our websites. We have another ten seasonal people who are responsible for helping to run the tours of the house and take care of our visitors. We always seem to have at least one major exhibition current somewhere in the world and annually contribute to eight or ten others. We also frequently work on TV and radio productions, and production of new books and catalogues.

LEFT: Carole Callow, the curator and fine printer of the Lee Miller Archives.
OPPOSITE: Hilary Roberts researching for the *Lee Miller: Women at War* exhibition at the Imperial War Museum, London, 2015.

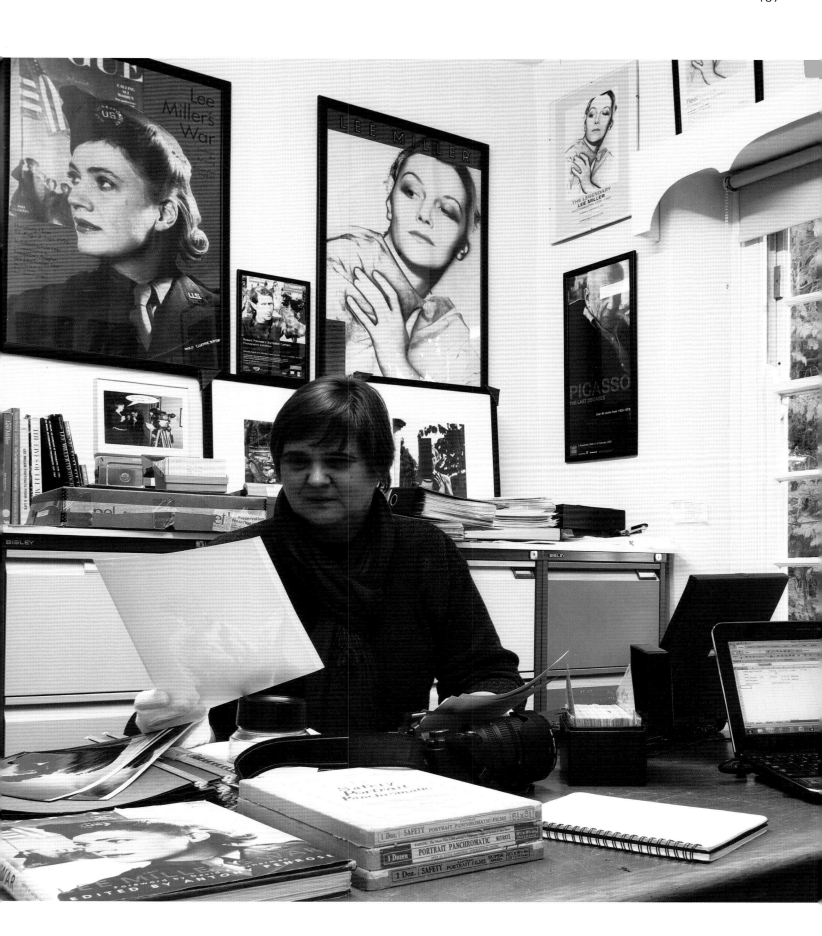

When Roland died, he left few specific instructions for the disposal of his books, papers and his own work. Suzanna and I decided that before we made any decisions we should catalogue everything, and we had the great good fortune to engage Michael Sweeney, an art historian who worked for eight years archiving Roland's work. Catherine Rickman, a talented conservator of works on paper, worked in parallel with Michael to rescue many of the collages and drawings that had suffered from damp in Roland's studio. The incredibly detailed catalogue Michael produced made it possible to sell the major part of Roland's library and papers to the Scottish National Gallery of Modern Art in Edinburgh, which now houses them as the Roland Penrose Archive. In this way the material is accessible to the increasingly large number of people who regard it as an important resource for the study of Surrealism.

For the first few years after Roland died, Farleys went through a sad and bleak period. In an attempt to give the house a purpose I began using some of the rooms as office space for a business enterprise – though this did not feel congruent with the spirit of the place. Then by chance (through Bettina McNulty's daughter Claudia), the house was featured in *World of Interiors* magazine. Suddenly, Alen McWeeney's fabulous photographs had evoked the old atmosphere. A trickle of enquiries from people who wanted to visit Farleys built quickly into a steady stream of parties of art lovers.

With great pleasure I found other accommodation for the offices. I restored the original furniture and many of the works in all the rooms on the ground and first floor that were not part of the archive. The colour schemes, carpets, curtains and much of the familiar clutter remain virtually unchanged. Although most of the key works by Picasso, Ernst and Miró are either sold or loaned to the Scottish National Gallery of Modern Art, a big enough selection remains to celebrate Roland and Lee's own work and their friendships. Indeed, it is often the small items like Mrs Noah that are the most meaningful in the context of the house. I also felt it pointless to continue old enmities and François Gilot's work is back on the wall.

In keeping with the spirit of Roland and Lee, there are several examples of work by young artists to be found around the house,

LEFT TOP: Antony Penrose, director of the *Lee Miller Archives* and *The Penrose Collection* in the archival store.
LEFT BOTTOM: Installation of *Man Ray* exhibition in Millesgarden, Sweden, 2014, photographed by Lance Downie.

among them a number of pieces by my children Ami, Eliza and Joshua, all artists in their own right. People who knew Farleys in my parents' day find the atmosphere today very similar to how it was and the constant activity of the Lee Miller Archives ensures that life around the old house is never static.

Josh Fifer who took over the gardens some years after Fred's retirement has done a marvellous job of restoration, so that the gardens now give those who visit the same sense of pleasure as they did in Roland and Fred's day. There are always flowers for Joan Baker, Fred's widow, to use in her delightful arrangements, which are ever present in the house. The farm, now let to Peter Braden's successor Mike Sturmer, is thriving and one day will become the domain of my son Joshua, already a successful agricultural contractor.

Sadly, Suzanna – who loved Farleys and would have been delighted to see it shine again – was not to be part of all this. She died of cancer in 1992, when our son Joshua was four. Since then I have had the great good fortune to meet and fall in love with Roz. We were married in 1994, and now I have a stepdaughter, Genevieve.

Ami's sister Eliza is a conservator of works on paper and frequently uses her expertise to care for the collection. Genevieve helps manage the data base for the website, and at times Joshua travels with me, helping ship and install exhibitions.

Ever present for fifty seven years against a perpetually shifting background of tears, laughter, tragedy and triumph, I had the constant support and love of Patsy, to whom this book is dedicated. She died suddenly on 20th February 2008 with the same 'no fuss' dignity that she had lived.

We had shared some of the best and worst moments of our lives, and I will always treasure the part of her life she so selflessly gave me. It is the greatest satisfaction to me that she is still fondly regarded as the heart of Farleys, and that she lived long enough to share with me the pleasure of seeing the place become recognised and cherished by others once again.

If you have enjoyed this book, I hope you will see it as homage to the vision and generosity of spirit of Roland and Lee – and of Patsy, without whom, as Roland asserted, Farleys would not have existed.

RIGHT TOP: *Tension*, 1990, mixed media, by Dan Geesin, as part of his graduation show hangs above *Fetiche,* c2008, by Samuel Paradela, in the hall outside the sitting room.
RIGHT BOTTOM: Fred Baker and Patsy, Joan Baker and Stan Peters Farleys House kitchen, 1964, by Lee Miller.

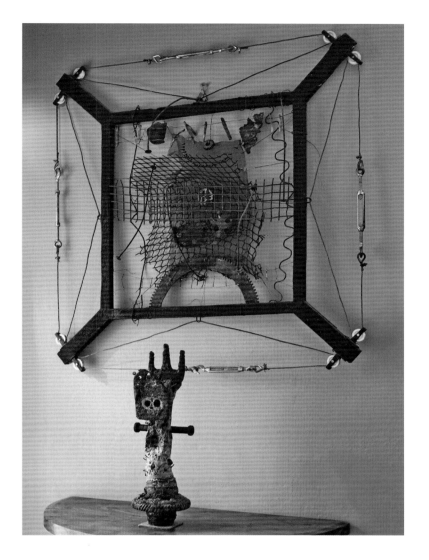

WORKS IN PERMANENT COLLECTIONS

ROLAND PENROSE

David and Alfred Smart Museum of Art, University of Chicago, Chicago, USA
Untitled collage, 1937, collage

Falmouth Art Gallery, Cornwall, UK
Study for *Breakfast* c1939, pencil on paper

Ferens Art Gallery, Hull, UK
Octavia (Aurelia), 1939, oil on canvas

Fundació Joán Miró, Barcelona, Spain
East West, 1983, collage

Israel Museum, Jerusalem, Israel
The Junction, 1938, oil on canvas
The Scales, 1936, oil on canvas
Untitled, 1929, pencil frottage on paper
Untitled, 1937, ink and gouache on paper

**Musée d'Art et d'Histoire
(Paul Éluard Archive), Paris, France**
Portrait of Nusch Éluard, 1937, pencil on paper

Museum of Contemporary Art, Chicago, USA
Camera Obscura, 1937, collage

National Portrait Gallery, London, UK
Self Portrait, 1947, watercolour

**National Trust, Willow Road,
Hampstead, London, UK**
The Real Woman, 1937, collage

New Orleans Museum of Art, New Orleans, USA
The Veteran, 1938, oil on canvas

**Scottish National Gallery of Modern Art,
Edinburgh, UK**
My Windows Look Sideways..., 1939, oil on canvas
Untitled, 1937, collage

Southampton Art Gallery, Southampton, UK
Good Shooting (Bien Visé), 1939, oil on canvas
The Conquest of the Air, 1939, oil on canvas

Tate Modern, London, UK
Captain Cook's Last Voyage, 1936, object
House the Lighthouse, 1981, collage
Le Grand Jour, 1938, oil on canvas and collage
Magnetic Moths, 1938, collage
Portrait, 1939, oil on canvas

Victoria and Albert Museum, London, UK
Elephant Bird, 1938, collage

ROLAND PENROSE TOURING EXHIBITION
Roland Penrose Surrealist Camera

LEE MILLER

VINTAGE PRINTS IN PERMANENT COLLECTIONS
Harry Ransom Center, The University of Texas
 at Austin, Austin, USA
Scottish National Gallery of Modern Art, Edinburgh, UK
The J. Paul Getty Museum, Los Angeles, USA
The Metropolitan Museum of Art, New York, USA
Musée Nationale d'Art Moderne, Paris, France
The Museum of Modern Art, New York, USA
San Francisco Museum of Modern Art, San Francisco, USA
Philadelphia Museum of Art, Philadelphia, USA
Vogue Archive, Vogue House, London, UK
Vivian Horan Fine Art, New York, USA
Frances Lehman Loeb Art Center, Vasser College,
 Poughkeepsie, USA
National Portrait Gallery, London, UK
The Art Insitute of Chicago, Chicago, USA
New Orleans Museum of Art, New Orleans, USA

MODERN PRINTS IN PERMANENT COLLECTIONS
Scottish National Gallery of Modern Art, Edinburgh, UK
National Portrait Gallery, London, UK
Falmouth Art Gallery, Cornwall, UK
Centre National de l'Audiovisuel, Dudelange, Luxembourg
Musée la Malmaison, Cannes, France
Los Angeles County Museum of Art, Los Angeles, USA
Museo Picasso Málaga, Malaga, Spain,
La Coupole, Centre d'Histoire et de Memoire,
 Nord-Pas-de-Calais, France
Fotografische Sammlung, Museum Folkwang,
 Essen, Germany
Musée de l'Elysee Lausanne, Lausanne, Switzerland
Stadt Brühl Rathaus, Brühl, Germany
Historisches Archiv Stadtköln, Cologne, Germany
Musée d'Art Modern de la Ville de Paris, Paris, France
Portland Art Museum, Portland, USA,
Tokyo Fuji Art Museum, Tokyo, Japan

LEE MILLER DEALERS
UK
Offer Waterman
17 George Street, London, W1S 1FJ
Tel: +44 (0)20 7042 3233
Email: info@waterman.co.uk Website: waterman.co.uk

EUROPE
CLAIR Gallery – France
CLAIR Galerie, 1, Rue de la Tour,
F-06570 Saint Paul de Vence, France
Tel: +33.(0)4.93 58 63 32
Email: info@clair.me Website: www.clair.me

CLAIR Gallery – Germany
CLAIR Galerie und Kunsthandel ein Unternehmen
der Circles GmbH, Franz-Joseph-Str. 10 D-80801
München, Germany
Tel: +49.(0)89.386674-42/46
Email: info@clair.me Website: www.clair.me

LEE MILLER TOURING EXHIBITIONS
Lee Miller's War
Surrealist Lee Miller
Lee Miller Portraits
Lee Miller and Picasso
Lee Miller at Farley Farm

WORKS BY OTHER ARTISTS IN PERMANENT COLLECTIONS

Other works mentioned in this book are now housed
in the permanent collections of the following galleries:

**The Metropolitan Museum of Modern Art,
New York, USA**
The Jewish Angel, Giorgio de Chirico, 1916, oil on canvas
Les Demoiselles d'Avignon, Pablo Picasso, 1907,
 oil on canvas
The Young Girl with a Mandolin, Pablo Picasso 1910,
 oil on canvas

**Musées Royaux des Beaux–Arts de Belgique,
Brussels, Belgium**
The Kiss, René Magritte, 1938, oil on canvas

**Museo Nacional Centro de Arte Reina Sofia,
Madrid, Spain**
Guernica, Pablo Picasso, 1937, oil on Canvas

Pulitzer Collection, St Louis, USA
Portrait of Uhde, Pablo Picasso, 1910, oil on canvas

**Scottish National Gallery of Modern Art,
Edinburgh, UK**
Head of a Catalan Peasant, Joán Miró, 1925 oil on
 canvas (SNGMA and Tate modern joint ownership)
L'Appel de la Nuit, Paul Delvaux, 1938, oil on canvas
Nude, Joán Miró, 1921, oil on canvas
Threatening Weather, René Magritte, 1929, oil on canvas

Tate Modern, London, UK
Elephant of Celebes, Max Ernst, 1921, oil on canvas
La Mandora, Georges Braque, 1910, oil on canvas
The Revolution in the Night, Max Ernst, 1923, oil on canvas
Three Dancers, Pablo Picasso, 1925, oil on canvas
The Uncertainty of the Poet, Giorgio de Chirico 1913,
 oil on canvas
Woman Weeping, Pablo Picasso, 1937, oil on canvas

Van Abber Museum, Eindhoven, Netherlands
Woman in Green, Pablo Picasso, 1909, oil on canvas

FURTHER READING

Penrose, Roland, *The Road Is Wider Than Long*, 1939
Facsimile edition J.P. Getty Museum, 2003
Penrose, Roland, *Portrait of Picasso*, London: Lund Humphries, 1956
Trevelyan, Julian, *Indigo Days*, Aldershot: Scolar Press, 1957
Penrose, Roland, *Picasso, His Life and Work*, London: Gollancz, 1958
Gilot, Françoise, *Life with Picasso*, New York: McGraw Hill, 1964
Breton, André, *Manifestoes of Surrealism* (translation by Helen R Lane
 and Richard Seaver), Ann Arbor: University of Michigan Press, 1969
Penrose, Roland, *Miró*, London: Thames & Hudson, 1970
Penrose, Roland, *Man ray*, London: Thames & Hudson, 1975
Penrose, Valentine, *Poems and Narrations* (translation and foreward
 by Ray Edwards), London: Carcanet Press and Elephant Trust, 1976
Gascoyne, David, *Journal 1937-1939*, London: Enitharmon Press, 1978
Penrose, Roland, *Tàpies*, London: Thames & Hudson, 1978
Morris, Desmond, *Animal Days*, London: Cape, 1979
Penrose, Roland, *Scrap Book*, London, Thames & Hudson, 1980
Penrose, Antony, *The Lives of Lee Miller*, London, Thames & Hudson, 1985
Chadwick, Whitney, *Women Artists and the Surrealist Movement*,
 London: Thames and Hudson, 1985
Tanning, Dorothea, *Birthday*, San Francisco: The Lapis Press, 1986
Agar, Eileen, *A look at my life*, London: Methuen, 1988
Baldwin, Neil, *Man Ray*, American Artist, New York: Clarkson N Potter, 1988

Gonzales, Sylvie (ed.), *Paul, Max et les Autres*, Paris: Éditions de l'Albaron, 1993
Melly, George, *Don't Tell Sybil: An Intimate Memoir of ELT Mesens*,
 London: Random House, 1997
Penrose, Antony, *The Legendary Lee Miller*, Lee Miller Archives, 1998
Remy, Michel, *Surrealism in Britain*, London: Ashgate, 1999
Richardson, John, *The Sorcerer's Apprentice*, New York: Knopf, 1999
Smith, Michael, *Lionel Sharples Penrose: A Biography*, Colchester: Michael Smith, 1999
Gascoyne, David, *A Short Survey of Surrealism*, London: Enitharmon Press, 2000
Penrose, Antony, *Roland Penrose, The Friendly Surrealist*, London, Prestel, 2001
Bailey, Dr Chris Howard and Thomas, Lesley, *Wrens in Camera*,
 (based on the original work of the same title by Lee Miller),
 Portsmouth: Sutton Publishing and Royal Naval Museum Publishing, 2002
Calvocoressi, Richard, *Lee Miller, Portraits from a Life*, London: Thames & Hudson, 2002
Cowling, Elizabeth, *Visiting Picasso*, London: Thames & Hudson, 2006
Haworth-Booth, Mark, *The Art of Lee Miller*, London: V&A, 2007
Penrose, Antony, *The Boy Who Bit Picasso*, London: Thames & Hudson, 2010
Conekin, Becky E, *Lee Miller in Fashion*, London: Thames & Hudson, 2013
Penrose, Antony (editor), *Lee Miller's War*, London: Thames & Hudson, 2014
Penrose, Antony, *Miró's Magic Animals*, London, Thames & Hudson, 2016
Allmer, Patricia, *Lee Miller: Photography, Surrealism and Beyond*, Manchester,
 Manchester University Press, 2016

FARLEYS HOUSE TOURS

Dates are available between April and October each year for individuals and groups to visit Farleys House, Gallery and Sculpture Garden.

Visit **www.farleyshouseandgallery.co.uk** or contact us for more details:

Farleys House and Gallery
Muddles Green
Chiddingly
East Sussex BN8 6HW

Telephone: +44 (0) 1825 872 856

FARLEYS HOUSE & GALLERY
HOME OF THE SURREALISTS

INDEX

AUTHOR'S ACKNOWLEDGEMENTS

I am indebted to Alen Macweeney who in the wake of his feature for *World of Interiors* January 1999 originated this book, published in 2001 by Frances Lincoln. Since then much has evolved in our continued restoration of Farleys House and the collection, and this edition needed all the contemporary photography to be updated. Tony Tree has steadily recorded the house and all our activity for more than a year, and his sensitive photographs have captured the atmosphere of the house perfectly. We have all enjoyed the company of this friendly and gentle person, and I thank him for his magnificent photographs, which are a genuine reflection of the spirit of Farley Farm House.

The foundation of research for this book is drawn from the work of Michael Sweeney, who in addition to cataloguing Roland's archive, compiled the vast data base of facts, references and interviews that I first used for my memoir of Roland, *Roland Penrose, The Friendly Surrealist.* I am most grateful to him for the incredible diligence of his research, and for the generosity of spirit and tact he has always shown. His Roland Penrose database, which was funded with support from the Elephant Trust, is now available in The Roland Penrose Archive at the Scottish National Gallery of Modern Art. I am extremely grateful, as always, to the former Director, Richard Calvocoressi, and the present Chief Curator Patrick Elliot, to Anne Simpson formerly the Head Librarian and Kirstie Mehan, now Senior Curator, Archive and Library. Also Keith Hartley, curator of the Roland Penrose retrospective at the Dean Gallery in 2001, Janis Adams, director of publications and the many other staff at the Scottish National Gallery of Modern Art for their unfailing courtesy, professionalism and enthusiasm. I must also thank the past members of the Elephant Trust, for their tremendous support throughout all our Roland Penrose projects: Chairman Lord Hutchinson, Joanna Drew, John Golding, John Bodley, Dawn Ades, Sarah Whitfield, Stephen Farthing, Nikos Stangos, Richard Wentworth, Secretary, Julie Lawson, and Accountant Antony Forward.

I am grateful to Françoise Gilot for her kindness to me and her generosity in discussing painful memories. My thanks go to Michel Remy, the indefatigable sleuth and recorder of British Surrealism for all the information and notes he has made available to me, and to Georgiana Colevile for her work on Valentine and Gwendoline Wells for her translations of Valentine's work and letters. I am most grateful to James Mayor and Andrew Murray of the Mayor Gallery for being so generous with their knowledge and their archives, and to Mark Byron-Edmond of the Information Office at Tate Modern.

My thanks also go to Christo Georgadidis, researcher and Greek scholar, and Barbara Tomlinson, Curator of Antiquities at the National Maritime Museum, Greenwich, London for the history of 'Iris' the ship's figurehead.

I am most grateful to David and Anne Martin of Archaeology South-East for their highly informative survey of Farleys House, and for the surveyor and local historian Nigel Braden, for his comments and assistance.

Thank you, Christopher Johnstone for your warm encouragement and advice. And thank you Mike Goss, the long-suffering computer wizard who rescued my original work from the depredations of a computer virus.

My sincere thanks to Monique Soulayrol of Villa Les Mimosas in Cassis, and Baudoin Jannick of Le Pouy, and Henri and Elvira Faget de Cassaigne for their invaluable help with my researches into Roland's life in France. Also, Richard and Deborah Klein of 21 Downshire Hill, and Caroline Compton for their continued kindness and help.

I greatly enjoyed reliving Farley memories with Joan Baker, Peter Braden, Pat and Bozourg Braden, Christopher Dinnis, Joanna Drew, John Golding, George and Kathleen Kennard, Alastair Lawson, Terry O'Brien, Rosemarie and David E. Scherman, Johnny Scott, Anthony Van Laast, and Bob and Anita Whitehead. My thanks to you all for your many contributions, and also to my many Penrose and Miller relatives all over the world who have been such willing supporters in every way. Your contributions form a thread through the whole narrative, especially the information so generously given by my cousins from Herstmonceux, Edward Penrose, Joan Jenkins and Gwen Penrose, and in Cornwall, Dominic Penrose and my much loved aunt Annie.

It was a privilege working on the original version of this book with Caroline Hillier, Carey Smith and Anne Fraser, at Frances Lincoln, and most especially I wish to thank Fiona Robertson for her diligent and clear sighted editing and Anne Wilson for her outstanding design work.

As always in any project that touches the work of Lee and Roland, the contribution of Carole Callow at the Lee Miller Archives has been vital, and for this version I particularly want to thank the present team at Farleys House and Gallery; Ami Bouhassane, my Co-Director, Lance Downie, Sarah French, Kate Henderson, Tracy Leeming, Brenda Longley, and Kerry Negahban. Thank you for your help, your patience, and the many good ideas you contributed, as well as the very carefully produced digital images by Lance from Lee's negatives.

I would also like to thank Matthew Butson and Helen Boulden at the Hulton Archive for access to and use of the Lee Miller photographs that were once part of the *Picture Post* archive.

Above all I could not have written this book without the help and the memories of Patsy and Georgina, who I hope feel this book is a worthwhile reflection on the life we shared. Finally I don't know how I would have stayed the course without the indulgence of my family, Ami and Salim Bouhassane, (who helped with translations), Eliza, Joshua and Genevieve Steele, and in particular the inspiration of my wife Roz, who has over the years selflessly given me her support and encouragement, and to whom as always I give my most heartfelt love and thanks.

PHOTOGRAPHIC ACKNOWLEDGEMENTS

a = above; b = below; c = centre; l = left; r = right, RPC = Roland Penrose Collection

The publishers have made every effort to contact holders of copyright works. Any copyright holders we have been unable to reach are invited to contact the Lee Miller Archives so that full acknowledgment may be given in subsequent editions.

All photographs by Tony Tree apart from those on the following pages:

1 Roland Penrose; 4 Lee Miller; 5 Lee Miller; 7 RPC; 8 Roland Penrose; 9 RPC; 12acb Private Collection; 13 Private Collection; 14 Roland Penrose; 15a RPC 15b Roland Penrose; 16l RPC; 16r Roland Penrose; 17l Roland Penrose; 17r Man Ray; 18a Roland Penrose; 18b Roland Penrose; 19a Roland Penrose; 19b Roland Penrose; 20 Roland Penrose; 21a RPC; 21b Roland Penrose; 22 Rogi André; 23 Roland Penrose; 24 Man Ray; 25 Lee Miller; 26l Private Collection; 26r Private Collection; 27 Private Collection; 28a Lepape/Vogue; 28b Private Collection; 29 Genthe; 30a Lee Miller; 30b Lee Miller; 31a Private Collection; 31c Man Ray; 31b Theodore Miller; 32a Man Ray; 32b Lee Miller; 33l Private Collection; 33ra Lee Miller; 33rb Lee Miller; 34a Private Collection; 34b Roland Penrose; 35a Roland Penrose; 35b Lee Miller; 36a Dora Maar; 36b Roland Penrose; 37 Lee Miller; 38 Lee Miller; 39a Roland Penrose; 39b Roland Penrose; 40 Picasso; 41 Private Collection; 42a Lee Miller; 42bl Lee Miller; 42br Guy Taylor; 43acb Roland Penrose; 45 David E Scherman; 46 Roland Penrose; 47 Roland Penrose; 48 Roland Penrose; 49ab Roland Penrose; 50 David E Scherman; 51alr Lee Miller; 51b David E Scherman; 52ab Lee Miller; 53a Private Collection; 53b David E. Scherman; 54ab Lee Miller; 55ab Lee Miller; 56lr Lee Miller; 57alrb Lee Miller; 58 Private collection; 59 Roland Penrose; 60 Lee Miller; 61 Roland Penrose; 62a Private Collection; 62b Roland Penrose; 63b Lee Miller; 64 Lee Miller; 66 Roland Penrose; 68lr Lee Miller; 69l Roland Penrose; 69r Lee Miller; 70–72 Lee Miller; 75–78 Lee Miller; 79 Roland Penrose; 80 Private Collection; 81 Roland Penrose; 83 Paul Delvaux; 84 Max Ernst; 85 Lee Miller; 86 Antony Penrose; 88–89 Private Collection; 90a Lee Miller; 94a Roland Penrose; 94b Lee Miller; 95a Beadle; 98b Antony Penrose; 110a Roland Penrose; 110b Lee Miller; 113 Lee Miller; 118–119 Lee Miller; 123 Lee Miller; 125 Beadle; 127 RPC; 130 RPC; 131 Antony Penrose; 132ab Private Collection; 133a Antony Penrose; 134a Private Collection; 134b Antony Penrose; 139b Lee Miller; Back Cover Roland Penrose.